BAUHAUS CO
Controversie

MW00779777

HATJE
CANTZ

BAUHAUS CONFLICTS, 1919–2009

Controversies and Counterparts

CONTENTS

INTRODUCTION
Philipp Oswalt

The Bauhaus emerged in Germany amid the revolutionary turmoil of 1919, during the transition from a monarchy to a republic. After the catastrophe of World War I,
the initiators of the school saw the need to break with tradition; the preceding era of the German Empire with its
decades of nationalistic policy, laissez-faire capitalism,
and grandiose historicism had led to a dead end. What
was needed now was a fresh start in every respect. By
returning to basic forms and colors as well as to the spirit
of the Gothic era, one sought to set the stage for a kind
of "zero hour." At any rate, the Bauhaus arose out of a
vehement rejection of the immediate past.
And it met with resistance just as quickly. Its founding
was intensely opposed by groups on the Right, and from
the outset the school was marked by conflicts both external and internal. In 1922, for example, Dutch avant-garde
artist Theo van Doesburg criticized the new educational
institution as too "mystical" and "Romantic," and in his
Weimar studio offered an art course in opposition to the
instruction at the Bauhaus. Although Walter Gropius was
able to prevent van Doesburg from becoming a master at
the Bauhaus, the De Stijl artist still exerted considerable
influence on the school's development. There was disagreement even among Bauhaus masters, which they
themselves welcomed. Josef Albers explained in retrospect: "It was the best thing at the Bauhaus, that we were
absolutely independent and we didn't agree on anything.
So, when Kandisky said 'Yes,' I said 'No'; when he said

'No,' then I said 'Yes.' So, we were the best of friends, because we wanted to expose the students to different viewpoints."

These differences were extremely productive and contributed significantly to the success of the Bauhaus experiment. The institution called into question not only existing historical and social conditions, but also its own methods and approach. When director Hannes Meyer appointed Hungarian art theorist Ernst Kállai as editor of the journal b a u h a u s , for example, he was recruiting an explicit critic of the Bauhaus style. Throughout the fourteen years of its existence, the school followed no single established program, but rather reoriented itself conceptually numerous times. Because of this powerful dynamic there was no such thing as t h e Bauhaus, but rather a multiplicity of differing, conflicting, and even contradictory currents and opinions.

Even the controversies surrounding the school each had their own character and consequences. The earlier attacks on the progressive educational institution unified and strengthened it; later ones, however, were destructive both internally and externally. Although it was the result of political necessity, the move from Weimar to Dessau ultimately furthered the development of the Bauhaus, but in Dessau, political pressure from the Right increasingly weakened the school. In 1930, the openly leftist director, Hannes Meyer, was dismissed with the backing of a number of Bauhaus masters. The institution was closed and then reopened, and politically active students were expelled. As the new director, Ludwig Mies van der Rohe hoped in this way to forestall further attacks

from the Right—yet as is well known, he did not succeed: in 1933, the Bauhaus was shut down by the Nazis once and for all.

Yet the conflict was by no means over; rather, the Bauhaus was now subjected to countless forms of political instrumentalization. The extent to which it was appropriated or rejected was determined in large measure by the prevailing political discourse. In National Socialism and Stalinism, the Bauhaus embodied the enemy, whether under the rubric of "degenerate art" or "formalism"; in the Federal Republic of Germany in the fifties and sixties, on the other hand, the Bauhaus was a weapon in the Cold War. Without exception, such appropriations were based both on clear misrepresentations of the Bauhaus legacy as well as a glossing over of each party's own contradictions. The cold warriors limited the Bauhaus to a style—in essence, to smooth white cubes, extensive surfaces of glass, and the colors red, yellow, and blue—and in this way bracketed out the societal aspirations and leftist objectives of the school. Also suppressed was the fact that some former members of the Bauhaus had been able to continue their activity as architects or designers even during the Third Reich.

This political instrumentalization, first by the one side and then by the other, produced a reciprocal effect. As an institution outlawed by the Nazis, the Bauhaus became an important symbol of the other, liberal Germany in the postwar Federal Republic, and for this reason was essentially immune to even the most justifiable critique. With the economic and growth crisis of the seventies and the advent of postmodernism, this phase was followed by equally superficial condemnation.

In addition to its fame, an important reason the Bauhaus was susceptible to such kaleidoscopic political instrumentalization was that its design-related objectives had always been connected to its goals for society. Each of these controversies thus reflected the relationship between politics and culture in the twentieth century—and with it the history of the formation of German identity since the Weimar Republic.

In this process, the Bauhaus derived its influence not from consensus, but from dissent. It was effective because it was controversial; it constituted an arena within which central questions of the relationship between politics, culture, and society were negotiated. The conflict over the inheritance of what the Bauhaus had taught in Weimar, Dessau, and Berlin was a continuation of the conflicts within the avant-garde of the twenties and early thirties. How should this successful, unfinished project of modernism be continued? How should we deal with the paradox that the avant-garde can itself become tradition? Is there an alternative to formalization and musealization on the one hand, and the constant negation of tradition on the other? These were the questions over which Bauhaus students fought with Situationists and party cadres, anti-establishment factions in East and West with the mainstream of society, museum experts with furniture manufacturers, and historic preservationists with architects.

The intense controversy over the Bauhaus more than seventy years after its closing is a sign of the continuing relevance of its idea and policy. The vitality of its legacy is a function of its contentiousness, which can and should be repeatedly activated. The present publication,

B a u h a u s C o n f l i c t s , originated within a few months of my appointment as director of the Stiftung Bauhaus Dessau. On this ninetieth anniversary of the school's founding, the book's intended purpose is to take another look, beyond myth, at the legacy of the Bauhaus and in this way take up a stance.
I am deeply indebted to the authors for their willingness, despite the short time frame, to contribute in this effort.

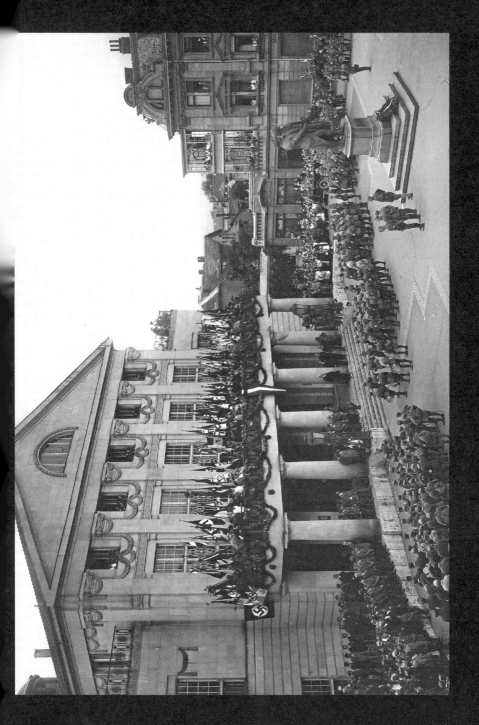

UN-GERMAN ACTIVITIES
ATTACKS FROM THE RIGHT, 1919–1933
Justus H. Ulbricht

■ ATHENS ON THE ILM

Edwin Redslob, the Reichskunstwart of the Weimar Republic who himself was from Weimar, is credited with saying that the history of the Bauhaus should be written as a "string of clashes." The hostility against the school that erupted repeatedly between 1919 and 1933 had the paradoxical effect of making the Bauhaus—which was conceptually heterogeneous and whose character changed markedly over the course of its years in Weimar, Dessau, and Berlin—appear unified or at least united in the struggle with its opponents. At the height of the first Bauhaus controversy in 1920, the aesthetic and political differences between people like Walter Gropius, Johannes Itten, Lothar Schreyer, and Gerhard Marcks were completely imperceptible to the outside; any information about the school's internal quarrels must be gleaned from the minutes of the Masters' Council or the diaries of Oskar Schlemmer.

Similarly, the differences in artistic personality among the faculty and students of the experimental art school went largely unnoticed. The subsequent self-mythologizing of the Bauhaus and its protagonists as well as characterizations from the outside resulted in a somewhat simplistic view of its aesthetic and political concepts, a black-and-white image of the institution and its opponents. The latter, however, were by no means to be found only among the ranks of populists, German nationalists, and National Socialists. The Bauhaus style was also crit-

14

icized by the avant-garde, including such sympathizers as Paul Westheim, Walter Dexel, and Adolf Behne. Nor did the catty epithet of "artists' hospital" come from a right-wing extremist like Paul Schultze-Naumburg, a devoted enemy of the school, but rather from Theo van Doesburg, whose De Stijl course changed the character of the Weimar Bauhaus in 1922.

The harsh attacks by the national-conservative establishment in Weimar had begun as early as in December 1919, only a few months after the founding of the art school on the Ilm River. Yet even today it is easy to forget how much both proponents and opponents of the Bauhaus had in common. Both groups shared the conviction that the chaos of the postwar period and the fundamental malaise of modern society could be overcome only by means of a new art. Equally self-evident on both sides was the notion that this new art—manifested in the idea of the "Gesamtkunstwerk"—had to be "rooted in the people." In his conflicts with local adversaries, Gropius repeatedly emphasized that the Bauhaus was "apolitical" in nature; this stance was adopted not merely to avoid making cultural-political waves, but rather was rooted in the conviction that true art transcended class and party lines and possessed quasi-metaphysical qualities capable of mending the fissures of modern culture.

As early as before World War I, various political-aesthetic factions had espoused the utopian idea that a new art could create "new human beings" who would then build a "healthy" society, regenerated from the ground up. At the time, adherents of widely differing world views shared the hope that this new art, together with technology and industry, would restrain the menacing powers of

the "demon's machine." The experiential background for such utopias was not only the rapid industrialization of the late German Empire, but above all the shocking, indeed traumatizing experience of technologized mass killing during the war. Even in, and especially after, 1918, the words "art" and "the people" signified the aesthetic and social wholeness nearly everyone was longing for at the time, enshrined in the first Bauhaus manifesto in the image of the masons' lodge and cathedral. Both the Right and the Left were inspired by the hope of a "German rebirth" combined with a messianic sense of their own anointing as cultural saviors.

The pervasiveness of such religious ideas in early conceptions of the Bauhaus is evident in the work of Expressionist painter and "master pupil" Hans Gross. Gross's dedicated advocacy for a Bauhaus built on a "German foundation" was the external catalyst for the first conflict over the newly founded art academy in December 1919. Gross's Gothicizing Expressionism was reminiscent of Matthias Grünewald and would certainly have enjoyed the attention of more conservative art lovers, whose critique of art and culture often invoked an imaginary Middle Ages onto which they projected their own longing for an integrated culture.

When Gropius began work in Weimar in 1919, it was the fulfillment of a desire he had had since the middle of the war. He had been encouraged by Henry van de Velde, whose Grossherzogliche Kunstgewerbeschule (Grand Ducal School of Arts and Crafts) in Weimar had already embraced an educational approach according to which young artists were trained in close contact with craft and industry. The Berlin architect Gropius, however, placed

greater emphasis on industry, which from the beginning tended to alienate the Thuringian craftsmen's association, and his philosophy of the masons' lodge drawn from the traditions of medieval architecture did little to counter their misgivings. Even more than these programmatic nuances, however, the association of individual members of the Bauhaus with Expressionism and the corresponding artistic circles in Berlin—most of them leftist in their politics—irritated the conservative Weimar public. For years, an anti-urban ideology emphasizing the divide between metropolis and province—propagated in the "Heimatkunst" of Adolf Bartels, Ernst Wachler, Friedrich Lienhard, and other writers—had prevailed in Weimar; this mindset now became a liability for the Bauhaus, which was seen by its adversaries as an aesthetic hotbed of socialism, indeed a "center of Spartacism." Even Gropius's emphatic invocation of the "Gothic spirit" could not allay these suspicions, and the lifestyle of individual Bauhaus masters and students did the rest. When Emil Herfurth, a prominent local spokesman for the Bauhaus opponents, asserted that "a city like Weimar is too small for a Schwabing" (the artists' district in Munich), his words revealed what the established citizenry feared: the disruption of their bourgeois lifestyle by bohemians, whose intent was to do exactly that.

Moreover, in a time of radical political and social uncertainty, the experimental nature of the Bauhaus and its cultivation of anti-bourgeois attitudes must have struck fear into all those who were looking for security. Contemporary newspaper reports reveal a larger context that must be taken seriously when considering the calculated attacks by individual middle-class citizens against

Gropius and his institution, though without justifying their reactionary aggression. A constant theme throughout those months were the Versailles peace negotiations, which for most Germans were disappointing, and the unclear domestic political situation. In particular, the duchy of Saxony-Weimar-Eisenach had disintegrated in 1918, and only now, little by little, was it beginning to regenerate itself politically and administratively. The winter of 1919/20 saw a massive supply crisis in Weimar; coal was scarce, and there were shortages of potatoes and cooking oil as well. The flood of obituaries for small children, the sick, and the old speaks for itself. In short, though today we may hail the experimental attitude of the Bauhaus as "modern," we must not forget that its contemporaries were hardly in a mental or practical position to uninhibitedly celebrate this modernity. For understandable sociohistorical reasons, the ideologically and politically biased anti-Bauhaus spokesmen could therefore count on the silent agreement of the majority of Weimar citizens.

The "völkisch" writer Leonhard Schrickel, the national-conservative painter and literary figure Mathilde von Freytag-Loringhoven, and the right-wing secondary school teacher and later provincial parliamentarian Emil Herfurth were the best known protagonists of the organized opposition to Gropius. Public unease with the modernity of the Bauhaus gained even greater plausibility when Max Thedy, Walter Klemm, and Richard Engelmann—three renowned professors of the old Weimar Kunsthochschule and one-time advocates of the Bauhaus—assumed the role of spokesmen for its opponents. Their letter of protest to the Weimar State

Ministry on December 19, 1919, was signed by other influential members of the educated Weimar cultural bourgeoisie, including Goethe scholar Wolfgang Vulpius, art professor Fritz Fleischer, writer Paul Quensel, history painter Hans W. Schmidt, painters Peter Woltze, Karl Pietschmann, and Arno Metzerodt, and sculptor Arno Zauche. Some of these Bauhaus foes appeared again on the faculty of the Staatliche Hochschule für bildende Kunst, founded once more in 1921 as a successor institution to the old Grossherzogliche Kunstschule. It shared its entire school infrastructure with the Bauhaus, giving rise to further conflicts.

Yet it was not merely the difficulties of everyday life that repeatedly led to discord between adherents and opponents of the avant-garde. Underlying the artistic struggles of the day and the personal animosities were cultural processes of much longer duration. The conflicts in and around the Bauhaus reflected the cultural fault lines within the educated German bourgeoisie, who could no longer come to agreement on what constituted good, or even German, art. Since the eighteen-seventies, more and more members of the educated classes had unreservedly, even enthusiastically, opened themselves to modern art and society. Simultaneously, others persisted all the more stubbornly in "consensual artistic nationalism" (Georg Bollenbeck), whose earliest roots extend back into the late eighteenth century. In this view, true art comes from the people, shapes them, and elevates them above the mundane.

This traditionalistic conception of the role of art and artists in the formation of national cultural identity had embraced Weimar Classicism as the absolute standard

of good art since the mid-nineteenth century; now, faced with the rise of the avant-garde, it could only be maintained by a kind of fundamentalist revolt. Moreover, the conjunction of the ideas of art and nation ensured that debates over art and culture were immediately politicized, though usually in the name of an ostensibly apolitical artistic nationalism. The crisis of the classically educated bourgeoisie amid the rise of technological-scientific intelligentsia and the epoch of mass culture further intensified these polarities. Concepts of a "German" or even "Germanic" modernism were developed around 1900 and brought into play against the internationalism of modern art movements as well as the expanding European art market.

What is remarkable about the artistic struggles in Weimar, however, is that the arguments that finally began to cut the lifeline to the Bauhaus in 1923 were fiscal ones; in an era of hyperinflation, this was certainly the best strategy for implementing a cultural-political agenda. In addition, there was also a shift in the political climate in Thuringia. In combination with Adolf Hitler's putsch in Bavaria and the leftist government in Saxony, this change was to fundamentally alter the political structure of the new province. The so-called Ordnungsbund Regierung that ruled from the provincial capital of Weimar beginning in late 1924 rejected cultural experiments and strove to meet the cultural-political demands of its German-nationalist clientele. The right-leaning Nietzsche Archive, for example, profited more than Gropius's art school, which continued to be considered leftist despite its political and aesthetic pluralism. After agitated debates in the Thuringian state parliament, drastic cuts in public fund-

ing, and a press campaign against the 1923 Bauhaus exhibition that stretched on into late 1924, Gropius and the Bauhaus masters saw the handwriting on the wall and announced their resignation effective the end of 1924. It is important to realize that the struggle over the Staatliches Bauhaus Weimar was important for all of Germany, and not merely in an aesthetic respect. The defeat of Gropius and his comrades both manifested the changing political climate of the state of Thuringia and fore-shadowed the approaching end of the Weimar Republic.

■ "DESSALIEN"

Immediately following its exile from "Athens on the Ilm," however, the art school found a new home in "Dessalien" (Oskar Schlemmer). Dessau—a medium-sized industrial city in the state of Anhalt, home to the Junkers factory as well as the splendor of the nearby Wörlitz Garden Kingdom—became the site of radical internal restructur-ing as well as the arena for both the public rehabilitation and later dismantling of the Bauhaus. Gropius's appoint-ment and reestablishment of the faculty in the new loca-tion was accompanied by plans for a new building, which was dedicated on December 4, 1926. Masters' Houses for the instructors were also built there, and between 1926 and 1928 a much-discussed workers' settlement was constructed in Dessau-Törten under Gropius's di-rection. The latter was immediately recognized as an example of subsidized housing according to the criteria of Neues Bauen (New Architecture). Members of the Bauhaus and their international architectural colleagues also left their mark outside of Dessau, particularly in the Weissenhofsiedlung in Stuttgart in 1927.

The harshest critics of Neues Bauen felt as if they had been involuntarily sent to Arabia: they denounced the flat roof as an oriental form, suited only to desert climes. For them, it was an architectural symbol of nomadic cultures, Stone Age peoples, or Pueblo Indians—which corresponded to their perception of modern German culture between the wars. The restlessness, rootlessness, and overdeveloped rationality they saw expressed in the "machines for living" and "machines for sitting" were laid to the account of avant-garde architects and artists, discrediting them in the eyes of a tradition-oriented art public. The emphatic celebration of industrial-technological rationality and aesthetics found in many manifestos of modernism was frightening, above all to those who had suffered from the results of progress and were barely surviving the social and political dislocations of the Weimar Republic—an understandable, if not justifiable, reaction.

At first, all went well for the Bauhaus. But by 1928, Grete Dexel was asking with both surprise and perplexity: "Why is Gropius leaving?" Her answer: "Gropius is leaving—and there is talk of a crisis in the Dessau Bauhaus. That is both true and false. It is false because crises are temporary and acute, arising out of exceptional circumstances. That is not what is happening here. If anything, the Bauhaus is in continual crisis—as long as it has existed, it has been fighting. It is one of the best-hated institutions of the new Germany. It has become a first-class object for election battles."

And the art school was in fact fighting, both internally and externally. Changes in faculty and curriculum did not take place without resistance. In general, the Dessau

school increasingly profiled itself as an educational institution for architects, so that from 1927 on, opposition to the Bauhaus became more and more a conflict over the stylistic elements of New Architecture. Even modern architects outside the Bauhaus scene found themselves in the crossfire of criticism. The epithet "cultural Bolshevism" made the rounds, a designation for allegedly "un-German" and "degenerate" art. Members of the Bauhaus and their sympathizers were all the more energetic in emphasizing the international quality of modern architecture and the essential openness of their cultural concepts. Beginning in 1928, the journalistic attacks multiplied against Gropius and his school, and later also against his successor, Hannes Meyer; the Bauhaus itself answered with a systematic press and publication campaign, in which the Bauhaus books and the Bauhaus journal played an important role.

A year before his resignation as director, Gropius had appointed the Swiss architect Meyer as head of the newly established architecture department. Though he had no idea at the time, in so doing he had brought his own successor to Dessau. There is no question that under Meyer, the art school once again flourished. But Herbert Bayer, Marcel Breuer, and László Moholy-Nagy also left Dessau along with the former director. The older masters and many younger students were probably irritated by Meyer's aggressive manner, as he implemented a fundamental reform of the Bauhaus in 1928 with a stronger orientation to social objectives—"the people's needs instead of luxury demands." At the same time, the school was also becoming increasingly politicized through Meyer's open sympathy for socialism as well as

the activity of a communist cell in the student body that had existed since 1927. While Gropius had at least tried to keep party politics out of the school during the Weimar and early Dessau years, from 1928 on the obviously politicized Bauhaus offered its opponents a ready target for ongoing attacks.

As had been the case in Weimar, soon after the arrival of the art school in Dessau, a citizens' group was formed that used its connections to the city council as well as to the local and regional press for frequent invectives against the "State Garbage Service," as Konrad Nonn from Berlin put it. It was becoming increasingly difficult for the liberal Dessau mayor Fritz Hesse to justify his support of the Bauhaus to his political opponents. In 1930, a "Fasching" prank by leftist students offered the right-wing local press a welcome opportunity to discredit the entire school as an ultra-leftist institution. When Meyer donated private money to the Mansfeld miners' strike in the summer of 1930, the authorities took the opportunity to call him to account. With the support of Gropius as well as Bauhaus masters Josef Albers and Wassily Kandinsky, Hesse—who in the meantime had clearly distanced himself from the Bauhaus director— dismissed him without notice, notwithstanding the protests of numerous students. Meyer went to Moscow with a building brigade.

His successor was Ludwig Mies van der Rohe. With Hesse's support, Mies took charge in an authoritarian manner, officially closed the school, changed the bylaws, and above all strengthened his own stance. One could say that such measures were suited to the era of "Präsidialkabinette:" in Dessau as in Berlin, power was

increasingly being concentrated in the executive branch, while parliamentary structures were successively weakened. In practice, Mies's strategy of depoliticization meant applying the instrument of expulsion more readily and more often to leftist students. Foreign students had to pay a "foreigner's fee." Soon it was not just the mood that had changed: the character of the entire school was altered to conform to Mies's maxims in organization, policy, and aesthetic practice. This included placing the educational accent more strongly on design according to the highest aesthetic and constructive standards; explicitly social and political intentions, on the other hand, receded in importance. Toward the outside, Mies was concerned to offer right-wing critics of his institution no opportunity whatsoever for new attacks. In actual fact, however, he conformed the school to reactionary political demands. This shift to the right was so momentous that some communist students even spoke of a "Fascist Bauhaus."

Tightened fiscal measures in the state of Anhalt and the municipality of Dessau permanently weakened the Bauhaus. In the fall of 1929, Black Friday marked the beginning of radical reductions in public spending, beginning with soft budget items, above all education and culture. Curtailing the school's budget was also a way for Hesse to silence its political opponents, since one of their primary allegations was that the Bauhaus squandered public money—another familiar argument from the struggles in Weimar.

The political breakthrough of the Nazis in the Reichstag elections of September 1930 heralded the party's triumph in the provincial government as well. In Weimar,

two Nazi ministers gained entrance into a German provincial government for the first time. Wilhelm Frick, Minister of the Interior and of Education in Thuringia, dismissed Otto Bartning and appointed the radical Paul Schultze-Naumburg, an activist of the Kampfbund für deutsche Kultur (Combat League for German Culture), as director of the Vereinigte Kunstlehranstalten (United Art Schools); he also caused avant-garde works to be removed from the Weimar Schlossmuseum. The mural by Oskar Schlemmer in the stairwell of what had formerly been van de Velde's School of Arts and Crafts was removed by Schultze-Naumburg.

In the fall of 1931, the Nazis gained the absolute majority in the parliament of the state of Anhalt; in the Dessau city council they held nineteen out of thirty-six seats. The main focus of the preceding election battles had been the "fight against the Bolshevist Bauhaus"; even the demolition of the building was called for. It was in fact Schultze-Naumburg who, at the request of Anhalt's Nazi minister president Freyberg, wrote a recommendation stating in no uncertain terms that the school should be shut down. The Nazis ordered that the Bauhaus Dessau be dissolved at the end of September 1932. A written vote of confidence, signed even by such conservative-leaning intellectuals and artists as Jena philosopher Carl August Emge, psychiatrist Hans Prinzhorn, architect Wilhelm Kreis, and Leipzig philosopher Hans Freyer, was unable to alter the decision. Although the Bauhaus was offered a new home in the cities of Magdeburg and Leipzig, which were still under Social Democratic rule, Mies had long since decided to continue the school as a private institution in Berlin.

■ BABYLON ON THE SPREE

The final picture in Magdalena Droste's standard work on the Bauhaus shows a young man in the rear courtyard of the Bauhaus building in Berlin—an empty telephone factory—staring into the camera with a somewhat bewildered expression; it is the student Ernst Louis Beck. By this time, the Bauhaus, now a private institution in the metropolis on the Spree River, had only a few months left to live. Three weeks after the "Ermächtigungsgesetz" (Enabling Act) was passed in March 1933, Nazi authorities closed the school once and for all. Previously, a search of the premises ordered from Dessau had uncovered "communist magazines" in the Bauhaus library sent from there to Berlin—a good excuse to officially end Mies's experiment on April 12, 1933. His attempt to exploit the polycratic structure of the Nazi cultural bureaucracy to reopen the school—playing Rosenberg's office, the propaganda ministry under Joseph Goebbels, the Kampfbund für deutsche Kultur, and the Prussian cultural ministry under Bernhard Rust against each other—failed miserably. On July 19, 1933, the masters and students gathered for the last time in Lily Reich's studio and unanimously voted in favor of Mies's resolution to dissolve the Bauhaus. Whether or not this act should be interpreted (as Magdalena Droste suggests) as a "final manifesto for intellectual freedom of choice" is another question.

The Bauhaus had come to an end. The survival of a few of its ideas and many of its protagonists within the Third Reich is another story, one that has only been researched since the eighties. At that time, new historical insights into the partial modernity of National Socialism made it

possible to more clearly recognize where representatives of Bauhaus modernism—including Herbert Bayer, Kurt Kranz, Gerhard Marcks, Ernst Neufert, and Lily Reich—no longer saw themselves as opponents of Nazi culture, but accommodated themselves to it. Prior to that, decades of interpretive dominance by Gropius and other exiled Bauhaus masters had obscured the strategies of conformity adopted by many who remained at home, and the persons in question had little interest in self-critically examining and exposing their role in Nazi Germany. Now, after another twenty years, the subject of the Bauhaus and National Socialism can be addressed with less agitation, and without completely negating older interpretations of the Bauhaus and its history in the perception of the non-specialist public. Yet clearly and without doubt, the Bauhaus as a whole could never have survived in Nazi Germany. The aesthetic and political stances diverged too widely, and in any case, in the eyes of Nazi cultural functionaries the art school had discredited itself from the very beginning.

■ LATER APPROPRIATION

The attacks on "degenerate art" and the "dentist's style with housing cubes" in the early thirties had been anticipated in the debates surrounding the Bauhaus in Weimar and Dessau. They returned again in the early fifties in sometimes alarmingly similar form—in East Germany in the guise of socialist agitation against artistic expression and the "bourgeois-decadent" avant-garde, and in West Germany in the Bauhaus debate of 1953.

Until the late twentieth century, the quest for cultural identity among Germans—living in separate countries

from 1949 on—remained closely connected to the struggle for and against the modernist avant-garde. For many decades following World War II, an adequate assessment of the strengths and weaknesses of the Bauhaus was hindered above all by two processes. While the affirmative reception of the Bauhaus as part of a "better Germany"—that is, as an anti-Nazi cultural legacy—perfectly accommodated the self-stylization of early West German culture and society, it effectively prevented a thorough investigation of the programmatic and conceptual weaknesses of the Bauhaus idea. To put it bluntly, the Bauhaus and the Federal Republic of Germany immunized each other against various kinds of legitimate criticism; from this perspective, all criticism of the Bauhaus was quickly accused of being retrogressive and even reactionary. This approach was exacerbated by the fact that, generally speaking, only extremely right-wing, intellectually unsophisticated critics were quoted instead of more carefully considering how many serious journalists, intellectuals, and architects could be critical of the Bauhaus without indiscriminately denouncing it.

In East Germany, on the other hand, wide swaths of Bauhaus history were inserted into the prehistory of Fascism. The protagonists and members of the Bauhaus—most of whom belonged to the bourgeoisie—were denied the correct anti-Fascist consciousness and were once again denounced, sometimes with old arguments. Amid the chill of the incipient Cold War and in the wake of the infamous Formalism Debate, the cultural policy of the German Democratic Republic severed an avant-garde tradition that was rehabilitated in a particular form only after the end of Stalinism.

In Germany today, anyone interested in the legacy of the Bauhaus is faced with a fundamental challenge. The myth of the Bauhaus is inscribed into the social myth of modernism, and the task of critically deconstructing both of them still remains—even after the "Age of Extremes," as Eric Hobsbawm once called the twentieth century.

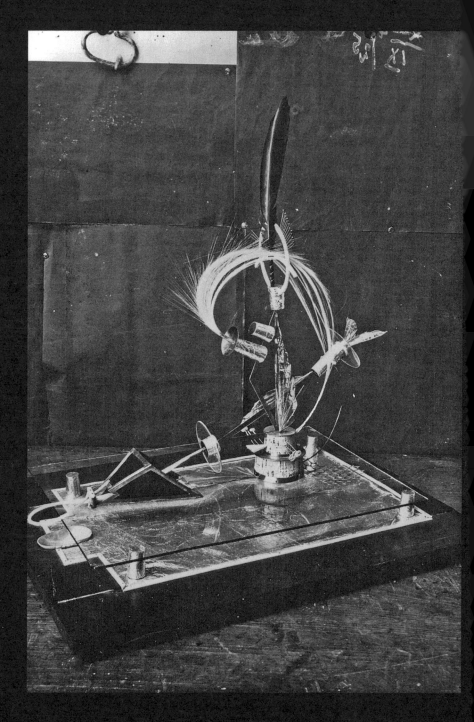

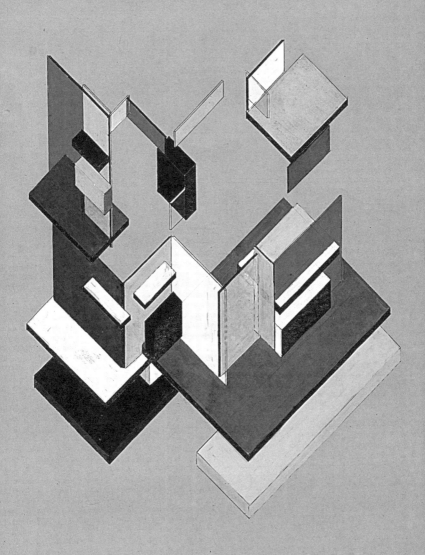

"CLASH OF THE NATURAL AND THE MECHANICAL HUMAN"
THEO VAN DOESBURG VERSUS JOHANNES ITTEN, 1922

Kai-Uwe Hemken

When Theo van Doesburg, one of the heroes of modern art, arrived in Weimar on April 29, 1922, he was emphatically welcomed by a certain following he already enjoyed there. Contrary to expectations, the Dutch De Stijl artist had not been offered a position at the Staatliches Bauhaus in Weimar, probably because its director, Walter Gropius, found him too dogmatic; now he set about teaching his own art course. Yet as provocative and conspiratorial as this undertaking may initially seem, it nonetheless followed the rules of bourgeois organization. Van Doesburg's registration and attendance records show that in addition to a number of Bauhaus students, some of the luminaries of Weimar cultural life also found their way to him; among the recipients of his tutelage were Max Burchartz, Walter Dexel, Werner Graeff, Karl Peter Röhl, and Andor Weininger. They met in his studio in the building at Am Schanzengraben 8 (now An der Falkenburg 3) directly above Paul Klee's studio. Officially, the course met every Wednesday from 7:00 to 9:00 p.m., from March 8 to July 8, 1922. The price was ten marks per session; the records indicate that a number of sessions were cancelled.

Behind these formalities, however, lies a key episode in the history of modern art: the encounter between Expressionism, De Stijl, and Dada. The year 1922 was highly significant for Constructivism. All three of the above-

mentioned "isms" of modern art—seemingly irreconcilable currents personified by Johannes Itten, Theo van Doesburg, and László Moholy-Nagy—would compete for the claim to relevance. The motivation for their respective engagements varied: Itten was concerned with grounding and systematizing his art, while van Doesburg was seeking to establish himself in the German art scene; Moholy-Nagy was idealistically pursuing a concept of art compatible with his technologized world. In retrospect, the controversy amounts to a clever offensive by van Doesburg, using Constructivism on the one hand as a weapon against the mystic Itten, and Dadaism on the other against the Constructivist Moholy-Nagy.

Beyond Constructivism and the personalities of the avant-garde, however, the events of 1922 in Weimar reveal a turning point in the development of modernism, one that implicitly marks the transition from the nineteenth to the twentieth century. The impulse for this change derived from the public sphere. In the course of the nineteenth century, relations between artists and the public had assumed a form that essentially still exists today; yet the generation of Theo van Doesburg, El Lissitzky, and László Moholy-Nagy took the artist's instrumentalization of the public arena to a new level. From that point on, the focus would no longer be on public opposition to an established order, as in the struggles of Impressionism or Secessionism against the Academy. Nor would the familiar strategy of artists taking action in order to attain public recognition for their work continue to be determinative. Rather, from now on, public action would be conceived as a crucial element of artistic creativity itself.

While both Itten and van Doesburg undeniably had potential for artistic innovation, their aesthetic concepts and understanding of themselves as artists differed. In the final analysis, van Doesburg's dispute with Itten was a carefully staged duel between the Dutch artist and Gropius. The latter, meanwhile—in closest proximity to van Doesburg's studio—unflinchingly pursued the transformation that would ultimately result in the Bauhaus motto "Art and Technology—A New Unity."

■ ITTEN'S TEACHINGS

When Johannes Itten arrived at the Weimar Bauhaus in 1919, his educational concepts were already well-developed. His pedagogical notion of a "mystical sensualism" was shaped not only by pioneers of modern education such as Johann Heinrich Pestalozzi and Maria Montessori, but in particular by the painter Adolf Hölzel, who had taught at the Akademie der Bildenden Künste in Stuttgart. Itten's program of material study, color theory, and visual analysis was incorporated into his preliminary course. Talent and creativity were to be developed apart from academic tradition. The objective was not merely specific knowledge of materials; part of the training also consisted in the individual experience of materials, a playful manipulation through which the foundations of modern design were to be learned. Loosely inspired by the aesthetics of Friedrich Schiller—according to whom art arises solely from play—Itten's curriculum began with the fashioning of toys, that is, of objects with no obligation to utility. By invoking the Classicist Schiller—a key source of the ideals and arguments of the educated German bourgeoisie—Itten succeeded on the one hand

in placing his work within a tradition, and on the other in giving new support to his own stylistic elements.

By applying this approach he was able to dispense with the life drawing exercises and nature studies so familiar from traditional art training and allow the students to revert to their childhood, giving free rein to their powers of imagination without regard for utility. Yet the game was infused with educational values. Itten viewed nearly every material—wood, stone, glass, metal, even fur and other substances—as worthy of art. He was concerned not with analyzing the serviceability of particular materials, but with forming his students' powers of perception. Their senses were to be mobilized as a whole. While the sense of sight remained fundamentally preeminent, the concept of "sensitive observation" served to emphasize the importance of activating tactile qualities as well, as evidenced by numerous projects from the preliminary course.

In addition to this sensitization, the artists' training included two other disciplines: visual analysis of works by old masters and color theory. Itten projected photographs of countless paintings onto the wall of his Bauhaus studio and had students analyze their composition in detective-like fashion. Wave forms, diagonal structures, networks, grids, and light-dark contrasts were all discovered, for example, in Stefan Lochner's works on biblical themes. The foundation for this analysis was Itten's conception that the laws of design propagate themselves beyond particular historical givens and individual personalities. For him, there existed a cultural permanence independent of the ups and downs of history. In this sense, Itten's concept of the world was not one of historical

progression, but rather of mystical continuity nourished by divine powers of culture. For him, knowledge of "form characters"—the circle, the square, the triangle—was not simply a matter of art-historical style, but an instrument for engendering religious spirituality.

This "contrast theory" is likely derived from contemporary writings such as the book Schöpferische Indifferenz (Creative Indifference) by philosopher Salomo Friedlaender, published in 1918, as well as the "harmonization theory" of singer Gertrud Grunow, who was active at the Bauhaus in Weimar. An anthropologically motivated conception of harmony arising from the spirit of opposites is found again in the third part of Itten's teachings, his color theory. Color, he maintained, could be studied in five ways: physically, chemically, physiologically, psychologically, and artistically. The latter was probably the highest form of color analysis, since it unified at least two of these dimensions, the physiological and the psychological. In the end, color should be experienced sensually-optically, physically, and intellectually-symbolically. On the basis of Isaac Newton's prismatic refraction of light rays, Itten developed a system of color relations, cosmically reinterpreting Newton's discovery that color consists primarily of light. The prism became an instrument for apprehending cosmic laws and allowing them to flow into aesthetic pictorial inventions. Itten developed a system for ordering numerous kinds of color contrasts; its precursors were the color theories of author Johann Wolfgang Goethe, chemist Wilhelm Ostwald, and painter Adolf Hölzel. He was also inspired by contemporaneous ideas about music, for example by the works of the Austrian composer and

music theorist Josef Matthias Hauer. Itten's system still retains its validity today: cold-warm contrast, simultaneous contrast, complementary contrast, and quantity contrast are only a few of the many color relations he described. His works, which are characterized by a kind of prismatic aesthetic, demonstrate this approach.

Itten's conception of art and life was undergirded by the anthroposophy of Rudolf Steiner, but above all by the Persian Mazdaznan sect, a certain kind of reformed Zoroastrianism. His persuasion was manifested in more than just the vegetarian menu of the Bauhaus cafeteria. In many respects, the graphic portfolio U t o p i a of 1921 bears witness to the transformation of Eastern philosophy to meet the needs of modern western Europeans. A reworked trial proof from the portfolio gives Itten's maxim for viewing a painting: after completing the analysis of a work by an old master, viewers should immerse themselves in it by attempting to reproduce it artistically. The reconstruction of the picture—on the one hand factually, and on the other hand visually—is based on a complete surrender to the experience of the painting, finally signifying its rebirth within the viewer.

In this context, the Eastern concept of reincarnation becomes an element of art education. If we remember Itten's "form characters" and their effect, we cannot avoid the impression that he was seeking to bring about renewal in the viewer through contemplation, indeed through the experience of art. Whereas Eastern thought conceives of reincarnation as taking place after physical death, Itten transferred this to the field of art and translated it into a renewal during one's lifetime. In that moment, aesthetic stimulation—the religious rapture

spoken of at the beginning—suddenly mutates into a therapeutic measure for stress-plagued modern humanity, more precisely for the neurasthenic inhabitant of the hectic metropolis. Itten's concept is one among a plethora of life-reforming approaches which, along with the religious view of art espoused by Wassily Kandinsky and Kasimir Malevich, also called for artists' retreats like Worpswede and other colonies.

■ VAN DOESBURG'S TEACHINGS

Such artistic-religious conceptions met with vigorous opposition from the new movements of Constructivism and De Stijl. As mentioned earlier, an indirect confrontation took place in Weimar in 1922 between Theo van Doesburg, the Dutch protagonist of De Stijl, and Johannes Itten: van Doesburg's art course constituted an attack on the instruction at the Bauhaus. His curriculum was intended to teach the system of design rules the De Stijl group had developed a number of years earlier with the goal of creating a "Gesamtkunstwerk." Now, in van Doesburg's course, the system was to be tested on the basis of what he called a "science of design." Itten's works, on the other hand, were disqualified by his opponent as the "individualistic art of a mystic" whose formal laws were inaccessible to the general public. Van Doesburg's critique found laconic expression in a drawing by Karl Peter Röhl inscribed "Clash of the natural and the mechanical human in Weimar in 1922." Itten's sensualistic principle earned him the label "thistle gazer," especially since in the portfolio U t o p i a he had shown a thistle as an object to be artistically contemplated. Van Doesburg, in contrast, was the new, mechanical man.

The point of departure for van Doesburg's Weimar art course was painting; its analysis was elementary for the creation of interior design and architecture. The ingredients for the experiment were the master's own works, above all his C o m p o s i t i o n 1 8 i n T h r e e P a r t s, which must have already been in Weimar, since it was shown in an exhibition at the Schloss only a short time later. Van Doesburg, however, had something much greater in mind when using his own creations as the subject of analysis for his art course. In his essay "Der Wille zum Stil" (The Will to Style), published at around the same time, he made it unmistakably clear that in the future, the definitive approach to design would be that of De Stijl. Just as previous centuries were divided into epochs such as Romanesque, Gothic, Renaissance, and Baroque, the twentieth century would be the epoch of De Stijl. The aesthetic consistency of the movement proved the truth of this prophecy: "The style which we are approaching will be, above all, a style of liberation and vital repose. This style, far removed from romantic vagueness, from decorative idiosyncrasy and animal spontaneity, will be a style of heroic monumentality I should like to call this style, in contrast to all the styles of the past, the style of the perfect man, that is, the style in which the great opposites are reconciled."[1]

Drawing from Piet Mondrian as a pioneer of De Stijl, van Doesburg insisted on a necessary harmonization of such phenomena as indeterminacy, vagueness, faith, beauty, complexity, and individualism. Such terms, of course, gave rise to a certain difficulty in defining the new art. Bauhaus students Peter Keler and Andor Weininger made concerted efforts to understand the

"basic concepts of the new art of design"; Keler was anxious to comprehend his master's visual aesthetic. But in the end, what the De Stijl course really became was a scientific laboratory. Van Doesburg's studio was transformed from an alchemist's den—the birthplace of individual easel paintings, whose creators acted in divine inspiration—into an educational and research institute for art-related matters. Detailed proportions were calculated, variations within limited artistic parameters were tested, directional forces in images were determined, and color distributions were altered according to established compositional schemes in order to ultimately achieve the widest range of pictorial tension and explore visual laws.

For all of the student Weininger's meticulousness, it remains questionable how clear and unequivocal the approach to design propounded by van Doesburg really was. It appears as if the students in his art course spent more time looking for supposedly iron-clad laws of design than actually finding them. Nonetheless, van Doesburg's sojourn in Weimar, and in particular his activity in the local public arena, was not without lasting impact. In the late summer of 1922, Max Burchartz, Walter Dexel, Karl Peter Röhl, and Josef Zachmann exhibited works of their own influenced by De Stijl, and among students the group KURI was formed—an acronym for "constructive, utilitarian, rational, and international."

■ ARTISTS' CIRCLES, ARTISTS' CLASHES
The influence of van Doesburg's stay in Weimar on Bauhaus director Gropius—and whether the latter's shift from craft to industry was if not caused then at least

accelerated by van Doesburg—can only be surmised in retrospect. For there were other events occurring at the same time that should not go unmentioned. Immediately following the ratification of the Treaty of Rapallo by Germany and Russia in April 1922, Germany experienced a massive influx of Russian avant-garde artists; the First Russian Art Exhibition, which opened at the Galerie van Diemen in Berlin in October 1922, doubtless also played a role. At the initiative of the artists' group Das Junge Rheinland (The Young Rhineland), the First International Congress of Progressive Artists took place in Düsseldorf in May 1922 with such avant-garde figures as Theo van Doesburg, El Lissitzky, Raoul Hausmann, Hans Richter, and Franz Wilhelm Seiwert in attendance. The meeting, however, ended in preprogrammed disaster. The Constructivist faction disrupted the assembly by belligerently presenting their theses and walking out. The dissenters had met days before to discuss their plans. They accused the congress of merely wanting to form a "protective administrative organization" in opposition to the conservative artists' associations. The critics had no interest in creating a union that would concern itself only with exhibitions, honoraria, and the like. Instead, the focus was to be on art itself.

"We had discussed everything in Weimar, ... but of course it all happened quite differently," wrote van Doesburg to poet Antony Kok a few days after the Düsseldorf debacle. "I powerfully defended De Stijl The end was, of course, that we had to leave the hall under vehement protest, since there was a huge commotion. The whole thing was dominated by trade interests! The congress was called by Das Junge Rheinland, a heap of bunglers,

blockheads, and old women who went about their work in an entirely Prussian manner The Germans ... are big babies. We are now working hard on the International, which must come into being before winter."[2] The ringleaders in Düsseldorf were van Doesburg and El Lissitzky. While still in Weimar, van Doesburg had composed radical counter-theses to the congress, repudiating art exhibitions and commercial exchange and instead advocating "demonstration-like exhibitions" for the presentation of ideas and concepts. He rejected the subjective and demanded the "systematic organization of artistic means in the service of universally comprehensible expression."[3]

The founding of a Constructivist International in accord with the demands made in Düsseldorf never materialized. Although a congress called for this purpose was convened at the Hotel Fürstenhof in Weimar in September 1922, it was sabotaged by the Dadaist antics of van Doesburg himself. The artist had traded adversaries: now he was no longer opposed to Johannes Itten but to László Moholy-Nagy. Van Doesburg had incited public opinion against the Berlin Constructivist, a newcomer and Bauhaus instructor-to-be, by accusing him of purely political motives. In the final analysis, van Doesburg's appearance in Weimar was a clever strategy for expanding his influence in the German art scene—of which he was in desperate need, since the Dutch De Stijl group was threatening to disintegrate. After his quarrel with architect J. J. P. Oud over the Spangen housing project in Rotterdam and constant tension with Piet Mondrian, his objective was to reconstitute the De Stijl group anew—this time with artists from Germany.

While the events of 1922 surrounding Itten and van Doesburg may be interpreted as a spectacle,[4] they also heralded a fundamental shift in the development of art. Itten and van Doesburg shared similar views with respect to the problems of modern society: both of them saw chaos, the loss of values, alienation, and human brokenness. Their answers, however, were different. While Itten still conceived of the role of art in terms of individual self-healing, van Doesburg envisioned the reordering of society as a whole. His critique of Itten and Moholy-Nagy had no substantive basis; it served only to instrumentalize the public for his own purposes. Van Doesburg's artistic doctrine reads as a series of theorems in quick succession, all of which show great similarity to existing concepts. But since his appearance at the latest, artists have devoted their energies not only to their work, but in equal measure to their public image—that is, to demonstrative action before the makers and purveyors of public opinion. Thus van Doesburg only anticipated a strategy that a short time later would be used by Gropius for the Bauhaus, first in Weimar and then in Dessau. The idea of the Bauhaus, we may conclude, consists in no small measure of a legend in its own time.

1 Theo van Doesburg, "The Will to Style," in Hans L. C. Jaffe, ed.,
 D e S t i j l (London, 1970), p. 148.

2 Theo van Doesburg in a letter to Antony Kok, June 6, 1922,
 Rijksbureau voor Kunsthistorische Dokumentatie Den Haag, Theo
 van Doesburg Archief. Cited in Kai-Uwe Hemken, "'Muss die neue
 Kunst den Massen dienen?' Zur Utopie und Wirklichkeit der 'Konstruk-
 tivistischen Internationale,'" in Konstruktivistische inter-
 nationale schöpferische Arbeitsgemeinschaft,
 1922–1927, Utopien für eine Europäische Kultur, ed.
 Bernd Finkeldey et al., exh. cat. Kunstsammlung Nordrhein-
 Westfalen, Düsseldorf (Stuttgart, 1992), pp. 57–67, here pp. 57, 59,
 and 67, and notes 7 and 16.
3 Theo van Doesburg et al., "Declaration of the International Fraction
 of Constructivists of the First International Congress of Progressive
 Artists," trans. Nicholas Walker, in Charles Harrison and Paul Wood,
 eds., Art in Theory 1900–2000 (Oxford, 2003),
 pp. 314–316, here p. 315.
4 For a chronology of artistic events related to Constructivism, see
 Finkeldey et al. 1992 (see note 2), p. 295.

THE DICTATE OF COLDNESS
CRITIQUE FROM THE LEFT, 1919–1933
Michael Müller

It is not surprising that a project like the Bauhaus, with its pursuit of social change as a radical break from the cultural and aesthetic values of the educated bourgeoisie, should encounter resistance from more than just the representatives of that class. Even among the ranks of the intellectuals, whose assessment of current conditions was no less critical than that of Bauhaus masters and students, the school met with not only enthusiasm but also censure. Above all, there was doubt as to whether the Bauhaus was ready or able, through aesthetic means, not only to modernize a society of class conflict, but also to overcome it. Le Corbusier's dictum "Architecture or Revolution" confirmed the opinions of those for whom experiments with form quickly wore thin. Ernst Kállai spoke of the "Bauhaus style" and of "dangerous formalisms,"[1] while Adolf Behne alluded to "flat-roof chic."[2] They and others were convinced that a technologically based rationalization of everyday life only played into the hands of conformity to the imperatives of a life-dominating capitalist society.

Opinions differed widely as to the possibility of critical intervention into established conditions through the practice of aesthetic design. Controversy surrounded the question of how far one could go with the politicization of design, and indeed, in view of its aesthetic autonomy, how far one should go. It was precisely this discourse that manifested itself from the beginning as a point of conflict between members of the Bauhaus.

■ A CULTURE OF INTERVENTION

In general, it can be said that in its conception of design, the political avant-garde of the Weimar Republic increasingly saw its artistic work as a way of affecting social conditions. The dominant culture at the Bauhaus—due in part to its internationalism—exhibited clear traits of a class-independent, increasingly market-oriented culture. The aesthetic of the special or the particular was abandoned and transformed into a medium for generalizing standards of living, consumption, and dwelling. For this reason, even in their exclusive form, the products of the Bauhaus still speak the language of industrially manufactured, typified, standardized mass culture.

After World War I, there were two dominant approaches to the transformation of the aesthetic core of bourgeois high culture—the improvement, but also the beautification of life—into mass culture: on the one hand the Fascist approach, and on the other the avant-garde cultural project.

The Fascist cultural project embodied in National Socialism shared the avant-garde critique of the elitism and solipsism of bourgeois culture, though it replaced the idea of politicization with the real primacy of politics, taking the form of a state apparatus after the Nazi seizure of power.[3] The avant-garde cultural project, on the other hand—as also represented by the Bauhaus—programmatically advocated the politicization of art and, conversely, the culturalization of everyday life. The rhetoric of a connection between art and life that emerged in this context signaled a conception of aesthetics that was charged both epistemologically and in an explicitly rationalistic manner. Culture was no longer understood as the

cultivation and development of the individual, and thus as something particular, but as an aesthetically mediated political reflection on life distinct from any specific institutional setting. It was a trans-bourgeois attempt to realize the bourgeois promise of cultural equality that bourgeois society itself, for structural reasons, could never keep. On the one hand, this project brought forth an enormous amount of art, which today we call classical modernism. On the other hand, at the programmatic level it had almost no lasting effect. It was impossible conceptually as well, because it sought to de-differentiate areas of society whose differentiation into autonomous functional systems had in fact been the central achievement of modernism.

■ BASIC ELEMENTS OF THE CRITIQUE

The leftist critique of the Bauhaus, too, was unable to extricate itself from this conundrum of the artistic avant-garde, namely the difficulty of redefining the relationship between art and life. The critique ranges from an attitude of solidarity among kindred spirits—for example with Behne or Kállai—and the ambivalent rejection on the part of architects such as Adolf Loos and Josef Frank, to the socially and epistemologically critical objections of the intelligentsia. Among the latter, it was above all Theodor W. Adorno, Ernst Bloch, Bertolt Brecht, and Siegfried Kracauer who made statements regarding the architecture of New Objectivity and thus also the Bauhaus. An exception was Walter Benjamin: in essays such as "Erfahrung und Armut" (Experience and Poverty) and "Der destruktive Charakter" (The Destructive Character), he emphasized the anticipatory side of New

Architecture,[4] which occupies an important place in his discussion of a materialist theory of culture and art.[5] An important aspect for Adorno, Bloch, and Brecht was the question of how the rational calculus of technologically liberated dwelling can open itself to the needs of the subject, and how the subject in the thrall of liberated dwelling can assert himself with respect to the collective and the masses. In writings such as M i n i m a M o r a - l i a, D i a l e c t i c o f E n l i g h t e n m e n t, and F u n c t i o n - a l i s m T o d a y, Adorno in particular forcefully observed and demystified the expectations associated with the dwellings of New Objectivity against the background of Nazi barbarism.

Common to all the critics, even architects such as Loos and Frank, was skepticism with regard to the Bauhaus's tendency to pursue rationalistic modernization for its own sake. All of them, however, viewed as unquestionably justified the Bauhaus's rejection of what Bloch termed the "infamous stylistic copies" of bourgeois art and culture and the associated model of bourgeois "pseudo-individualism."[6]

■ ABSTRACTION AND EXPERIENCE
In 1944, Adorno noted in his M i n i m a M o r a l i a: "The traditional residences we grew up in have grown intolerable: each trait of comfort in them is paid for with a betrayal of knowledge, each vestige of shelter with the musty pact of family interests." Of the dwellings of New Objectivity, he continues: "The functional modern habitations designed from a tabula rasa, are living-cases manufactured by experts for philistines, or factory sites that have strayed into the consumption sphere, devoid of

all relation to the occupant: in them even the nostalgia for independent existence, defunct in any case, is sent packing." The distance between the Wiener Werkstätte and the Bauhaus is diminished as well, for "[p]urely functional curves, having broken free of their purpose, are now becoming just as ornamental as the basic structures of Cubism."[7]

For Adorno, architectural rationalism stands for the defeat of the subject in its resistance to the general, which swallows up everything in sameness: the extent of his conviction is manifested by the fact that in the Dialectic of Enlightenment, written together with Max Horkheimer in America, he begins the chapter "The Culture Industry: Enlightenment as Mass Deception" with a discussion of recent developments in architecture and urbanism. He speaks of "the new bungalows on the outskirts," which "like the flimsy structures at international trade fairs, sing the praises of technical progress while inviting their users to throw them away after short use like tin cans."

He characterizes the town-planning projects of the twenties as attempts "to perpetuate individuals as autonomous units in hygienic small apartments," but maintains that they "subjugate them only more completely to their adversary, the total power of capital." For Adorno, it is the "conspicuous unity of macrocosm and microcosm" that "confronts human beings with a model of their culture: the false identity of universal and particular."[8] He is referring to the identity of the subject and the collective, of private and public space, that results from the logic of rationalistic planning. The consequence is the withering of what the Minima Moralia calls "the new human type,"

since it is surrounded by things that "under the law of pure functionality, assume a form that limits contact with them to mere operation." A dwelling environment with all the charm of a tin can "tolerates no surplus, either in freedom of conduct or in autonomy of things, which would survive as the core of experience, because it is not consumed by the moment of action."[9] It is this experience that is lost; even the experience of pleasure in the use of things.

■ AUTONOMY OR FUNCTION

Over twenty years later (fall 1965), Adorno gave a lecture at a conference of the Deutscher Werkbund in Berlin entitled "Funktionalismus heute" (Functionalism Today). He began by emphasizing his sympathy for the idea of "concrete competence as opposed to an aesthetics removed and isolated from material questions." For him, this dictum was familiar from the realm of music, thanks to the school of Arnold Schönberg, "which cultivated close personal relationships with both Adolf Loos and the Bauhaus, and which was therefore fully aware of its intellectual ties to objectivity (Sachlichkeit) in the arts." Probably for this reason, the idea of a humane architecture is emphasized again later in the M i n i m a M o r a l i a in a more differentiated but no less critical fashion. Adorno conceives of the relationship between architecture and the human being as a contradictory one in which the human being's right to architecture and the architecture's right to autonomy cannot be reconciled. The lecture also touches on the question of how far design should be permitted to go in its effort to persuade human beings of the correctness of the truth preserved in artistic form.

Adorno leaves no doubt: "The new 'objective' asceticism does contain therefore an element of truth; unmediated subjective expression would indeed be inadequate for architecture." Rather, "the position of subjective expression ... is occupied in architecture by the function for the subject." Yet this function is "not determined by some generalized person of an unchanging physical nature"— and here begins the problem of "Sachlichkeit."

"Because architecture is in fact both autonomous and purpose-oriented," Adorno says, "it cannot simply negate men as they are. And yet it must do precisely that if it is to remain autonomous." Architecture alone cannot free itself from this antinomy; it must not be permitted to disregard subjective need in the interest of objective need, absolute form, and the pedagogical formation of a style. "If it would bypass mankind t e l q u e l , then it would be accommodating itself to what would be a questionable anthropology and even ontology." For "[l]iving men, even the most backward and conventionally naïve, have the right to the fulfillment of their needs, even though those needs may be false ones." This antinomy is caught in the phenomenon of "cultural lag": the non-congruence between technologically progressive architecture and "empirical subjects, who ... still seek their fortunes in all conceivable nooks and crannies." For Adorno, this issue must be dealt with; under no circumstances should it be anticipated as having already been overcome, lest architecture be transformed into "brutal oppression."[10]

■ PROLETARIAT AND OBJECTIVITY
In the case of the proletariat, this contradiction between taste and rational architecture gives rise to an enormous

disproportion between the proletariat's vision for the design of everyday life and that of the avant-garde, which in its progressive attitude believes it must take the part of the revolutionary subject. It is primarily Brecht, but also Benjamin, who warns against trying to overcome this cultural lag too quickly. In the mid-thirties, Brecht noted that the architecture of New Objectivity, perceived as beautiful by the "progressive architects," is generally rejected by the workers: "They don't think the rectilinear houses are attractive; they call them barracks or penitentiaries and complain that the new, functional furniture is tasteless." Brecht also knows why this is so: "The architects—many of whom, precisely because they are progressive, favor the workers as the most progressive and important class—have forgotten what a dwelling means to a worker. By no means is it a mere shelter for him, a machine whose only object is to perform its obligations as practically as possible."[11] In T h e A r c a d e s P r o j e c t, Benjamin makes a similar point related to art: "At no point in time, no matter how utopian, will anyone win the masses over to a higher art; they can be won over only to one nearer to them."[12]

Brecht intensifies the critique of the one-dimensional transfer of "pure function" to dwelling because he sees it as the reason for the proletariat's rejection of New Objectivity. A fragmentary text from 1936 entitled "Schön ist, was nützlich ist" (Beautiful Is What Is Useful) draws connections between great architects, owners, workers, and machines. The text reads as a barely concealed polemic against the architects of the Bauhaus; they appear here as Chinese "tuis" with an "ear for everything new and progressive," who are the first to discover

the "beauty of the machine." The machine, they explain, is beautiful because it is "thoroughly useful." Thus the machine becomes the model for the construction of houses and furniture, which become "unadorned, simple, and practical."[13] Yet as the reader soon finds out, the association of the beautiful with the useful serves only for profit; the machine is employed only to save labor. That is why the machine pleases the owners; the workers, however, reject the machine, which exploits them and robs them of their work. As long as this alienated, objectified logic of the machine dominates the face of the dwelling, the worker will not find it attractive. In its abstraction, it is devoid of any critical epistemological content.

■ IN HOLLOW SPACE: DESIGN AS OMISSION

As early as in his Expressionistic phase, Bloch was convinced that "obstetric tongs must be smooth, sugar cube tongs never." The machine, he wrote in 1918 in The Spirit of Utopia, is a capitalist invention: it is "in its industrial application, solely for purposes of fast turnover and high profits, and certainly not, as is so often claimed, in order to alleviate our labor, let alone improve the results." Never for the rest of his life, neither in Heritage of Our Times nor in The Principle of Hope, did Bloch abandon his early resentment against the regime of "lavatoriality," where "even the most expensive products of our age's industrial diligence now partake of the wizardry of modern sanitation, the a priori of the finished industrial product."[14]

In The Principle of Hope, Bloch finds it inevitable that, with the continuation of the late bourgeois life-

style, the originally justifiable "purging of the mustiness of the previous century and its unspeakable decoration" had ossified into a "mere architectural reform" which was "no longer disguisedly but deliberately soulless." It is inevitable that "that part of the art of engineering which claims to be so progressive ... so rapidly ends up on the scrap-heap." Bloch complains that "for over a generation, this phenomenon of steel furniture, concrete cubes, and flat roofs has stood there ahistorically, ultra-modern and boring, ostensibly bold and really trivial, full of hatred towards the alleged flourish of every ornamentation and yet more schematically entrenched than any stylistic copy in the nasty nineteenth century ever was."

Bloch considers this an example of rationalization without rationality, which in design tends toward mere omission: "The longer it went on, the more clearly the motto emerges as an inscription over the Bauhaus and that which is connected with it: Hurrah, we've run out of ideas." In other words: nothing but omission. Bloch laments the fact that "no third element between plush and steel chair, between post offices in Renaissance style and egg-boxes, seizes the imagination any more." He misses that element of utopian abundance that cannot dispense with the aesthetic in order to indicate that we have not yet arrived in a new society. "[T]he utopia of the glass structure needs forms worthy of transparency. It needs formations which retain man as a question"[15]

Less utopian than Bloch, but engaged in the sober pursuit of the "phantom of New Objectivity" (as Helmut Lethen once put it), Siegfried Kracauer attempts to evaluate the relation between the subject and rationality in his essay "The Mass Ornament." For Kracauer, the

"rationality of the capitalist economic system," which is also apparent in functional architecture, is "not reason itself but a murky reason" because it does not encompass the human being. Yet the contempt for the human being arising from this abstraction cannot be corrected by a regressive conception of community. According to Kracauer, the problem with capitalism is that "it rationalizes not too much but rather too little." With respect to Bauhaus design, this means that its abstraction is "the expression of a rationality grown obdurate."[16] For this reason, abstraction is here devoid of content; it loses itself in formalism.

■ DWELLING: DICTATORSHIP OR PLURALITY

The critique on the part of modern architects as well as architectural critics and theorists revolved around the problematic inherent in any tendency toward the formation of a style, be it ever so slight: that it should essentially be avoided. Hungarian art critic Ernst Kállai, brought to Dessau by Hannes Meyer to serve as editor of the journal b a u h a u s, expressed this view when he wrote in his retrospective essay "Zehn Jahre Bauhaus": "Dwellings shining with glass and steel: Bauhaus style. Tubular steel armchair frame: Bauhaus style. Lamp with nickel-plated base and matte glass lampshade: Bauhaus style. No pictures on the wall: Bauhaus style."[17]

The judgment of Viennese architect Josef Frank was harsher. In his 1931 book A r c h i t e k t u r a l s S y m b o l he wrote: "The everlastingly repeated nonsense that in former days, all architecture was representational, but that it now serves a functional purpose ... does not rec-

ognize that what is represented now is poverty." Symbolic of this attitude is the tubular steel armchair, a fashionable object, indeed a "worldview on display, demonstrated to every visitor." To Frank, this worldview is German in that it "seeks to instruct in absolute moral principles ... that stand in contradiction to real life and have therefore resulted in our present-day cannibalistic architecture." Frank calls for account to be taken of what is secondary and multifarious in our world, since it is a part of the basis of modern life. "A building is modern if it can accommodate everything living in our time.[18] Earlier, in a fictitious interview in the journal B a u k u n s t in 1927, Frank had challenged his German Bauhaus colleagues to permit every human being his or her "sentimentality," be it ever so tasteless; "at least," he says, "it is human." In contrast, an environment consisting of nothing but beautiful things leaves the "impression of superficiality." And in a tone reminiscent of his model Loos, Frank professed: "I crave tastelessness."[19]

Four years later in connection with his exhibition in Frankfurt, Loos for his part would assert that the Bauhaus had misunderstood his teaching. "Useless constructions, orgies of preferred materials (concrete, glass, and iron). The romanticism of the Bauhaus and Constructivism is no better than the romanticism of ornamentation."[20] In the circles associated with the journal D a s N e u e F r a n k f u r t, which organized the 1931 exhibition in honor of Loos, this statement was never contradicted.

■ JANUS FACE

The critique of the Bauhaus from colleagues outside the institution was leveled primarily at the reduction of an

idea, policy, and strategy that had once been valid. This reduction had once again led to the creation of social distinction through a unified style, a style that tended to be intolerant of whatever deviated from the logic of the functional and rational. Moreover, though their terminology differed from that used today, protagonists like Behne, Kállai, and Frank saw more and more clearly as time went on that a rational architecture unaware of its participation in the "dialectic of enlightenment" was in danger of taking on the form of "concretized consciousness," as Adorno would say. But here, too, once the critique went beyond the formal level, it did not know how to escape from the conundrum mentioned earlier: that de-differentiation in the cultural sector, concurrent with further differentiation of the class society, necessarily undermines that sector's intentions for critical intervention. This is always the case when culture subjects itself to the logic of another sector or system—for the Bauhaus, economically motivated rationalization.

Kállai, for example, had no illusions about the possibility of socialized architecture in a capitalist society. He even warned, not without cynicism, against proletarian dwellings equipped all too comfortably "with toilet, bath, light, and a few friendly walls." For him, the contentment of the workers with their "machines for living" was in the long term a "profitable business" for capitalist social and cultural politics.[21] Yet the uncertainty of the assessment once again becomes apparent in a statement by Bloch. In Heritage of Our Times, he notes that "the many technical-collective 'beginnings' in late capitalism can nowhere already directly be greeted as 'socialist.'" With regard to the new architecture in the Soviet Union,

he observes that "one senses bourgeois poison in Objectivity at least as clearly as possible future."[22] There it is again, the oft-invoked "Janus face of modern architecture" of which the journalist and political activist Alexander Schwab wrote in his 1930 book D a s B u c h v o m B a u e n. New Architecture, he says, is "bourgeois and proletarian, extremely capitalistic and socialist. One can even say: autocratic and democratic." One thing, however, it is no longer: "individualistic."[23]

1 Ernst Kállai, "Zehn Jahre Bauhaus," D i e W e l t b ü h n e (April 1930), pp. 135−140, here pp. 135f.
2 Adolf Behne, "Dammerstock," D i e F o r m (June 1930), pp. 163−166, here p. 166. Also in Christoph Mohr and Michael Müller, F u n k t i o n a l i t ä t u n d M o d e r n e: D a s N e u e Frankfurt und seine Bauten 1925 − 1933 (Cologne, 1984), pp. 327−330, here p. 329.
3 Cf. Franz Dröge and Michael Müller, D i e M a c h t d e r S c h ö n h e i t, Avantgarde und Faschismus oder die Geburt der Massenkultur (Hamburg, 1995).
4 Walter Benjamin, "Erfahrung und Armut," in id., G e s a m m e l t e S c h r i f t e n, vol. II.1, ed. Rolf Tiedemann and Hermann Schweppenhäuser (Frankfurt am Main, 1989), pp. 213−219. Walter Benjamin, "Der destruktive Charakter," in id., G e s a m m e l t e S c h r i f t e n, vol. IV.1, ed. Tiedemann and Schweppenhäuser (Frankfurt am Main, 1972), pp. 396−398.
5 Cf. Michael Müller, "'Architektur für das Schlechte Neue,'" in id., A r c h i t e k t u r u n d A v a n t g a r d e: E i n v e r g e s s e n e s Projekt der Moderne? (Frankfurt am Main, 1984), pp. 93−147.
6 Ferdinand Kramer, "Individuelle oder typisierte Möbel?," D a s N e u e Frankfurt (January 1928), pp. 8−11. Also in Mohr and Müller 1984 (see note 2), pp. 116−118, here p. 118.
7 Theodor W. Adorno, M i n i m a M o r a l i a: R e f l e c t i o n s o n a D a m a g e d L i f e, trans. E. F. N. Jephcott (London, 2005), pp. 38−39.

8 Max Horkheimer and Theodor W. Adorno, D i a l e c t i c o f
 E n l i g h t e n m e n t : P h i l o s o p h i c a l F r a g m e n t s, ed.
 Gunzelin Schmid Noerr, trans. Edmund Jephcott (Stanford, 2002),
 pp. 94–95.
9 Adorno 2005 (see note 7), p. 40
10 Theodor W. Adorno, "Functionalism Today," trans. Jane O. Newman
 and John H. Smith, O p p o s i t i o n s 17 (1979), pp. 31–41, here
 pp. 31, 38.
11 Bertolt Brecht, "Lyrik und Logik," in id., G e s a m m e l t e W e r k e,
 vol. 19: S c h r i f t e n z u r L i t e r a t u r u n d K u n s t 2 (Frankfurt
 am Main, 1967), pp. 385–387, here pp. 386f.
12 Walter Benjamin, T h e A r c a d e s P r o j e c t, ed. Rolf Tiedemann,
 trans. Howard Eiland and Kevin McLaughlin (Cambridge, MA, 1999),
 p. 395.
13 Bertolt Brecht, "Schön ist, was nützlich ist," in id., G e s a m m e l t e
 W e r k e, vol. 12: P r o s a 2 (Frankfurt am Main, 1967), pp. 657f.
14 Ernst Bloch, T h e S p i r i t o f U t o p i a, trans. Anthony A. Nassar
 (Stanford, 2000), p. 11.
15 Ernst Bloch, T h e P r i n c i p l e o f H o p e, vol. 2, trans. Neville
 Plaice, Stephen Plaice, and Paul Knight (Cambridge, MA, 1986),
 pp. 734–737.
16 Siegfried Kracauer, T h e M a s s O r n a m e n t : W e i m a r
 E s s a y s, ed. and trans. Thomas Y. Levin (Cambridge, MA, 1995),
 p. 81.
17 Ernst Kállai, "Zehn Jahre Bauhaus," D i e W e l t b ü h n e (April 1930),
 pp. 135–140, here p. 135.
18 Josef Frank, A r c h i t e k t u r a l s S y m b o l : E l e m e n t e
 d e u t s c h e n n e u e n B a u e n s (Vienna, 1981), pp. 129, 131, 133ff.
19 Josef Frank, "Vom neuen Stil: Ein Interview von Josef Frank," in
 Mikael Bergquist and Olof Michélsen, eds., J o s e f F r a n k :
 A r c h i t e k t u r (Basel et al., 1995), pp. 112–119, here p. 116f.
20 Adolf Loos, "Adolf Loos über Josef Hoffmann," D a s N e u e
 F r a n k f u r t (February 1931), p. 38. Also in Amt für Industrielle
 Formgestaltung, ed., N e u e s B a u e n N e u e s G e s t a l t e n,
 D a s N e u e F r a n k f u r t / d i e n e u e s t a d t : E i n e
 Z e i t s c h r i f t z w i s c h e n 1 9 2 6 u n d 1 9 3 3 (Berlin, 1984),
 pp. 384–385, here p. 385.
21 Ernst Kállai, "wir leben nicht, um zu wohnen," b a u h a u s (January
 1929), p. 10.
22 Ernst Bloch, H e r i t a g e o f O u r T i m e s, trans. Neville and
 Stephen Plaice (Berkeley, 1991), pp. 200–201.

23 Alexander Schwab, "Das Buch vom Bauen": Wohnungs-
not, Neue Technik, Neue Baukunst, Städtebau aus
sozialistischer Sicht, erschienen 1930 unter dem
Pseudonym Albert Sigrist, Bauwelt Fundamente 42
(Düsseldorf, 1973), p. 67.

THE SUCCESSOR'S DISINHERITANCE
THE CONFLICT BETWEEN HANNES MEYER AND WALTER GROPIUS
Magdalena Droste

The Battle for the Staatliches Bauhaus — so ran the title of a brochure published by the Bauhaus in June 1920, the first in a series of attempts by Walter Gropius to present it to the public as an institution defined by a unified artistic will. Today, critical interpreters of the Bauhaus agree that until his death in 1969, Gropius consistently championed this view of the school as a monolithic institution. Yet historiographers have been slow to break free from the repetition of this Gropius-centered history and to finally discredit the latter's version of the Bauhaus story.

But how can the Bauhaus according to Gropius be described? As Gabriele Diana Grawe has shown, from 1919 to 1928, Gropius sought to represent his Bauhaus in all its purity, and in this respect exercised a controlling function. Grawe speaks of a "historicizing codification" of the "original Bauhaus"; at the same time, Gropius claimed that "his Bauhaus" had "developed a timeless, ahistorical design."[1]

The following discussion examines how Hannes Meyer— second director of the Bauhaus from April 1928 to early August 1930—attempted to alter Gropius's discourse as to the meaning of the Bauhaus and how the latter responded to these attempts. There is not a single photograph of the two men together; no image shows Meyer's residence in the Gropius Master House, where he also lived. This fact can be interpreted as mere chance, or as

symbolic: the architects soon distanced themselves from one another, drawing and redrawing the battle lines between them in accord with changing circumstances.

The actual events at the Bauhaus and their interpretation after the fact can hardly be disentangled from each other; rather, they merge together, since the differences of opinion arose during the school's existence and were further elaborated after its was closed. The present discussion traces various attempts to shape the discourse about the Bauhaus up until the time of Gropius's death; the role of the German Democratic Republic and the Hochschule für Gestaltung (HfG) in Ulm, however, merits a separate discussion and will for the most part be omitted here.

■ 1928: "THE BAUHAUS LIVES"

The Swiss architect Hannes Meyer assumed directorship of the Bauhaus on April 1, 1928. Two months later, the Hungarian art theorist Ernst Kállai, whom Meyer had hired as editor for the b a u h a u s journal, published the article "das bauhaus lebt" (the bauhaus lives) in the March 2, 1928 issue. Kállai's texts were to serve as a mouthpiece for Meyer until 1929, and this first essay already included many of the arguments that would shape the conflict to come. This text must have already been perceived by Gropius as a challenge, since Kállai spoke of having overcome both the "first Weimar period" and a "second Bauhaus period," the latter characterized by "constructivist restriction." Thus, without mentioning his name, a critique was formulated that on the one hand made reference to Gropius's stylistic debt to De Stijl, and on the other suggested that he had thereby embraced

form at the expense of content. The phrase "Bauhaus style" that emerged at this time embodied the essence of this critique. Kállai's essay implied that now a third, true phase of the Bauhaus had begun, marked by "life" and a "loosening of the concept of style." Meyer's school building for the Allgemeiner Deutscher Gewerkschaftsbund in Bernau near Berlin, it was suggested, was a "formally unbiased response to the building task."

It was evidently Kállai and Meyer who, with the term "Bauhaus style" (previously used only outside the Bauhaus), initiated a debate that Gropius had heretofore avoided.[2] At the same time, "life" and the polar term "style" provided a useful conceptual scheme. In this regard, Meyer drew from theories he himself had developed in the context of the Swiss journal A B C, as well as from El Lissitzky's Constructivism and the doctrines of the Russian philosopher Alexander Bogdanov: "Design as the organization of life."[3]

Gropius and above all his ally László Moholy-Nagy read the article; Moholy-Nagy's estate contains a manuscript that not only refutes Kállai and Meyer, but also considers how such a critique should be countered. Meyer is described as a "predecessor, therefore to some extent a rival"; reference is made to "attacks" and "demagoguery." The text, however, hardly alludes to the strongest offensive—style versus life—and concentrates instead on the accusation of "luxury" as well as the question of the affordability of worker housing;[4] one gets the impression that the two combatants were still shooting past each other. Although Moholy-Nagy's manuscript was never published, both texts mark the beginning of the struggle between competing interpretations of the Bauhaus.

■ 1929: "BAUHAUS AND SOCIETY"

In issue 1/1929 of b a u h a u s, Meyer reiterated his critique in an introductory essay entitled "bauhaus und gesellschaft" (bauhaus and society). Ten years after the founding of the Bauhaus, Meyer framed his essay as a manifesto, even appropriating a formulation from Gropius's Bauhaus manifesto of 1919. Gropius had written: "The final goal of all artistic activity is the building! The final, if also distant, goal of the Bauhaus is the unified work of art." Meyer, however, wrote: "the final goal of all bauhaus work is the summing up of all life-giving powers into the harmonious arrangement of our society," and in so doing shifted the goal of the Bauhaus—which Gropius had still conceived in artistic terms—into a social context. This point was illustrated visually as well; on the page oppo- site the essay he published a "photo taken through the co-op window," the image of a careworn woman. The contrast with Gropius, who had illustrated his manifesto with Lyonel Feininger's woodcut of a cathedral, could not have been greater.

In this way, Meyer visually overturned Gropius's guiding principle of "a new unity of art and technology." This repudiation was repeated in the text as well: the Dessau Bauhaus, Meyer said, was "not an artistic, but rather a social phenomenon." Almost half of the essay was devoted to the architectural school and curriculum he had been developing since his appointment as a master on April 1, 1927. These ideas had been published for the first time in the manifesto-like essay "bauen" in issue 4/1928 of the journal; now, he was integrating his archi- tectural theory into his new conception of the Bauhaus. Perhaps no other text so clearly formulates Meyer's

vision. He begins by once again repudiating the Bauhaus style with its "fashionably flat surface ornamentation, horizontal-vertical division, and neoplasticistic indulgence," its "cubistic cubes of bauhaus objectivity." Meyer's primary concepts, on the other hand, are the collective, life, the people, harmony, order, landscape, and standard. He develops three themes, ultimately unified by his architectural theory, with which he seeks to revise Gropius's conception of the Bauhaus and which were to be the focus of controversy: the critique of style, the centrality of the concept of life for his own architectural theory, and the opposition to art.

Meyer's project of changing the concept of the Bauhaus and "not merely standing still and holding out, but moving forward" (as Kállai had described it in his essay "das bauhaus lebt") was propagated in lectures as well. The three above-mentioned themes dominated the manuscript for a lecture given by Meyer in Basel in May 1929, the first station in a traveling Bauhaus exhibition. Once again, Meyer began by addressing the theme of a Bauhaus style, describing Gropius's master houses as "clever neoplasticistic structures." The school was, he said, bound up in a "horizontal-vertical world of form." Against this negative backdrop, Meyer could then explain the "new theory of building," which he wanted to develop into a "new school of architecture." The motto here was "back to life": for Meyer, the artist was to be the "clear organizer of existence."[5]

■ 1930: "MY EXPULSION"
Beginning in May 1930, state conservator Ludwig Grote and Bauhaus masters Wassily Kandinsky and Josef

Albers joined together with Gropius to procure Meyer's dismissal, which was finally announced by Dessau mayor Fritz Hesse. To inflict this humiliation upon his opponent was probably Gropius's greatest triumph; Meyer answered him with a verbal attack.

Only fourteen days after his termination without notice on August 1, 1930, Meyer published what is probably his most-quoted text "Mein Hinauswurf aus dem Bauhaus: Offener Brief an den Oberbürgermeister Hesse, Dessau" (My Expulsion from the Bauhaus: An Open Letter to Mayor Hesse of Dessau) in the leftist-liberal magazine Das Tagebuch. In this witty polemic against his former superiors, Meyer once again contrasted his own time at the Bauhaus with that of Gropius and exemplified his claim that the latter's Bauhaus had been trapped in a stylistic corset. He heaped scorn upon tea glasses and tapestries, but also elaborated his own architectural theory. The concept of life was downplayed in favor of an emphasis on the scholastic character of Bauhaus instruction; in addition, the school's economic successes and the commissions it had received constituted a significant argument during a time of global economic crisis.

The climax of the article was a political declaration: Meyer spoke of the proletariat, of the spirit of Marxism forbidden by the mayor, of materialism. Yet although it had been the ostensible reason for Meyer's dismissal, Gropius did not react to this political stand until the fifties.

■ EXHIBITIONS 1929/30

Meyer's dismissal put an end to further initiatives planned in connection with the launching of his new Bauhaus in

1930. The first step in this direction was the exhibition 10 Jahre Bauhaus, which opened in Basel on April 21, 1929, and from there traveled to Breslau, Essen, Dessau, Mannheim, and Zurich. The exhibition, however, was not a retrospective, but showed only work from Meyer's era. The accompanying catalogue published by the Bauhaus did not include a homage to Gropius as founder, but rather kept its distance and engaged in critique. Kállai's text included the familiar accusations as well as a few new ones. The Weimar Bauhaus, he said, had "suffered from ideological overload"; the preliminary course was criticized as a "lingering echo of the golden age of the Weimar Bauhaus." As an architect, Gropius was "not free from a certain formalism" or from "aesthetically inspired overzealousness." Once again, "formalism" was the backdrop against which Meyer was presented as someone whose buildings had a "soul." Kállai wrote that Meyer numbered among "the few modern architects who view rationalization and industrial construction as a subordinate means to a higher end"—a critique, once more, of Gropius, who was regarded as a protagonist of the rationalization of architecture.

In late 1929, however, Kállai left the Bauhaus at odds with Meyer. He gave up the editorial direction of b a u - h a u s ; no. 4/1929 was the last one edited by Meyer and Kállai, and not a single issue of the journal was published in 1930. Meyer was thus forced to find other ways of reaching the public. In January 1930, he attempted to publish in the French journal C a h i e r s d ' a r t with the help of art critic Will Grohmann.[6] Grohmann had wanted to publish an article by the end of March 1930; the essay he and Meyer wished for, however, illustrated with twenty-

four photos, was never printed. While the May issue did include an article on the Bauhaus by Grohmann—quite positive with respect to Meyer's work—the illustrations showed only Gropius's Bauhaus.

In a letter to Grohmann dated January 1930, Meyer wrote that he had always hoped to one day show work from the Bauhaus in Paris. His desire for an exhibition devoted solely to the Bauhaus probably explains why only a short time later, he rejected an offer from French artist Sonja Delaunay to participate in the E x p o s i t i o n d e l a S o c i é t é d e s A r t i s t e s D é c o r a t e u r s F r a n ç a i s planned for mid-1930. Meyer was no doubt aware that in November 1929, the Deutscher Werkbund had commissioned Gropius to design the "Section Allemande" for this exhibition. The French, however, were oblivious to the conflict between Meyer and Gropius; Sonja Delaunay had invited not only Meyer, but also Moholy-Nagy to participate. In March 1930, Meyer wrote to Delaunay that the Bauhaus was "not interested in a new style, but in the fundamental reorganization of life" and therefore "no longer had much in common with the Gropius era."[7]

While Meyer's debut in Paris fell through, Gropius was able to show parts of his Bauhaus, including figurines by Oskar Schlemmer, in a section designed by Moholy-Nagy with lamps, photos of Bauhaus buildings, and furniture by Marcel Breuer. "In its disposition towards formalism, the Section Allemande of the Werkbund was in fact the very 'Bauhaus exhibition' it was later perceived to be," observed Joachim Driller after the fact.[8]

Meyer's subsequent activities met with little success. The special Bauhaus issue of the magazine R e d , edited by critic Karel Teige and published in June 1930, had

little appeal, as it was printed predominantly in Czech and on bad paper. Two additional publications—a volume on the Bauhaus from the Malik Verlag and an issue of the magazine S t e i n, H o l z, E i s e n —were never realized due to Meyer's dismissal. Yet even after his rival's departure, Gropius continued his efforts to dominate Bauhaus discourse.

■ 1930: "HEADS OR TAILS" AND BAUHAUS BUILDINGS DESSAU

"I had a view and I represented it as clearly as possible," wrote Meyer in "Mein Hinauswurf." Gropius answered with a double strategy; first, he endeavored to respond to Meyer directly.[9] Gropius's confidante Xanti Schawinsky, still a student at the Bauhaus in 1929, was available as an author. Under his name, the article "Kopf oder Adler" (Heads or Tails)—probably written by Gropius and others—was sent to the German press. After months of delay, it appeared on January 10, 1931, in the B e r l i n e r T a g e b l a t t; neither the journals D a s T a g e b u c h nor D i e W e l t b ü h n e had wanted to publish it. Reading the text today, one can understand their refusal: the authors failed to sustain the polemical tone that makes Meyer's "Mein Hinauswurf" an entertaining read even now. Their article repeatedly lapsed into mere self-justification, attack, and obscure details. Schawinsky and Gropius spoke of "counterfeit history"; Meyer suffered from an "obsession."

Here we find two of Gropius's lifelong strategies employed for the first time: the allegation of counterfeit history and personal defamation. Gropius would repeat these attacks as late as 1965 in response to Claude

Schnaidt's first monograph about Meyer. He also pursued another and more successful strategy in his 1930 book b a u h a u s b a u t e n d e s s a u (bauhaus buildings dessau), where the history of the school as described in the introduction simply ends with the year 1928. But upon closer examination of Gropius's texts, it becomes clear that he had studied the attacks, manifestos, and polemics of his successor in great detail. He refrained from any direct retaliation, but addressed themes that had been introduced by Meyer into Bauhaus discourse: Bauhaus Style: According to Gropius, an "aesthetic-stylistic conception of form" had been superseded: "The goal of the Bauhaus is not a 'style.'" In so doing, he rebutted Meyer's primary accusation.

Art: "The 'work of art' must 'function' exactly like the product of an engineer, in both an intellectual and a material sense." Here Gropius came close to Meyer's position, who had rejected the notion of the artist and wanted to redefine art: "the new work of art—only a manifestation of order" and "artist—clear organizer of existence," as Meyer had put it in his Basel lecture.

Luxury: In "Mein Hinauswurf," Meyer had spoken of "the needs of the people instead of the demands of luxury." In b a u h a u s b a u t e n d e s s a u, Gropius reiterated that at the Bauhaus, "artistic design" was to be "not a question of luxury, but a matter of life itself."

Life: The concept of life was key for Meyer. We can perhaps interpret his references to life as a synonym for the soft factors of architecture that he arranged around the material processes. In his article "das bauhaus lebt," Meyer had spoken of the "organization of life processes" and of "new life." Gropius now appropriated these

thoughts: the Bauhaus, he said, had striven for an architecture "in the service of spirited life." Behind "changeable form" they were seeking the "fluidity of life itself."

Organization: Along with the ordering of life, the concept of organization was another central element in Meyer's architectural theory. In a lecture at the Bauhaus in the spring of 1927, even before his appointment as a master, Meyer had identified the "organization of needs" as the motto of his work, as documented in a letter from Oskar Schlemmer to Otto Meyer-Amden.[10] The thesis seems plausible that Gropius appropriated this idea from Meyer, since from April 1927 on Gropius began to use such formulations as "to build is to give form to the processes of life."[11] The same proposition also appeared in Gropius's 1927 foreword to the second edition of the book Internationale Architektur, where the "meaning of the new architecture" is identified as "giving form to processes of life." And in 1930 in bauhausbauten dessau, Gropius spoke of the "ordering of life functions" and of the "calling of the architect" as that of a "unifying organizer."

Thus the absurd situation arose that from 1927 to 1930, Meyer and Gropius were using almost identical language. Writing in 1985, Winfried Nerdinger noted Gropius's ability to "adjust his texts to the new circumstances of the time."[12] From 1927 on, Gropius integrated the soft factors of life, organization, and order—concepts drawn from Meyer's architectural theory—into the history of the institution he himself had founded, as if they had already been important in 1919. This revision served, as it were, to neutralize the controversy over the interpretation and continuing development of the Bauhaus. At

the level of mere language, Gropius appropriated Meyer's version of the Bauhaus; the content of these terms, however—above all their strong social determinism—fell by the wayside. Since Meyer left for the Soviet Union in early October 1930, this appropriation of the Meyer Bauhaus remained uncontested and even dominant for decades to come.

This observation—that Gropius integrated central parts of Meyer's architectural theory into his own concept of the Bauhaus—could also serve to refute the accusation that Gropius later directed at Meyer: that the latter had allegedly profited from "long years of preliminary work" and had been able to draw from an "eminent substance."[13] In actual fact, the reverse was true: Gropius profited from the work of his successor. Only in later texts for the British and American culture industry were such adaptations of the Meyer Bauhaus revised in favor of other emphases.

Over the course of 1928 and 1929, the fronts shifted. Until his dismissal, Meyer had understood his directorship of the Bauhaus as a continuation and revision; the Basel catalogue of 1929 stated that for him, the school was a "significant legacy and responsibility." After his termination without notice and profession of Marxism, however, Meyer no longer viewed Gropius as a rival; at most, he was the representative of an era that for Meyer belonged to the past. With Gropius, however, the situation was different: throughout the coming decades, his attitude toward Meyer continued to be marked by the need to identify his own concept of the Bauhaus as the true one, as had already been obvious in the book bauhausbauten dessau.

■ MEXICAN AND AMERICAN INTERPRETATIONS

In the decades that followed, the cultural spheres of the two architects ceased to intersect. In 1930–31, in the only Bauhaus exhibition and catalogue to be published in Russian, Meyer continued the same publication policy he had initiated with the traveling exhibition 1 0 J a h r e B a u h a u s —namely, to show only material from 1928 to 1930. Having in the meantime professed communism, however, he also yielded to certain expectations of his environment—the cover of the catalogue, for example, was adorned with the image of a female communist fighter. In 1940, during his exile in Mexico, Meyer published material about the Bauhaus under his direction in the magazine E d i f i c a c i ó n. Here he subdivided the history of the Bauhaus according to the tenures of the three directors Gropius, Meyer, and Mies. To this day in Bauhaus studies, Meyer's assertion that "around the turn of the year 1927/28, Walter Gropius resigned for reasons of local politics" is ignored in favor of the interpretation propounded by Gropius in b a u h a u s b a u t e n d e s s a u that he had given up his position in order to "once again devote himself to his own architectural activity." The relationship of Meyer's article to his situation in exile remains to be investigated. The article particularly emphasized the success of "polytechnical education"— today we would call it interdisciplinary project study— probably because at the time, Meyer was working in an institution of that type. In 1947/48 he was occupied with a Bauhaus album in preparation for his return to the fledgling German Democratic Republic; the work, however, remained unpublished.

Meyer's three forays into Bauhaus affairs were intended to integrate it into leftist cultural politics. This project seems to have been fruitless, yet not only with respect to his personal career: Bauhaus historiography in general hardly noticed the continuation of the Bauhaus after Gropius. Meyer died in 1954, and it was not until 1965 that Gropius responded to the article written in Mexico twenty-five years earlier. In a letter to Tomás Maldonado published in the monograph on Meyer by Claude Schnaidt, Gropius wrote: "His essay in E d i f i c a c i ó n is new proof of his lack of integrity and opportunistic behavior. I erred in my judgment of his character." In the same letter, Gropius also accused Meyer of having had no "political instinct." At the height of the Cold War, this combined discrediting of both Meyer's work and his political outlook was particularly effective.

Gropius's earlier publication strategy in the United States had been similarly successful. A variety of omissions and appropriations are demonstrable in the 1938 catalogue for the Museum of Modern Art in New York, where the exhibition B a u h a u s 1 9 1 9 − 1 9 2 8 dealt only with the Gropius era. Even Meyer's school building in Bernau was subsumed under the Gropius Bauhaus on a double-page spread, while Meyer's directorship in Dessau was mentioned only in a caption. It was above all this catalogue that conveyed the image of a Bauhaus that revolved around Gropius. Although Hans Maria Wingler's major Bauhaus monograph of 1962 helped alter this perspective, as late as 1968 Gropius was still successfully asserting the centrality of his own interpretation in the widely disseminated book for the traveling exhibition 5 0 J a h r e B a u h a u s . Here, Gropius's

circular diagram of the Bauhaus curriculum from 1922 is presented as having held sway from 1919 until 1933, though in actual fact it was subject to constant change. Thus, Gropius succeeded in assimilating not only Meyer, but also Ludwig Mies van der Rohe into his version of the Bauhaus.

1 Gabriele Diana Grawe, Call for Action: Mitglieder des Bauhauses in Nordamerika (Weimar, 2002), pp. 27, 29.
2 Andreas Haus, "Bauhausstil? Gestalteter Raum!" in Regina Bittner, ed., Bauhausstil: Zwischen International Style und Lifestyle (Leipzig, 2003), pp. 176–193, here pp. 183 and 187. In contrast to my account, Haus establishes no connection to Meyer; according to him, Gropius no longer used the word "style" after 1916.
3 Winfried Nerdinger, "'Anstößiges Rot,' Hannes Meyer und der linke Baufunktionalismus—ein verdrängtes Kapitel Architekturgeschichte," in Hannes Meyer 1889–1954: Architekt, Urbanist, Lehrer, ed. Bauhaus-Archiv Berlin and Deutsches Architektur- museum, Frankfurt am Main, exh. cat. Bauhaus-Archiv, Berlin, et al. (Frankfurt am Main, 1989), pp. 12–29, here p. 15
4 "unterhaltung zwischen einem wohlgesinnten kritiker und einem vertreter des bauhauses weimar-dessau," in Krisztina Passuth, Moholy-Nagy (Budapest, 1986), pp. 415–417. This text was intended as a response to the article by Kállai, as is clear from the use of the phrase "erste weimarer zeit" as found in Kállai's text. According to Passuth, p. 450, the author is anonymous.
5 Lena Meyer-Bergner, ed., Hannes Meyer: Bauen und Gesellschaft; Schriften, Briefe, Projekte (Dresden, 1980). The Basel lecture is reproduced in facsimile on pp. 54–62.
6 For the treatment of France, I draw from Christian Derouet, "Le Bauhaus des peintres contre Walter Gropius, ou le silence des 'Cahiers d'Art' sur le Werkbund au 'Salon des Artistes Décorateurs Français' en 1930," in Isabelle Ewig et al., eds., Das Bauhaus und Frankreich (Berlin, 2002), pp. 297–311.
7 Hannes Meyer in a letter to Sonja Delaunay, March 1930, cited in Werner Möller and Wolfgang Thöner, "Das Bauhaus: Eine Balance in mehreren Akten," in G. W. Költzsch and Margarita Tupitsyn, eds., Bauhaus Dessau, Chicago, New York (Bramsche, 2000), pp. 28–33, note 6.

8 Joachim Driller, "Bauhäusler zwischen Berlin und Paris: Zur Planung und Einrichtung der 'Section Allemande' in der Ausstellung der Société des Artistes Décorateurs Français 1930," in Ewig 2002 (see note 6), pp. 255–274, here p. 256.

9 The following episode is described and discussed by Barbara Paul in Peter Hahn, ed., X a n t i S c h a w i n s k y : M a l e r e i , B ü h n e , G r a f i k d e s i g n , F o t o g r a f i e (Berlin, 1986), pp. 196–199.

10 Schlemmer's letter to Meyer-Amden from April 17, 1927, reads: "A motto of his work is, with respect to architecture: organization of needs." Cited in Tut Schlemmer, ed., O s k a r S c h l e m m e r : B r i e f e u n d T a g e b ü c h e r (Berlin and Darmstadt, 1958), p. 207.

11 Walter Gropius, "systematische vorarbeit für rationellen wohnungs- bau," B a u h a u s , Z e i t s c h r i f t f ü r G e s t a l t u n g 2 (1927), pp. 1–2.

12 Winfried Nerdinger, "Von der Stilschule zum Creative Design—Walter Gropius als Lehrer," in Rainer Wick, I s t d i e B a u h a u s p ä d a g o g i k a k t u e l l ? (Cologne, 1985), pp. 28–41, here p. 28.

13 Hans Maria Wingler, D a s B a u h a u s 1 9 1 9 – 1 9 3 3 : W e i m a r D e s s a u B e r l i n u n d d i e N a c h f o l g e i n C h i c a g o s e i t 1 9 3 7 , 3rd ed. (Bramsche, 1975), p. 18.a

SURFACES FOR A TECHNICALLY OBSOLETE WORLD
R. BUCKMINSTER FULLER, SHELTER MAGAZINE, AND THE OPPOSITION TO THE INTERNATIONAL STYLE
Joachim Krausse

■ A LETTER TO JOHN McHALE IN LONDON

On January 7, 1955, the American inventor, universal architect, and design philosopher R. Buckminster Fuller responded in a long letter to British artist John McHale's question about the extent to which the Bauhaus had influenced him and his work. McHale's interest can be traced to his discussions with other members of the Independent Group, a loosely organized but highly productive alliance of artists, architects, and theorists, at the Institute of Contemporary Art (ICA) in London during the early years of the fifties.[1] The series of exhibitions, lectures, and meetings at the ICA—which was inspired in large part by the theoretical curiosity of such figures as Reyner Banham, Lawrence Alloway, and John McHale himself—offers clear evidence of a trend toward the critical scrutiny of the modernist movement in the fields of art, architecture, and design. Written during those years, Banham's dissertation and the book published in 1960 entitled Theory and Design in the First Machine Age, for which it provided the foundation, were among the fruits of this discourse.

The book ends with a discussion of Fuller. If his Dymaxion House had actually been built, Banham contended, it would have made Le Corbusier's "Les Heures Claires"—

the Villa Savoye—appear technically obsolete.[2] Banham's text was accompanied by the best-known photograph of the third model of the Dymaxion House: a nighttime image that emphasizes the futuristic qualities of the building, presumably made in the studio in 1930.[3] He cites the designer of this building, but Fuller's statements are the only quotations in Banham's book for which no source is cited. The trail leads to McHale's question and Fuller's response. Until the letter of January 7, 1955, was published in the British journal Architectural Design in 1961, Fuller's text was accessible only to the addressee and his friends,[4] including above all the founding members of the "Dymaxion Fan Club," to which Banham professed his affiliation.[5] The letter was more than merely a response to McHale's question. Fuller wrote a lengthy autobiographical essay in which he defined his position in detail. Not until the end of his essay did he address the issue with which we are concerned here: his relationship to the Bauhaus and modern European architecture.

It is precisely this passage—a summary critique of the "Bauhaus International"—which Banham quotes in his Theory and Design in the First Machine Age, as Fuller's position enabled him to develop his own critical standpoint with regard to the New Architecture movement in Europe during the twenties and early thirties. Neither Banham nor McHale was content merely to have been present for a moment during the "origin of a new tradition," as it was expressed in the subtitle of Sigfried Giedion's influential book Raum, Zeit, Architektur (Space, Time and Architecture). Shortly after receiving Fuller's letter of January 7, 1955, McHale

wrote his own critique of the Bauhaus. In response to the publication of Giedion's monograph entitled Walter Gropius: Mensch und Werk, McHale published an essay in which he emphasized the temporal determinacy of the concept of the machine adopted by the Bauhaus and the "eternal laws of the nature of materials" proposed by Giedion. In view of the advent of automation and synthetic materials, wrote McHale, such ideas were out of date.[6]

Fuller regarded his letter to McHale as so important that he had it reprinted as the first chapter ("Influences on My Work") of his book Ideas and Integrities in 1963. "Many people have asked if the Bauhaus ideas and techniques have had any formative influence on my work. I must answer vigorously that they have not." The author adds that such a blunt "negative" regarding such an influential institution left a "large vacuum" which he wanted to "eliminate." In the following passages, Fuller emphasizes the formative experiences of a life at the waterside, with boatbuilding and shipbuilding, which he traces back to his childhood. During his service in the Navy, as he explains to his readers, he was particularly impressed, among other things, by the new media and navigation technologies that were soon adopted as terrestrial technological standards as well.[7] Fuller had studied the differences in mentality between the historical land and sea powers in quite a similar way as Carl Schmitt, the German philosopher of law, and voted in favor of the "fluid geography" of the seafarers.[8] For this reason alone, he was highly skeptical of a design revolution imported to America from Europe, although he had read the English edition of Le Corbusier's Vers une

Architecture with enthusiasm in early 1928 and shared a close friendship with a representative of the avantgarde in the person of the architect Paul Nelson, who had worked with both Auguste Perret and Le Corbusier.

■ FROM THE CLARIFYING PERSPECTIVE OF THREE THOUSAND MILES

"In 1929 in Chicago," Fuller wrote in Influences on My Work "student designers ... informed me of a seeming revolution in European design activities in Sweden, France, Holland, Denmark, and in Germany at the Bauhaus. It was evident in the pictures they showed me that the European architects were beginning to experience with cogency those same vital stimulations, through privations persistent within the paradoxical environment of high potentials, which had come flooding upon me a few years earlier, as I came to maturity in the accelerating frontier economy opening chapters of new magnitude on the coast of the American continent It was also evident to me that the 1920–1930 wave of architectural awareness regarding important design potentials, realizable as design simplifications and improvements, had been generated in Europe in the post-World War I decade by the European's 3,000-mile perspective-clarifying review of architecturally unencumbered, giant silos, warehouses, and factories in the cleanly emergent United States—structures which had been disembarrassed in unique degree, in the space-rich American scene, of economically unessential aesthetics. This American inspiration was well documented by the European style protagonists whose original publications invariably fortified their arguments for design reform by photographic

examples of American silos and factories as constituting sources of the European inspiration."[9]

The importance of these American sources of inspiration for the European avant-garde, and specifically for Walter Gropius, is beyond dispute. Shortly after his admission to the German Werkbund in late 1910, Karl Ernst Osthaus, founder of the Museum Folkwang in Hagen, commissioned him to develop a collection of photographs of exemplary industrial structures. The American examples in this collection play an important role in that Gropius recognized the "heralds of a coming monumental style"[10] in their forms. Yet Gropius consistently refused to propagandize a specific style. Even in his earliest writings he was concerned primarily with identifying its preconditions. He eventually discovered the signs of the times in industrial architecture. The disparity between industrial architecture on the one hand and other architectural objectives on the other was much greater in America than in Europe. And with respect to perceptions of this disparity, Fuller affirmed the clear gaze of the Europeans: "It was also amusingly clear that European designers of the twenties had glimpsed and understood the design paradox within the American continent. This was the aesthetically pure silos' and factories' coexistence with the aesthetically impure nonsense-beshrouding Americans' dwellings and patron-occupancy buildings, as the latter wallowed hypnotically and superstitiously within the European-originated architectural garmenture."[11]

Up to that point, the leading exponents of New Architecture who had traveled to America during the twenties to see things with their own eyes shared Fuller's views without

reservation. It was the ideas expressed later that engendered opposition among the European avant-garde. Even Banham spoke of the "strain of US patriotism running through this hostile appraisal" in his Theory and Design in the First Machine Age. Yet Fuller's critique of the Bauhaus, wrote Banham, was more than "mere wisdom after the fact," more than an "Olympian judgment."[12] Indeed, in his letter to McHale, Fuller had referred to an old dispute about the International Style unleashed by Henry Russell Hitchcock and Philip Johnson in 1932, against which Fuller and his friends—with moral support from Frank Lloyd Wright—had organized an opposition movement that had no chance of success. Only within this context does the peculiar tone of Fuller's critique of "Bauhaus International" begin to make sense—especially in view of the fact that the fronts in this dispute were rather vaguely defined.

"It was also evident," wrote Fuller in his letter to McHale, "that the going design blindness at the lay level in the United States afforded European designers an opportunity in Europe and America to exploit their farview discernment of the more appealing simplicities of the industrial structures which had inadvertently earned their architectural freedom. This had been accomplished not by conscious aesthetical innovation, but through profit-inspired discard of economic irrelevancies in non-popular occupancy structures. This surprise discovery, the European designer well knew, could soon be made universally appealing as a fad, for had they not been themselves so faddishly inspired. The international style thus brought to America by the Bauhaus innovators demonstrated a fashion inoculation effected, without necessity

of knowledge of the scientific fundamentals of structural mechanics and chemistry. ... The superficial aspects [of the design revolution which] had inspired the international stylism ... and [the international style's] simplification was then but superficial. It peeled off yesterday's exterior embellishment and put on instead formalized novelties of quasi-simplicity permitted by the same hidden structural elements of modern alloys which had permitted the discarded beaux-arts garmentation The international Bauhaus school used standard plumbing fixtures and only ventured so far as to persuade the manufacturers to modify the surface of the valve handles and spigots and the color, size, and arrangement of the tiles. The international Bauhaus school never went back to the wall surface to look at the plumbing, never dared to venture into printed circuits of manifoldly stamped plumbings. They never inquired into the over-all problem of sanitary functions themselves In short, they only looked at problems of modification of the surface of end products, which as end products were inherently subfunctions of a technically obsolete world."[13]

This criticism may or may not be appropriate. If we accept it, then we also realize that since his presentation of the Dymaxion House in 1929, Fuller approached the issue of human housing from the perspective of life-support systems, which had changed dramatically under the influence of industrialization and scientific and technical innovation during the first third of the twentieth century.[14] Fuller interpreted the dwelling as the totality of economic and technically efficient life-supporting systems. In one of the descriptions of the Dymaxion House written as early as 1928 is a maxim that is both truly American and

characteristic of Fuller: "A home, like a person, must be as completely as possible independent and self supporting, have its own character, dignity, and beauty or harmony."[15] With this program, it is no wonder that Fuller became not only the most vociferous critic of the International Style, but also a prophet of resource conservation and efficiency in the use of material and energy, though he was not recognized as such for decades. It was Fuller who confronted the followers of the International Style with the unfamiliar concept of ecology in the early thirties and pointed to the alternative in his journal S h e l t e r : "Shelter means the instrumental safety and the service of ecology and economics combined."[16]

■ AN ATTACK ON THE FUNCTIONALISTS
In 1932, Fuller; the architect, designer, and scenographer Friedrich Kiesler, who had immigrated to America from Austria; and the Danish architect Knud Lönberg-Holm, who was closely acquainted with Erich Mendelsohn and admired by the De Stijl group and at the Bauhaus, came together in a group known as the Structural Study Associates (SSA). For a brief period, the SSA formed a many-voiced opposition against the attempts by Hitchcock and Johnson to elevate the modern design movement from Europe to the status of aesthetic sainthood. The Modern Architecture International Exhibition and the book accompanying this show at the Museum of Modern Art (MoMA) in New York, T h e International Style: Architecture since 1922, expressed opposition to the functionalism propagated, for example, by Hannes Meyer at the Bauhaus in Dessau. For the same reason, MoMA Director Alfred Barr would

93

have preferred the term "post-functionalist" rather than "international."[17] The reference to "post-functionalist architecture" in the title of the book would have reflected the program of the exhibition more accurately. What the triumvirate of Barr/Hitchcock/Johnson had in mind with this project was ultimately expressed in a nutshell by Johnson as "style, nothing but style."[18] This position excluded both the social dimension of New Architecture and its orientation toward scientific and technical innovation. Hitchcock defended his aestheticism, remarking that modern architecture could be presented more effectively to a liberal-conservative public through the "shock of novelty" than through technological and sociological explanations that would only bore people. Such people could be reached by art criticism, however, despite its somewhat esoteric concepts, as they had grown up with it.[19] The fact that the curators of the Modern Architecture International Exhibition were concerned not only with the presentation of modern architecture but also with establishing their authority to judge it and, indeed, to include or exclude certain architects from consideration, is made evident by a critique written by Frank Lloyd Wright, who referred to Barr, Hitchcock, and Johnson as a "self-appointed style committee."[20] In the same issue of Shelter, Knud Lönberg-Holm criticized the "fashion show" in a satirical text montage. Presented opposite an ad by the Standard Sanitary Manufacturing Company for its Neoclassical "Teriston Closet" was a selection of descriptions of stylistic characteristics of architects and buildings representing the International Style written by Hitchcock and Johnson. Lönberg-Holm also took the opportunity to refer to

Ludwig Mies van der Rohe's famous statement of 1923: "We reject every form of aesthetic speculation, every doctrine, and every kind of formalism."[21]
Barr, Hitchcock, and Johnson opposed the programs and discourses of precisely those architects who offered the clearest examples in the New York exhibition. According to Johnson, their book entitled T h e I n t e r n a t i o n a l S t y l e was deliberately conceived as an "attack on the functionalists," as a means of handing "Gropiusism" a "defeat."[22] The curators fed on the ideas of the architects they celebrated as stars, of course, but they also did everything in their power to eliminate their original discourse. In a recent monograph on the intellectual origins of the MoMA, we read that Barr, Hitchcock, and Johnson applied their own aesthetic standards, that they incorporated the ideas of Le Corbusier, Ludwig Mies van der Rohe, and J. J. P. Oud, but that they had also stripped them of their ideological content. Like the programs of the avant-garde, the technical, economic, and social conditions affecting the development of New Architecture in Europe were simply disregarded. The sole intention of the American promoters of the New York exhibition was to present the best and newest examples of aesthetic progress as a fashion trend.[23]

■ A GENUINELY AMERICAN AFFAIR

Thus, both those who were selected for the show but were unable to defend themselves from a distance against biased interpretation and misrepresentation and those who were excluded because they did not fit the mold of the International Style, although they regarded themselves rightly as representatives of modern archi-

tecture, faced a problem. This selective sorting had consequences for the few American modernists, including such architects as Frederick Kiesler, Knud Lönberg-Holm, and Rudolf Schindler, who had come to the United States before the political eclipse of Europe and whose already difficult situation threatened to turn them into members of a fringe group. Much the same can be said of the Americans who regarded themselves as true functionalists. Frank Lloyd Wright—a man regarded by all exponents of modern architecture in Europe as their source of inspiration—was represented at the exhibition but not afforded a single mention in the book.

All of the controversial positions on modern architecture in America are expressed in S h e l t e r in 1932.[24] It is not the writings of Barr, Hitchcock, or Johnson, but rather the articles published in this small magazine which show that the modern movement and the discourse surrounding it in the United States were much more than merely a matter of form. The authors writing in S h e l t e r focused on the roots of the American identity. Functionalism, which Hitchcock and Johnson attacked with the same arguments, was in the eyes of their opponents not only the cornerstone of the international modernist movement, but a genuinely American affair, as was impressively documented in the work of Louis H. Sullivan. Authentic functionalism is a natural philosophy of creativity within the perspective of the self-confidence of individuals in a democratic society. "The heart is ever gladdened by the beauty, the exquisite spontaneity, with which life seeks and takes on its forms in an accord perfectly responsive to its need …. Whether it be the sweeping eagle in his flight or the open apple blossom, the toil-

ing work horse, the blithe swan, the branching oak, the winding stream at its base, the drifting clouds, over all the coursing sun, form ever follows function, and this is the law."[25] This was Sullivan's program, outlined in 1896 in his article on the tall office building as a new architectural objective. He defined its characteristics by designing from the inside out—from the size of a standard office to the structure of the load-bearing framework, and from the dimensions of windows to the façade facing.

This authentic functionalism received a philosophical boost from the American Transcendentalism of Ralph Waldo Emerson, Henry David Thoreau, and Margaret Fuller, whose ideas about the abolition of slavery and the elimination of feudalism in every form were applied to personal life and culture as well. The writings and lectures of the Transcendentalists contain the seeds of a critique of European cultural hegemony based on the concept of American self-reliance. When it comes to self-development in the young society, they contended, the styles and fashions of the old continent must give way to the study of nature.

Viewed from this perspective, the presentation of the European-dominated International Style in New York in 1932 represented a betrayal of the ideal of American cultural independence. Frank Lloyd Wright's equally pathetic and polemical essays in the journal originally published as T - S q u a r e and then as S h e l t e r clearly expressed this sense of affront. It can be seen as the reaction to a personal as well as patriotic insult.[26] Fuller's article "Universal Architecture" published in 1932 revealed a similar current of feeling. In this essay he speaks of projected but unrealized exhibitions by the

great Chicago department stores, which had planned to show models by Le Corbusier, Gropius, Mies, and other architects in 1929. This selection, noted Fuller, was "christened" the International Style three years later. In fact, he contended, it was really "an aesthetic mode developed by European designers in appreciation of American Industrial Buildings, through the advantage of a four-thousand-mile perspective. This 'Quasi-Functional Style' has been codified in European schools, such as the Bauhaus, and is reinfiltrating itself into this country, from which it sprung, as an aesthetic, static dogma—of its original economic science."[27] Fuller's critique was no longer directed at the maneuver of the curators Barr, Hitchcock, and Johnson, but at the contents and their creators, that is, at the leading European architects of New Architecture and the only institution at which these forces had been bundled and consolidated at the time— the Bauhaus.

■ ARCHITECTURE IN THE AGE OF ITS MECHANICAL REPRODUCTION

Whereas functionalism was banished from the dictatorships of Europe in the mid-thirties and continued to struggle for recognition in the Netherlands, Czechoslovakia, Scandinavia, and Switzerland, it had never been more than a marginal phenomenon in the United States. Firmly rooted in the philosophy of American Transcendentalism, however (he had familial ties to the circle associated with Emerson through his great aunt, the women's rights advocate Margaret Fuller-Ossoli),[28] Fuller had led a renewal of authentic functionalism since 1928—with his plans for the Dymaxion House but above all with a

philosophy of human housing in the age of its mechanical reproduction.

As they considered the design requirements for a minimum standard for industrially produced houses, Fuller and his followers—some fifty volunteers, according to Fuller, who worked on the basis of his program for the SSA in New York—were confronted with a world of ultramodern science and technology.[29] This world paved the way for the age of space flight but had little to do with building and housing in its own time. The uncompromising rigor with which Fuller and his followers devoted themselves to the study of universal requirements for industrially produced architecture and wrote about them in T - S q u a r e and S h e l t e r earned them the image of left-wing planners and technicians who had nothing at all to do with architecture or art.

Yet the Archimedean point in Fuller's authentic functionalism is not the machine, but rather the recreative potential of life to which he attributes technical reproduction and standardization. "Is it not the very secret of nature that it must be recreative after its own image in direct proportion to its adequacy and satisfaction of the universal ideal?" A crucial factor is the structural-functional similarities of living organisms and technical artifacts and whether this systemic approach can be applied to architectural design strategies. "These new houses are structured after the natural system of humans and trees"[30] Fuller's plans for residential dwellings have a central trunk or a central backbone to which all utility lines are connected as well as an outer shell that regulates a building's climate. This, he contended, results in an engineering design much like that of an aircraft. Unlike his

contemporaries, who consistently borrowed only formal aspects of natural phenomena—as in the organic form or in streamlining, for example—Fuller's description of natural systems focuses on their structuring from discreet parts, their behavior as a whole, their reciprocal effects, their origin, their transformation, and their decline.

Despite his grasp of purely technical processes, Fuller's approach to natural systems is originally poetic rather than technical.[31] Thinking in terms of natural systems opens other avenues to technologies and aspects of finding form. Fuller obeyed the energy-saving, entirely economical principle of nature—in other words, the concept of making the most of the least. This approach led him to types of construction that were unknown in the building trade—such as the separation of pressure and tension elements, flexible joints, the division of structures into stabilizing triangles of force—that were typical of his work.[32] Fuller and Lönberg-Holm assembled corresponding image-and-text tableaus for presentation in S h e l t e r. These pages introduced readers to the world of lightweight construction, of ship and sailboat design principles, and even of the framework structures used by acrobats. In contrast, the primarily aesthetically encoded cubes and blocks celebrated by the advocates of the International Style were criticized by Fuller and the SSA because of their poor aerodynamic properties and the resulting high energy loss. This criticism contributed to the development of the SSA's theory of "environment controls." Yet its practical application was long in coming and was first demonstrated in Fullers Expo Dome. The skin of the huge geodesic dome of the U.S. Pavilion at the World Exposition in Montreal in 1967 was designed

by Fuller and his associates as a computer-controlled light- and climate-active membrane that behaved like a living skin.

1 Cf. David Robbins, ed., The Independent Group: Postwar Britain and the Aesthetics of Plenty, exh. cat. ICA London et al. (Cambridge, MA, and London, 1990).
2 Reyner Banham, Theory and Design in the First Machine Age (London, 1960), p. 326.
3 For a reliable dating based upon source materials in Fuller's estate see Joachim Krausse and Claude Lichtenstein, eds., Your Private Sky: R. Buckminster Fuller; The Art of Design Science, exh. cat. Museum für Gestaltung Zurich et al. (Baden, Switzerland, 1999), pp. 80–141.
4 R. Buckminster Fuller in a letter to John McHale, January 7, 1955, printed in Architectural Design 7 (1961), pp. 290–296.
5 Reyner Banham, "The Dymaxicrat," Arts Magazine 10 (1963), pp. 66–69; also in Mary Banham, ed., A Critic Writes: Essays by Reyner Banham (Berkeley and London, 1996), pp. 91–95; here: p. 91.
6 John McHale, "Gropius and the Bauhaus," Art (March 3, 1955). Cited in Robbins 1990 (see note 1), p. 182.
7 R. Buckminster Fuller, "Influences on My Work," chap. 1 in Ideas and Integrities: A Spontaneous Autobiographical Disclosure (Englewood Cliffs, 1963), pp. 9–34.
8 Carl Schmitt, Land und Meer: Eine weltgeschichtliche Betrachtung (Leipzig, 1942). R. Buckminster Fuller, "Fluid Geography," American Neptune 2 (1944), pp. 119–136.
9 Fuller 1963 (see note 7), pp. 62f.
10 Walter Gropius, "Monumentale Kunst und Industriebau," lecture delivered on April 10, 1922 at the Museum Folkwang in Hagen, typescript, pp. 2, 35–37, estate of Walter Gropius, Bauhaus-Archiv Berlin. Cf. Gerda Breuer, "Werbung für das eigene und das Neue Bauen: Walter Gropius und die Fotografie," in Gerda Breuer and Annemarie Jaeggi, eds., Walter Gropius: Amerikareise 1928, exh. cat. Bauhaus-Archiv, Berlin, and Universität Wuppertal (Berlin and Wuppertal, 2008), pp. 88–89.
11 Fuller 1963 (see note 7), p. 63.
12 Banham 1960 (see note 2).
13 Fuller 1963 (see note 7), pp. 63, 63f., 65.

14 R. Buckminster Fuller, "Dymaxion House: Lecture for the Architectural League, New York, 1929," in Joachim Krausse and Claude Lichtenstein, eds., Your Private Sky: R. Buckminster Fuller; Discourse (Baden, Switzerland, 2001), pp. 82–103. Cf. Joachim Krausse, "Architektur der Hochtechnologie: Buckminster Fullers Dymaxion House 1929," in Stefan Andriopoulos and Bernhard J. Dotzler, eds., 1929: Beiträge zur Archäologie der Medien (Frankfurt am Main, 2002), pp. 191–223.

15 R. Buckminster Fuller, "Lightful Houses," in Krausse and Lichtenstein 2001 (see note 14), pp. 64–75, here p. 73.

16 R. Buckminster Fuller, "Putting the House in Order," editorial, Shelter 5 (1932), p. 2.

17 Alfred Barr, "Introduction," in Henry Russell Hitchcock and Philip Johnson, The International Style: Architecture since 1922, exh. cat. Museum of Modern Art (New York, 1932), pp. 14f.

18 Philip Johnson, cited in Terence Riley, The International Style: Exhibition 15 and the Museum of Modern Art, exh. cat. Museum of Modern Art (New York, 1992), pp. 14f.

19 Henry Russell Hitchcock, "Architectural Criticism," editorial, Shelter 3 (1932), p. 2

20 Frank Lloyd Wright, "Of Thee I Sing," Shelter 3 (1932), pp. 10, 12.

21 Ludwig Mies van der Rohe in G: Material zur elementaren Gestaltung 1 (1923), n.p. (p. 3). Cited in Knud Lönberg-Holm, "Two Shows: A Comment on the Aesthetic Racket," Shelter 3 (1932), pp. 6f.

22 Philip Johnson, cited in Sybil Gordon Kantor, Alfred H. Barr, Jr. and the Intellectual Origins of the Museum of Modern Art (Cambridge, MA, and London, 2002), p. 283.

23 Ibid., p. 276.

24 This periodical has received appropriate scholarly attention only by Marc Dessauce to date: "Contro lo Stile Internazionale: 'Shelter' e la stampa architettonica americana," Casabella 604 (1993), pp. 46–53, 70f.

25 Louis Sullivan, "The Tall Office Building Artistically Considered," Lippincott's Magazine (March 1896). Online at http://academics.triton.edu/faculty/fheitzman/tallofficebuilding.html (accessed July 18, 2009).26 Cf. the article by Frank Lloyd Wright, "For All May Raise the Flowers Now—For All Have Got the Seed," T-Square 2 (1932), pp. 6ff.

27 R. Buckminster Fuller, "Universal Architecture, Essay One," T-Square 2 (1932), p. 22. The author reaffirms the criticism expressed in this article in Fuller 1963 (see note 7), pp. 62–65.

28 R. Buckminster Fuller in a letter to Rosamund Fuller, June 13, 1928, reprinted in Krausse and Lichtenstein 2001 (see note 14), pp. 77–79.

29 Fuller 1932 (see note 27), pp. 22, 37ff.

30 Ibid., p. 35.

31 Joachim Krausse, "Thinking and Building: The Formation of R. Buckminster Fuller's Key Concepts in his 'Lightful Houses,'" in Hsio-Yun Chu and Roberto G. Trujillo, eds., New Views on R. Buckminster Fuller (Stanford, 2009), pp. 53–75.

32 R. Buckminster Fuller, "Universal Architecture, Essay Three," Shelter 4 (1932), p. 36. Cf. the illustrations on pages 36 and 39 of the journal in Krausse and Lichtenstein 1999 (see note 3), pp. 166f.

A FAILED REBIRTH
THE BAUHAUS AND STALINISM, 1945–1952
Simone Hain

■ THE POETRY OF THINGS: BEHAVIORAL THEORY IN PLACE OF ICONS

"Those Bauhaus people were magicians. Think of it—there was nothing after the war. And with a handful of nails and a ball of twine, they built an exhibition booth." In an apartment on Karl-Marx-Allee in Berlin, a tall lady with snow-white hair remembers the early years after the war. Liv Falkenberg-Liefrinck is from Holland, but that means little. She studied art history in Zurich and Paris and then learned cabinetmaking in Hellerau near Dresden. It was she, of course, who brought Mart Stam to the German Democratic Republic (GDR); as a young girl, she had taken care of him during his six months of imprisonment as a conscientious objector and had also worked with him in the Amsterdam underground during occupation. Two years his junior, she was close to him not only politically, but had chosen the same profession as he. Both had participated in the construction of the Weissenhofsiedlung in Stuttgart in 1927 and had been members of the avant-garde groups Opbouw in Rotterdam and De 8 in Amsterdam. After the war, when her German husband became director of the Amt zur Neuordnung der Industrie (Office of the Reorganization of Industry) in Saxony, Liv insisted on bringing the inventor of the cantilever chair to Dresden to establish progressive product design in the Soviet-occupied zone.

gation of lived space, had in fact succeeded in opening up the processes of the soul to students who at first had been "completely materialistic." "It was a glorious struggle," Dürckheim later recalled with respect to this greatest triumph of his life, "in which I learned that in the end, the suggestion of qualitative experiences is more powerful than purely rational argumentation."[3]

Thanks to Hannes Meyer, the encounter with Dürckheim alone was enough to turn Selmanagić's functionalism into a method focused on elementary synaesthetic experiences rather than a one-sided utilitarian program. At the late Bauhaus with its Surrealistic interests, Selmanagić learned that one simultaneously hears, smells, and feels warmth and air when crossing a room and perceiving different objects one after the other. According to Dürckheim, when extreme opposites flow into a complex gestalt, when all the senses are addressed simultaneously, the satisfaction that results is experienced as a healing liberation; indeed, as the discovery of Self. In the final Dessau years, the methodology of the Bauhaus had expanded to include this knowledge, relevant to all processes of design.

In the clubroom of the Deutsche Verwaltungsakademie in Forst Zinna, designed in collaboration with Liv Falkenberg-Liefrinck, Selmanagićused sensually appealing colors and corporeal forms to show how space can be organized and orchestrated in such a way that merely entering it becomes an experience. This remote location in Brandenburg was where the young elite of the Soviet occupation zone were trained. The colors and material contrasts of the clubroom inspired contemporary critics to compare it to the great creations of the Baroque. Even

before the call was made for monumental "workers' palaces," Forst Zinna provided a competing interpretation of worker emancipation. Later, Selmanagić would be asked by a dogmatic traditionalist what references guided him in his furniture designs. The answer: "I always just followed my gut." Anything else, laughs the nearly hundred-year-old Liv in her comfortable Indian rocking chair, would be "pure kitsch."

■ COLORS AND FORMS AS FREE FORCES: CONFLICT AT THE SCHOOL

When Mart Stam moved to the Soviet-occupied zone from the Netherlands in late 1948, it was not merely the small community of former Bauhaus students who were hoping for a new, systematic beginning in art education and design theory. Stam came with the support of the Soviet Military Administration in Germany (SMAD) and had been expected for a long time by Dresden mayor Walter Weidauer. Stam was protected: Alfred Schnittke, the cultural officer in Saxony, had been a member of the Moscow CIAM group, and in Berlin, Gerhard Strauss of the Staatliche Kunstkommission (State Art Commission) held protecting hands over the attempt to reorganize the two academies in Dresden. Although there was no longer an educational institution for architects, Stam wanted to unify the Akademie für Bildende Künste (Academy of Fine Arts) and the Hochschule für Werkkunst (School of Applied Art) under the primacy of architecture with a clear orientation to the promotion of industrial and everyday culture. In light of the cultural climate in traditionalistic Dresden, with its strong personalities from the circle of the Assoziation Revolutionärer Bildender Künstler

Deutschlands (Association of Revolutionary Visual Artists in Germany), Stam's appointment as the successor of the seriously ill painter Hans Grundig was risky. The result was conflict between the "cosmopolitan globetrotter" on the one hand and the artists of Dresden on the other.

It is important to remember that attitudes toward the Bauhaus in the zone occupied by the Soviets and the early GDR varied widely according to institution and region. In Weimar, Konrad Püschel had his Bauhaus diploma revoked; in Berlin, however, former Bauhaus student Edmund Collein held office for many years as vice president of the Deutsche Bauakademie (German Building Academy). For their part, the Staatliche Kunstkommission and the economic ministry of Saxony wanted a new Bauhaus to facilitate as close a relationship as possible between design and production. In an article entitled "Das Bauhaus in Dessau kommt wieder" (The Bauhaus in Dessau Returns) in N e u e s D e u t s c h l a n d, the primary mouthpiece of the SED, an extremely positive report was published on February 6, 1948, on Hubert Hoffmann's initiative in Anhalt: "The artistic concepts of yesterday and the study of nature connected with them consisted, one might well say, of an embarrassingly differentiated exploration of appearance The art of observing non-optical impressions and concepts and rendering them visible, however, was neglected. The Bauhaus masters provided their students with a 'second vision': they awakened in them a sense of digging for the essence of things."[4] Politically, as a former Bauhaus instructor whom the Russians knew and valued as an international authority, Stam appeared perfectly suited to reclaim the Bauhaus legacy. His school quickly received the name "bauschule"

as well as suitable facilities near the famous theater in Hellerau in the institute once directed by Emile Jaques-Dalcroze. The community with the famous furniture workshop was now to become a proper school. While Stam began his term as rector by dismissing four prominent instructors who did not accord with his educational concept and had been discredited by their high standing during Fascism, he also invited John Heartfield to come to Dresden. "About a year ago," Stam wrote to the artist on October 4, 1949, "we, too, gladly abandoned our work in the West (Holland) in order to devote ourselves here to the great task of democratic reconstruction. We are putting all our energies into reforming the education of the next generation of artists and believe that you, too, can make an essential contribution."[5]

In addition to designer Marianne Brandt, Stam appointed a dozen new instructors from the Bauhaus milieu. In so doing, he allowed himself to some extent to be guided by impulses clearly opposed to academic tradition. In reaction to the cult of the individual artistic genius and of easel painting, he instituted the practice of the "painters' collective," which worked on large murals for public spaces in 1949. The artists of Dresden saw this attitude as an attack on the principle of the academy and the master studio. They in turn took up arms "to give those buggers a good dressing down." The controversy intensified when Stam refused to appoint graphic artist Lea Grundig, who had just returned from exile in Palestine, because he did not share her aesthetic conception. Her rejection was perceived as a further evidence of cold-heartedness. "It is the eternal battle between the so-called intellectuals, cold aesthetes, angular architects,

and the creative powers, the artistic people," wrote the Dresden sculptor and graphic artist Eugen Hoffmann to the painter Hans Grundig on December 10, 1948. "We must attempt to preserve as much as possible of the essence of the academy, that is, do everything we can to secure a future generation that ... will preserve visual art for the future, in which it has a great social responsibility to fulfill. In my view, Stam is ... not the man to have a productive and forward-looking effect, not in this area The old guard lives, despite all that. The divine eyes of the world are upon us. In reality, only we can provide genuine evidence ... that socialism is not mere utopia."[6]

The sharp conflict that followed—in which, in addition to Grundig and Hoffmann, the artists Josef Hegenbarth, Wilhelm Lachnit, and Hans Theo Richter also turned against Stam—was in fact solely a manifestation of the "old guard." In essence, the conflict was only the revival of an already twenty-year-old dispute among leftist artists concerning the role of art in the class struggle. Here, in accord with the writings of Georg Lukács, the principle of reflection was brought into position against all kinds of modern abstraction.

In Czechoslovakia, incidentally, this confrontation was called the "generation debate." In 1929, the Poetism of the younger artists and architects had been able to assert itself as the official party aesthetic against the older generation of proletarian-revolutionary writers in a shift unique in the communist movement. In Germany, the question of whether the red flag would wave above the Bauhaus had remained open until 1933; the unions, at least, had decided in favor of Bruno Taut, Max Taut, Erich Mendelsohn, and, in the case of the Bundesschule

des ADGB in Bernau, the Bauhaus under Hannes Meyer. The communist press published enthusiastic reports on the Bauhaus. The Halle newspaper K l a s s e n k a m p f had this to say at the opening of the Dessau building in December 1926: "The greatest thing about the Bauhaus is that the educational structure of this school ... shows a creative spirit. Students and teachers are a collective, a working community of the best kind. At the Bauhaus, the dialectical struggle in politics finds its parallel in the experimentation of the designers. The student is not hit over the head with the interests of the 'specialist,' but rather is forced to study the meaning of the work from broader points of view The Bauhaus people do not ignore the social transformations of our time, but live and struggle with these problems; they have a social conscience. That is their strength."[7]

But back to the Dresden controversy of the late forties. The course of events was especially tragic for subsequent developments, for by adopting adversarial positions and allowing themselves to be drawn into bitter aesthetic confrontation—as longtime chair of the Verband bildender Künstler (Association of Visual Artists) of the GDR, Lea Grundig would become the leading representative of doctrinaire Socialist Realism—the comrades played into the hand of the incipient Stalinist campaign against "cosmopolitanism." There is no question that Grundig, Hegenbarth, Hoffmann, Lachnit, and Richter were significant artists. But when in the name of Vitalism they denounced Stam as an "intellectual," "aesthete," and "angular architect," they assaulted their own ranks and exposed him to the kind of secret-service attacks typical of the Cold War. Adolf Behne's attempts to inter-

vene against the malapropism of modernism proved to be in vain. Already renowned in the twenties as an art and architecture critic, Behne passionately defended Abstract Art and called for emancipation instead of affirmation. "Even if the radical art is non-objective and turns away from 'nature' as an inexhaustible storehouse of models," he wrote in one of his final essays, published in the magazine B i l d e n d e K u n s t in early 1948, "it is nonetheless concrete. It appeals to perception, to the senses … . Colors and forms are free forces—and not house painters … . Let's have the courage for life, for adventure, for imagination, and the courage for a beauty that does not represent something else beautiful, but rather is in itself beautiful."[8]

■ BUT OH, THE IMAGE OF THE CITY: A PARADIGM SHIFT

Despite these conflicts over educational policy, Stam's program received the support of both the Deutsche Zentralverwaltung für Volksbildung (German Central Administration for National Education) and the SMAD. The "bauschule" in Dresden was integrated into the two-year plan of the Soviet-occupied zone with development projects. Stam began to take part in architecture and urban planning competitions. And here, in his own field—not as the director of a school or as a designer, but as an architect and urbanist—he would undergo his true debacle. In the competition for the culture palace of the Saxon mining city of Böhlen in 1949, his refined and somewhat classicizing project, with its symmetry and rows of supports, was rejected; a little later, a heavy, monumental building was constructed in place of the light grid Stam

115

had proposed. This defeat was still accompanied by some expression of regret; a letter from the president of the Deutsche Bauakademie, Kurt Liebknecht, speaks of an unfortunate decision by the jury.[9]

But the real trouble for Stam began when his concept for the reconstruction of downtown Dresden was to be put into effect. Under his direction, the Freie Arbeits-gemeinschaft Neuaufbau (Free Working Committee for Reconstruction) had developed a plan that completely ignored the historic ground plan of the old city of Dresden, inscribed bold Dutch housing blocks over the old network of streets, and called for the demolition of numerous burned-out architectural monuments. Kurt W. Leucht, executive director of the planning committee, objected to this concept, which did in fact seriously endanger the image of the city and the collective mem-ory of its form. But instead of protesting openly, this obscure opportunist from the shadowy milieu of Nazi hangers-on chose the way of intrigue. At the latest when he learned from Walter Ulbricht that Stam had been declared a persona non grata by Stalin and that he was therefore on the way out, Leucht no longer had any scru-ples.[10] He became Stam's most zealous secret enemy and, thanks to his own advancement, was able to pursue him all the way to Berlin.

■ GLOBAL CULTURE WAR

On May 1, 1950, Stam became rector of the Hochschule für Angewandte Kunst (School of Applied Art) in Berlin-Weissensee. His transfer was considered by all involved to be the best solution, since he could "better develop his unquestionably substantial abilities" in Berlin-Weissen-

see than in Dresden. The Party Control Commission approved the new rector's professional and educational work but found fault with his political qualities. They said his "attitude toward the Party" was "individualistic," and added: "The idea of party discipline and party loyalty is not strong enough in Comrade Stam for him to carry out decisions with which he disagrees."[11] These statements constitute a political, not an artistic, verdict; they indicate that Stam did not concur with the progressive Stalinization of the SED. In an evaluation ordered in 1951, however, professional deficits were identified along with political ones. As this document indicates, in the meantime the premises not only of urbanism, but also of art policy had shifted: "The persistence he demonstrates in following what is essentially ... an incorrect path suggests that, guided by his sense of professional superiority, ... he views the new paths of the present day ... as inadequate and in fact sees it as his mission to work for the preservation of culture according to his perspective From an educational perspective, his specialized professional side is so specifically reformist and Bauhaus-like that it can clearly no longer be viewed as tenable by us today."[12] As rector of the Hochschule für Angewandte Kunst, Stam also directed the affiliated Institut für Industrielle Gestaltung (Institute for Industrial Design) in Berlin-Mitte. His efforts concentrated on the promotion of this institution, which continued under another name as the leading political center for design until the end of the GDR. Stam's duties included participating in the branch-related councils for product design at the Ministerium für Leichtindustrie (Ministry of Light Industry) as well as the commissions for prototype selection for the samples fair

in Leipzig. As an assessor he stood in high esteem with industry, with the Zentralamt für Forschung und Technik (Central Office of Research and Technology), with the Staatliche Plankommission (State Planning Commission), and with the Deutsches Amt für Messwesen und Warenprüfung (German Office of Metrology and Product Testing).

Yet all these efforts came to an abrupt end. In 1951, the Hochschule für Angewandte Kunst and its rector Stam suddenly found themselves at the center of the so-called Formalism Debate. Apparently, the SED cadre perceived the school, from painting to architecture, as the last bastion of the Bauhaus idea. For months, the faculty was subjected to art-theoretical brainwashing; on May 2, 1951, representatives of the Economic, Propaganda, and Culture Division of the Central Committee of the SED were in attendance at a specially convened professional conference on questions of architecture. But to no avail: professors and students alike rejected the new architectural doctrine from the ground up. They refused to adorn buildings with artistically designed ornaments; it was even said that they glorified American architecture.

This accusation reveals the crucial point for understanding the situation at that time. The rigid anti-formalist position can only be understood in light of the contemporaneous, espionage-backed cultural offensive of the United States in western Europe. Beginning in the early fifties, the Central Intelligence Agency (CIA) conspiratorially cultivated a broad intellectual network associated with the Congress for Cultural Freedom (CCF), financed through sources including the return flow of the Marshall

Plan and the funds of the Henry Ford Foundation. Launched in 1950 in West Berlin and then quickly moved to Paris due to espionage by the USSR, the CCF was an organization completely controlled by the CIA. Its goal was to influence significant left-wing liberal intellectuals, authors, and artists in accord with its own aims, that is, to engage them in the critique of totalitarianism and instrumentalize them against the socialist states. What the American initiators of the CCF feared was not Stalinist cultural production, it was the artistic and intellectual positions of communist sympathizers in the bastions of cultural and political discourse, i.e., in Paris, London, and Berlin. In this global conflict, the two German states were colonized in their cultural politics from opposite directions by the two superpowers.[13]

Compared to earlier controversies among leftist artists, the Formalism Debate was a new entity. At issue here was neither internal artistic rivalry nor domestic political affirmation, as had been the case in the thirties, but imperial interests. It was decades before it really became clear what drove the Soviet Union and its German satellite, beginning in 1946, to shut down with perfidious sensibility the very intellectual allies who were most committed to the new society and to a politically engaged art. In his book D i e I n t e l l e k t u e l l e n , Werner Mittenzwei, a theater and literary scholar and longtime member of the Academy of Sciences of the GDR, noted that the cultural-political "purge" initiated by Andrei Zhdanov was "in its worldwide effect ... comparable only ... to the Council of Trent"[14]—which in 1562 had been concerned with purifying Catholic church music from anything

lascivious. It should be noted that this purification was not merely an artistic matter, but part of the arsenal of the Counter-Reformation.

The background of the Formalism Debate was revealed only with the memoirs of Vladimir S. Semjonov, then political advisor of the Soviet Control Commission in Germany and later longtime ambassador of the USSR in the Federal Republic of Germany. It was the reports of returning soldiers that caused Zhdanov to fear that Soviet society could be corrupted by Western cultural standards.[15] In principle, the USSR was reacting to the same phenomenon as the United States; both victorious powers saw themselves as culturally inferior and were concerned about hegemony. It was the spontaneous fraternization in occupied Europe, it was the self-confident air of even ruined, conquered Germany—with its glowing club chairs by Selmanagić and Futuristic ceramic lamps by Stam—that unintentionally represented a challenge. For the statist, totalitarian socialism of the twentieth century, for the Stalinist system, the simmering crucible of Europe, where radical communists played an important cultural-political role, posed the threat of a reformation. What unsettled Stalinism as a repressive political structure was the situation in central Europe with its openness to the future, the Soviet military's contact with the men and women of the first hour, the encounter with the culture of the remigrants, or simply friendship with and love of Germans. Before private contact between Russians and Germans was prohibited by Moscow, probably as early as 1946, the cultural officers fraternized. They not only raved about Heinrich Heine to the Germans, they applauded Existentialist theater and sponsored exhibi-

tions of paintings dealing with angst and despair.[16] And when the Russians really liked something, they occasionally confiscated it under the authority of occupation law. Such was the fate of the luxurious modern clubroom of the Deutsche Verwaltungsakademie in Forst Zinna. After the facilities changed hands, the new Soviet overlords were so taken with the furnishings by Selman Selmanagić and Liv Falkenberg-Liefrinck that they simply sent the entire interior back to Russia—perhaps for a sanitorium of the Red Army in the Crimea or the officers' club of a garrison. In the mid-fifties, Selmanagić saw his work again—on the cover of the Soviet magazine A p p l i e d A r t, where it was of course presented as a model of Soviet design. And so the Bauhaus, its cultural assets carefully packed in crates, caused an unexpected stir in the Soviet Union. But the return home was not so easy for the men who had sent the furniture on ahead. It was feared that the returning intellectuals, far more than the common soldiers before them, could threaten the interior peace of the Soviet Union; hence Stalin's decision to order the cultural officers of the Red Army home and detain them.[17] Whether in Berlin, Dresden, or Vienna, at the "zero hour" they had been much too close to the freedom of the experiment.

■ WHAT REMAINED
At the climax of the anti-modernism campaign in early 1953, Mart Stam left the GDR.[18] As great a loss as his departure was, it would be wrong to see it as the end of the Bauhaus legacy in East Germany. The prevailing view of the horrors of the Formalism Debate can easily mask the lasting presence and truly dialectical effect of

the Bauhaus idea in the GDR. Despite penetrating criticism of the Bauhaus—first of its functionalist aesthetic, then of its activist, "reformist" conception of society, and finally of its doctrinaire, ahistorical urbanism—over the long term the Bauhaus enjoyed greater respect and a deeper resonance in East than was ever the case in West Germany. It may well have been the harsh Stalinist critique of the Bauhaus—extremely unfair to those affected by it—that involuntarily imbued it with a subversive attraction. The fact that in the seventies, works by the philosopher and cultural theorist Lothar Kühne could present a revised "communist functionalism" as a critical challenge to "socialism as it exists,"[19] the fact that there was no true postmodernism in the GDR, that the word "Baukunst" (the art of building) still seemed odd and even suspicious to those who in the nineties were referred to as "trained GDR citizens," and that industrial building was considered honorable even beyond the bitter end— all of these social and cultural phenomena suggest a much closer connection between the Bauhaus and East Germany than has generally been assumed.

Strong lines of tradition were likewise unmistakable in the curriculum of the art schools, in the interdisciplinary state design organization, in architectural research—that is, in the scientific justification of building—and especially in the responsibility of design in the area of public finance and even ecology. There were three things that migrated from the Bauhaus into the GDR and marked its identity, as far as can be seen in objects both great and small: a concreteness irrelevant to product aesthetics; an interdisciplinary view of the city as a whole, along with urbanism as design and personally responsible urban

architects; and industrial building as a thoroughly socialized form of the production of space, conceived in workers' terms.[20] And last but not least: the "second vision," the "sense of digging for the essence of things" of which Hubert Hoffmann spoke in 1948.

1 Klaus Kühnel, ed., Der Mensch ist ein sehr seltsames Möbelstück: Biographie der Innenarchitektin Liv Falkenberg-Liefrinck, geboren 1901 (Berlin, 2006), pp. 109–130.
2 "Selman Selmanagić im Gespräch mit Siegfried Zoels," transcript of tape recording, nineteen eighties. Cf. Simone Hain, "Gegen die Diktatur des Auges, Selman Selmanagić zum 100. Geburtstag," form + zweck 21 (2005), pp. 78–99.
3 Karlfried Graf Dürckheim, Erlebnis und Wandlung: Grundfragen der Selbstfindung (Frankfurt am Main, 1992), p. 41.
4 "Das Bauhaus in Dessau kommt wieder," Neues Deutschland, February 6, 1948. The author is probably Hubert Hoffmann.
5 Mart Stam in a letter to John Heartfield, October 4, 1949, Archiv Hochschule für Bildende Künste (HfBK) Dresden, Handakte Stam.
6 Eugen Hoffmann in a letter to Hans Grundig, December 10, 1948. Cited in Hochschule für Bildende Künste Dresden, ed., Eugen Hoffmann, Lebensbild—Dokumente—Zeugnisse (Dresden, 1985), n.p.
7 Martin Knauthe, "Zur Einweihung des Bauhauses in Dessau," Klassenkampf, December 3, 1926. The author, an architect from Halle, disappeared in Stalin's camps.
8 Adolf Behne, "Was will die moderne Kunst?" Bildende Kunst: Zeitschrift für Malerei, Graphik, Plastik und Architektur 1 (1948), pp. 3–7, here pp. 3, 4, 6. Cf. Simone Hain, "Kolonialarchitektur? Die Stalinallee im Kontext internationaler Ästhetikdebatten seit 1930," in Helmut Engel and Wolfgang Ribbe, eds., Karl-Marx-Allee: Magistrale in Berlin; Die Wandlung der sozialistischen Pracht-straße zur Hauptstraße des Berliner Ostens (Berlin, 1996), pp. 75–101.
9 Kurt Liebknecht in a letter to Mart Stam, 1949 or 1950, estate of Kurt Liebknecht, Akademie der Künste, Berlin.

10 "Kurt W. Leucht im Gespräch mit Simone Hain," transcript of tape recording, 1996.

11 Stiftung Archiv der Parteien und Massenorganisationen der DDR im Bundesarchiv (SAPMO-BArch), DY 30/IV 2/906/180 Akte Überprüfung, sheet 1.

12 Professor D. Dähn, "Beurteilung über Professor Stam," May 17, 1951, Archiv Hochschule für Bildende Künste (HfBK) Dresden, Akte Kader (Ka 10) 1951–1959.

13 On this subject, cf. Volker Berghahn, Transatlantische Kulturkriege: Shepard Stone, die Ford-Stiftung und der europäische Antiamerikanismus (Stuttgart, 2004); Greg Castillo, "Building Culture in Divided Berlin, Globalization and the Cold War," in Nezar AlSayyad, ed., Hybrid Urbanism: On the Identity Discourse and the Built Environment (Westport, CT, and London, 2001), pp. 181–205; Frances Stonor Saunders, The Cultural Cold War: The CIA and the World of Arts and Letters (New York, 2001).

14 Werner Mittenzwei, Die Intellektuellen, Literatur und Politik in Ostdeutschland 1945–2000 (Leipzig, 2001), pp. 91.

15 Wladimir S. Semjonow, Von Stalin bis Gorbatschow: Ein halbes Jahrhundert in diplomatischer Mission 1939–1991 (Berlin, 1995), p. 154. See also the discussion of the proceedings in Mittenzwei 2001 (see note 14), p. 90.

16 On the atmosphere in occupied Berlin, cf. Wolfgang Schivelbusch, Vor dem Vorhang: Das geistige Berlin 1945–1948 (Munich and Vienna, 1995). On the background and attitudes of Soviet culture officers, see especially pp. 55–61.

17 On the limiting of interactions between Soviet cultural officers and Germans and the Soviet officers' sudden departure, cf. Annett Gröschner, Jeder hat sein Stück Berlin gekriegt: Geschichten vom Prenzlauer Berg (Reinbek bei Hamburg, 1998), p. 276.

18 Mart Stam's activity in the GDR is discussed extensively in Simone Hain, "'Spezifisch reformistisch bauhausartig', Mart Stam in der DDR," part 1, form + zweck 2/3 (1991), pp. 58–61, and Simone Hain, "Kultur und Kohle: Das Böhlen-Projekt; Mart Stam in der DDR," part 2, form + zweck 4/5 (1992), pp. 68–73. See also Simone Hain, "ABC und DDR: Drei Versuche, Avantgarde mit Sozialismus in Deutschland zu verbinden," in Günter Feist et al., eds., Kunstdokumentation SBZ/DDR, 1945–1990: Aufsätze Berichte Materialien (Cologne, 1996), pp. 430–443, here pp. 435–440.

19 Cf. Lothar Kühne, Haus und Landschaft: Aufsätze (Dresden, 1985).

20 Cf. Simone Hain, "Das utopische Potential der Platte," in Axel Watzke et al., eds., Dostoprimetschatjelnosti (Hamburg, 2003), pp. 79–87. See also Simone Hain, "Marzahn, das sozialistische Projekt zwischen rational choice und Diktatur," in Allee der Kosmonauten: Einblicke und Ausblicke aus der Platte, ed. Kulturring in Berlin e.V., exh. cat. (Berlin, 2005) ,pp. 9–13.

THE POSTWAR DISPUTE IN WEST GERMANY
THE RENEWAL OF RATIONALISM
Thilo Hilpert

> "And to the new city, the city of all cities, we are
> on the way, full of hunger."
> Wolfgang Borchert, 1946

The Bauhaus polemic initiated by church architect Rudolf Schwarz early in 1953[1] was one of the first attempts to define the position of West German architecture against the background of the destroyed remnants of modernism and a horizon empty of the public memory of images of the city. The catalyst for the polemic, as well as for the various statements that followed, was Ludwig Mies van der Rohe's contribution to the competition for the new National Theater in Mannheim. Along with Schwarz, Hans Scharoun, and other architects who had not been discredited, Mies had been invited to participate by Herbert Hirche, his former student at the Bauhaus who had survived the thirties with Egon Eiermann.[2]

In the fifties, the connections to Bauhaus tradition were established haltingly at first, but then in seemingly linear fashion, parallel to Mies's growing international reputation. In reality, however, these connections were more complex and contradictory than is generally known today. There has been little public awareness, for example, of the role of the Mannheim competition or of the conflict between the architects Max Bill and Konrad Wachsmann at the Hochschule für Gestaltung in Ulm in 1957, which will be discussed here.

The initial concern in 1953 was the way in which associations with the modern architecture of the twenties and thirties would be established; in this context, the conservative Schwarz was attempting to resist the dominance of Bauhaus-oriented rationalism, but was sidetracked into diffuse and sometimes abrasive arguments. Four years later, however, it was the continued development of this very rationalism that was at stake in the conflict between Bill, who had studied at the Bauhaus, and Wachsmann, who had worked with Walter Gropius und Mies.

■ MIES AS MODEL: THE CONTRADICTORY TRIUMPH OF LIGHTNESS

In many respects, the Bauhaus debate of 1953 consisted of the proclamation of old formulas of censure, such as "technicism" or "functionalism," from the early thirties. At the same time, it was also characterized by hasty professions of solidarity from new Bauhaus devotees, with both sides lacking theoretical undergirding or argumentative proof. Against the background of Mies's "glass boxes," the texts referred somewhat associatively to the life atmosphere connected with glass architecture in the period of reconstruction: transparency, lightness, and even dematerialization to the point of the complete removal of spatial boundaries. Scharoun's defeat in Mannheim received much less attention than the rejection of Mies's "glass box" with its large, support-free interior and theatrical p a r c o u r s, as shown in the model. At the time, photos of the project were not published in the architectural press, not even in connection with Schwarz's Bauhaus polemic, though Schwarz was sup-

posedly sympathetic to Mies. The skepticism toward Bauhaus modernism expressed in Schwarz's attitude had to do with the significance of the glass façade as a symbol of the avant-garde.

At the time of the Bauhaus debate, the need for an architecture of lightness had begun to be articulated in the first glass façades of the still-ruined cities. It was manifested in the exteriors of the department store chain Kaufhof—built by the offices of Skidmore Owings & Merrill (SOM) even without first-hand knowledge of the constructive details—as well as in the façade of the Haniel garage by Paul Schneider-Esleben, a student of Schwarz, and Eiermann's design for the expansion of the University of Saarbrücken, which was far more radical in its use of glass walls than Mies's project for Mannheim. Fascist architecture had made its last bid for mass-psychological mooring in the overbearing massiveness of the flak towers, skyscrapers of concrete built by Friedrich Tamms that are still visible today in Berlin, Hamburg, and Vienna.[3] Now, the dematerialized lightness which in Dessau had become the identifying feature of the Bauhaus and of avant-garde modernism in Germany answered a social need that welcomed this very lightness as an American achievement.

Schwarz's Bauhaus polemic was also an attempt to clarify the relationship to the Bauhaus tradition, not among Bauhaus students themselves, but within the influential Poelzig school.[4] In the postwar period, the Poelzig school produced such diverse architects as Tamms, director of urban planning in Düsseldorf and former ideologue of Albert Speer's bunker aesthetic; Karola Bloch, who kept her husband, philosopher Ernst Bloch, informed about

architecture; and Gerhard Kosel, who promoted the industrialization of building in East Germany beginning in 1955. Above all, however, it included Eiermann, who had clung tightly to his conceptions of modern architecture throughout the thirties and was overshadowed by Schwarz for a long time after the war. Schwarz knew how to present himself as the representative of the Poelzig school, while Eiermann was considered an industrial architect and builder of functional structures.

Eiermann's breakthrough came with his pavilion for the World Exposition in Brussels in 1958. Built under the direction of "economic miracle" minister Ludwig Erhard, the pavilion marked Germany's return to the modernism of the Barcelona Pavilion and was perceived more as a revival of Mies's aesthetic than as the aesthetic of Eiermann. Inside the pavilion, a continuous tradition was constructed representing the architecture of the postwar period as the "Weg des Neuen Bauens" (Path of the New Architecture), tracing its lineage from the Fagus-Werken of 1911, the Bauhaus building of 1926, the Weissenhofsiedlung of 1927, and the Barcelona Pavilion of 1929 to the Berlin Interbau of 1957.[5] The completion of the Seagram Building in New York in 1958, the same year as the exposition, confirmed the international reputation of the final director of the Bauhaus.[6]

Mies's competition entry for the National Theater in Mannheim—a private, not a state initiative—signaled a commitment to the avant-garde of architects in exile and thus failed in 1953 as a political symbol. Yet the design itself, too, was an as yet inhospitable symbol of the "American way of life,"[7] characterized by the curtain-wall façade of SOM's 1952 Lever House in New York. At the

same time, a new and different manifestation of postwar modernism was appearing on the European continent with Le Corbusier's 1953 Unité d'Habitation in Marseille, supported by a much more developed anti-Fascist public than in Germany.

■ RUDOLF SCHWARZ: AN AESTHETIC OF RUINS AND THE BAROQUE

The Bauhaus debate of 1953 scarcely went beyond public statements for or against the Bauhaus, and in fact failed as a discussion. It occurred at a juncture when conservative modernism was looking back at its own notions from the thirties, at fruitless offers of alliance and attempts at collaboration after 1933. Now once again, conservative modernism failed in its attempt to solidify its claim to leadership as a modernism of the middle. For indeed, in his Bauhaus polemic Schwarz hardly succeeded in clarifying his own ideas about architecture, though he did gain considerable attention for his horror of skyscrapers and collective housing as well as his contempt for the Bauhaus's experimental, radically leftist practices—in other words, his rejection of any kind of avant-garde.

Schwarz's polemic seems like a repetition of the arguments that Alfons Leitl, editor in chief of the journal Baukunst und Werkform and involuntary initiator of the Bauhaus debate, had used in 1936 as editor of Bauwelt. At that time, Leitl had sought an understanding with the opponents of the Bauhaus[8] in order to make continued public activity possible for at least the moderate modernists of the Poelzig school, including Eiermann and Schwarz but also Hermann Henselmann. Now, in

1953, the fact that Schwarz, unlike Eiermann, had once attempted to recommend himself to the new leaders with his critique of the architectural currents of the Weimar Republic came back to haunt him.

Three years after its closing, Leitl had rejected the Bauhaus as a stylistically determinative architectural direction, yet he still defended it as a school of applied arts, as a laboratory for the "creation of models for useful objects." Under the aegis of the Catholic Center Party, he wanted to see the creation of a new style in architecture. What he had in mind was an alliance between Paul Bonatz, Konstanty Gutschow, and Julius Schulte-Frohlinde on the one hand—architects who ascended to key positions in Albert Speer's expanding architectural operations after the Summer Olympics of 1936—and the moderate modernists around Otto Bartning, Otto Erich Schweizer, and Schwarz on the other. These moderates, who emerged largely unscathed from the catastrophe, were the architects of the first hour who could point to a shared, ostensibly unbroken development and who now, with their modernism of the middle, wanted to form the center of reconstruction efforts. They were the ones who supported Alfons Leitl as editor-in-chief of B a u k u n s t u n d W e r k f o r m , although the influential Hans Schwippert soon distanced himself from his model Schwarz.

Schwarz had never been uncomfortable with an aesthetic of cubes; indeed, his Soziale Frauenschule of 1930 in Aachen and his home for a physician in Offenbach in 1934 had been based on such an aesthetic, oriented more to Heinrich Tessenow than to his teacher Hans Poelzig or even to Mies.[9] As early as in the thirties,

Schwarz's denunciation of "technicism" was a response to the admiration expressed by people like Ernst Neufert, construction manager of the Bauhaus building in Dessau, for the architectural firm Holabird & Root's 1930 A. O. Smith Company Research and Engineering Building in Milwaukee: a building constructed "entirely of metal."[10] But Schwarz's Bauhaus polemic of 1953 could not gain support, because it was too obviously directed at political power constellations and was thus too closely associated with polemics that by this time were seventeen years old.

None of Schwarz's new themes related to reconstruction—whether regarding urban structure or architectural aesthetics—were addressed in the Bauhaus debate. But he had good reason for rejecting his rival Eiermann, who may be considered one of the unnamed targets of his Bauhaus polemic of 1953. For Eiermann conceived of architecture as a rational technique. In this view, a design did not originate from perspectival interior spaces, but was constructed on the basis of grids; as in plant construction, a finished building consisted of an assembled and disassembled steel skeleton. Since, unlike Schwarz, Eiermann had shed no tears over the destruction of the old cities, neither could he mourn the temporary existence of his Brussels pavilion, a masterpiece of steel disassembled at the end of the exhibition.

The oval in the ground plan of the church of St. Michael in Frankfurt am Main in 1954, one of Schwarz's first important buildings after the war, marked a change in his relationship to the "Vitalists," though Scharoun was never mentioned. Following completion of the Festhaus Gürzenich in Cologne in 1955—the same year as Le Corbusier's

Notre Dame du Haut in Ronchamp and Max Bill's building for the Hochschule für Gestaltung in Ulm—Schwarz once again attempted to revive the discussion of 1953, making reference to Le Corbusier. The sinuous curves in the monumental staircase of the building in Cologne, which also integrates the ruins of Gürzenich and St. Alban, shows certain parallels to the postwar style of Le Corbusier; it also includes a pacifist statement with its replica of the sculpture G r i e v i n g P a r e n t s by Käthe Kollwitz, in whose realization the young Joseph Beuys participated.

In an important lecture of 1958, Schwarz professed adherence not only to Classicism in the tradition of Mies— "an entire vegetation of cubic buildings has arisen, becoming almost the trademark of the new city"—but also to the Baroque in the tradition of Poelzig. Above all, however, he spoke out against a landscape of "monocultures."[11] The fact that Schwarz's views had so little effect was due not only to the merely local impact of German postwar architecture; it was also because Le Corbusier succeeded in representing his new formal language as the result of a development within modernism, while in his relationship to modernism Schwarz never escaped the suspicion of betrayal.

■ THE HOCHSCHULE FÜR GESTALTUNG IN ULM: WHERE THE BAUHAUS WOULD HAVE BEEN IN 1950

In 1953, in the wake of Schwarz's Bauhaus polemic and the choice of a banal solution for the new theater in Mannheim, a number of other events occurred that were equally determinative for the development of modernism

in the West. One of them was the CIAM Congress in Marseille in July, attended by young West German architects including Hardt-Waltherr Hämer, Ludwig Leo, and Oswald Mathias Ungers. Around the same time, in August 1953, the first course began at the newly founded Hochschule für Gestaltung (HfG) in Ulm, led by Walter Peterhans, a colleague of Mies from Chicago. And in April 1953, around 100,000 visitors had already seen the exhibition S c h ö n h e i t d e r T e c h n i k — d i e g u t e I n d u s t r i e f o r m (The Beauty of Technology—Good Industrial Form) in Stuttgart, organized by Herbert Hirche.[12] The HfG Ulm, which moved into a new building designed by Max Bill on the Kuhberg in October 1955, is generally viewed as the continuation of the Bauhaus in the new Federal Republic of Germany. But while its contributions to design—that is, to product design and visual communication—have been extensively published, its role in the architectural discussion of postwar Germany has received little attention. Mies had visited the construction site in Ulm in July 1953 on his trip through West Germany during the competition for the National Theater in Mannheim; he was accompanied by Hugo Häring, with whom he had shared a studio in Berlin. The HfG Ulm can be credited with a key role in the reception of modernism after the war, and it was understood that way by Bill, too: "my idea was to carry on from the place where, in a normal development, the bauhaus would have been in 1950."[13] Mies's influence in Ulm was indirect, but vastly more effective than that of Gropius, who was invited to the opening of the building in 1955. It was because of Mies that Konrad Wachsmann from the Illinois Institute of Technology (IIT) in Chicago came to Ulm in 1955 and,

in the academic year 1956–57, took over from Bill as head of the department of architecture, which then came to be called the department of building.

Bill, director of the HfG Ulm, had begun his studies at the Dessau Bauhaus in 1928, immediately after Gropius had left and Hannes Meyer had become his successor; by the time Mies took over as director, Bill had left the school again.[14] In contrast to the Dessau Bauhaus, at the HfG Ulm architecture was no longer conceived as a "Gesamtkunstwerk" toward which all other activity was directed. While still in Dessau, Gropius had declared architecture to be the goal of all art; his building of 1925–26 was a colored sculpture, with all of the workshops behind the curtain wall of the "aquarium" centered around the area of architecture. Even the new idea of "industrial design" was related above all to building, to the construction of row houses in Törten or the production of steel houses with the fabrication techniques of a strongbox manufacturer.

In Ulm, architecture had apparently lost this leading role—even with regard to the spatial arrangement of the new building on the Kuhberg. Otl Aicher's department of visual communication in the right half of the great hall and Bill's department of product design in the left half shared the largest area of the building. At first, Bill functioned not only as the school's rector, but also as head of the department of product design and head of the department of architecture, which was located in a narrow strip adjacent to the laboratory for product design. The building of the HfG Ulm is not a sculpture accentuated with color like the Dessau Bauhaus, but a structure that emphasizes its edges and corners with the colors of con-

crete and wood. Clearly, after 1950 Bill was following a tradition different from the one prescribed by the architecture of Gropius or Mies. The only pictures in the building are the black-and-white photographs of the murdered Hans and Sophie Scholl in the rector's conference room. Incidentally, Eiermann's claim to architectural leadership beginning in the late fifties was not shaken by the construction of the HfG Ulm, nor even relativized, but rather strengthened. When Wachsmann took over from Bill as head of the department of architecture in 1956–57, he continued to cultivate the contacts he had made while in Chicago in the early fifties. For Wachsmann, Eiermann in Karlsruhe was the dialogue partner with the strongest conceptual affinity. Herbert Ohl, at first Wachsmann's assistant and then his successor in Ulm after the latter's abrupt departure in the winter of 1957, had received his diploma under Eiermann.

In the early fifties, Bill's intent for his building in Ulm was that it serve as a "prototype" for reconstruction. In its finished form of 1955, however, the references implicit in the HfG Ulm were nearly impossible to decode. Its architecture has nothing of the transparency of Mies's glass buildings, to which Eiermann made reference; nor is it related to Schwarz's aesthetic of ruins, though Aicher had initially proposed the construction of a glass tower on the fortification wall of the Kuhberg as a pacifist gesture.

■ THE BUILDING IN ULM: PROTOTYPE OF AN ILLEGITIMATE TRADITION
In its entirety, the building in Ulm bears witness to a different attitude toward technology, which in fact makes it

something other than a manifesto of the most advanced state of building technology, as one might have expected from architecture in the tradition of Gropius and Mies. Instead, it constitutes an aesthetic expression of local resources, production methods, and building materials, be they ever so humble or meager. The rudimentary materiality continues on the interior with the well-known wooden stools designed by Bill. The latter are a veritable paraphrase of Marcel Breuer's stool/tea table of chrome-plated tubular steel, which served as the universal furniture of the Dessau Bauhaus and symbolized its allegiance to industrial aesthetics.

Bill's conspicuous silence with respect to Hannes Meyer—whom he had met during his studies in Dessau in 1928 and who, like himself, was from Switzerland—is in itself a telling omission. For a number of reasons, the influence of this Bauhaus teacher—plain to see in Bill's own architecture—could hardly be admitted, nor was it perceived by his contemporaries. In his rejoinder to Schwarz in 1953, Gropius had firmly maintained his distance from Meyer as a Communist anti-aesthete; the latter's substitution of "function" for "composition" in the manifestos of the twenties was still reverberating. In an absurdity of political prejudice, however, the clichés about Meyer that persist to this day are in fact the opposite of what his architecture actually was. In his time, he was no propagandist of industrial building like Ernst May or Gropius; at the first congress of the CIAM in La Sarraz in 1928, he spoke out against the fetishization of the flat roof and reinforced concrete by Le Corbusier, who was present, and advocated the use of wood and local

materials. Since in his view a building emerged from local resources, it acquired an originality that belonged to a work of art and was not amenable to industrial mass production.

Bill referred to the complex of the HfG Ulm as a "conglomerate."[15] This kind of arrangement, which is difficult to comprehend in terms of visual axes, since the complex is almost entirely lacking in symmetry, is the clearest borrowing from Meyer's architectural ideas. At the competition for the Bundesschule des Allgemeinen Deutschen Gewerkschaftsbundes in Bernau in late 1928, the jury—including such prominent members as Adolf Behne, Heinrich Tessenow, and Martin Wagner—had been swayed by Meyer's project, because his design broke out of a rectangular composition and followed the modulation of the topography. It was a revolutionary step that fundamentally distinguished Meyer's entry from the other solutions, including those of Max Taut or Erich Mendelsohn, and it was this approach that Bill repeated in Ulm.[16]

In so doing, Bill introduced a new theme into the architecture of postwar modernism. After Mies's emphasis on transparency and universal space, the new theme was: building as grid and skeleton. What gives the HfG complex its coherence is the unified effect of the exterior of the cubes, which in fact seem not to be transparent, but monolithic. On the interior, however, the cubes dissolve into a skeleton structure that establishes an additional theme: spatial grid and flexibility. "I have realized that often, things that are too differentiated and too specialized are not useful for life," wrote Bill, explaining his design in a letter; "therefore, as much flexibility as pos-

sible."[17] Construction manager Fred Hochstrasser described the structural, and at the same time sculptural and functional basis of the building in idealistic terms as a cube based on a reinforced concrete skeleton of modular cubes three meters to a side.[18] Bill, in turn, described it as a "neuter with aesthetic ambition." The building has more to do with Auguste Perret than with Le Corbusier; the grid becomes a honeycomb sculpture—functionally neutral, not neutral in terms of expression, but rather symbolic.

The reinforced concrete skeleton formulates a theme that was integral to Bill's art as well. It goes beyond a mere system technique for the prefabrication of frameworks, because it is a theme for sculpture as well as for architecture: a regular grid expanding outward in space. The open cube is a structure with latent functional flexibility, and in the Ulm building it also serves as the symbol for a radically democratic program. It is sculpturally succinct and expressive. "Art is neither ersatz nature, nor ersatz individuality, nor ersatz spontaneity," Bill would write later. Rather, "Art = Order."[19]

The "crisis of rationalism" identified by James Stirling in 1956 begins when this framework is no longer seen as a sculpture, as a symbolic, abstract expression of the building, but rather is conceived as a purely technological system of prefabrication—to which, in Ulm, Le Corbusier's scarcely repeatable singularity in Ronchamp was viewed as radically opposed. System instead of space—that was Wachsmann's programmatic principle, toward which Eiermann also tended and in which both architects claimed a relation to the spirit of Mies's grids.

■ THE CRISIS OF RATIONALISM: ULM AND THE SCHISM OF MODERNISM

The polemic against Ronchamp and the artist Le Corbusier was a basic, informal understanding that characterized the architecture department at the HfG Ulm. This attitude was not the result of Bill's minimalism, but rather was derived from Wachsmann's conception of modern architecture as a supra-individual, scientific method. There must have been substantial disagreements behind the "irreconcilable differences of opinion" that caused Bill to resign as a member of the rectors' college of the HfG in May 1957.

Ulm had arrived at a schism of modernism. It was a schism that Stirling, writing in 1956, still viewed simply as a difference between two cultures, between the United States and Europe. As he stated at the time: "With the simultaneous appearance of Lever House in New York and the Unité in Marseilles, it had become obvious that the stylistic schism between Europe and the New World had entered a decisive phase. The issue of art or technology had divided the ideological basis of the modern movement, and the diverging styles apparent since Constructivism probably have their origin in the attempt to fuse Art Nouveau and late-nineteenth-century engineering. In the U.S.A., functionalism now means the adaptation to building of industrial processes and products, but in Europe it remains the essentially humanist method of designing to a specific use."[20]

With Wachsmann's appointment in 1957, an architect of classical modernism assumed leadership of the department of architecture. He represented a new kind of engineer-architect; his design for a hangar with an enormous

142

space frame of prefabricated parts, developed during his time at the IIT in Chicago, had appeared in the German press since 1953. Wachsmann supplanted his predecessor Bill in terms of policy as well. While he had not been a student at the Bauhaus, since his emigration he had been close to Gropius and above all to Mies. In 1951, he had awarded Mies an honorary doctorate from the University of Karlsruhe on behalf of Eiermann. In 1942, he and Gropius had developed the "packaged house system," a prefabricated dwelling with numerous variations and combinations intended for use in connection with new housing developments in the United States after the war.[21] At the HfG, Wachsmann wanted to establish a project workshop for developing prototypes for industrial building; he even brought with him a contract for the development of a façade element.

In 1958, the magazine M a g n u m published an extensive report on Wachsmann and his architectural innovations: "A house is dismantled into absolutely uniform, standardized parts, which then can quickly be assembled. This innovation, the most important in the new architecture, makes it possible to industrialize housing construction. Nowadays, everything from toothbrushes to cinema entertainment is industrially manufactured in order to satisfy the demands of masses of consumers." Regarding the word prefabrication: "most people, and even most architects, have a horror [of it]. Standardization, for them, means the extinguishing of individual action … . There is no 'design,' no 'brilliant idea,' but instead a flexible process of construction, open to all sides at all times."[22] Wachsmann insisted that the students be present on an ongoing basis, as in a development office, which caused

resentment among those who wanted to attend other academic programs at the HfG as well. Thus a catastrophe was precipitated that no one could have predicted: after the summer holidays of the 1957–58 school year, Wachsmann did not return. From one day to the next, the HfG Ulm was without a conceptual architect, a rupture from which the department of building never recovered. The young Frei Otto had only a short intermezzo, for his ideas on self-construction within a prefabricated framework were fundamentally different from the notion of the industrial mass production of modules prevalent in Ulm. Even a visit by R. Buckminster Fuller in 1958 was not enough to exert a lasting effect. The architect and designer Ferdinand Kramer, who like Theodor W. Adorno and Max Horkheimer before him had returned from America to Frankfurt am Main in 1952, refused an appointment to the HfG Ulm, choosing instead to remain director of the architectural office of the Goethe Universität in Frankfurt am Main.[23]

Although in the area of product design, the HfG Ulm showed direct continuity with the "industrial design" of the Dessau Bauhaus, in its architecture it remained without such a connection. But perhaps it was that very thing that established a continuity between the Bauhaus and the HfG Ulm: the tension within rationalism that became apparent as early as in the twenties, between expression and space on the one hand, and system and prefabrication on the other. It is this that helps explain, in postwar architecture, the revolution of Le Corbusier—Gropius's most important dialogue partner in the twenties—as well as Wachsmann's radicalization in the shadow of Mies.

■ PROSPECTS: SPACE CITY AND LABYRINTH

Wachsmann's programmatic premises continued to have an effect in Ulm even after his departure. Due to the conceptual one-sidedness of his successors, all programmatic critique of the artists of the "Imaginist Bauhaus" of 1957–58 was systematically passed over, though the latter had sought dialogue with Ulm and were equally entitled to engage in a reinterpretation of the Bauhaus. As a result, the critique of functionalism long stood in the shadow of a school that laid exclusive claim to the Bauhaus succession and thus paradoxically delayed the effect of a sociologically grounded critique of functionalism until the nineties.[24]

Asger Jorn and Constant Nieuwenhuys, however, were only calling attention to that part of the Bauhaus inheritance that had been suppressed by Eiermann's pathos and Wachsmann's methodology: expression in art as the prerogative of everyone, and space as sculpture and a social sphere—and thus also as an urbanistic problem not solved by the new large-scale housing developments in France and elsewhere. Formally, Jorn and Constant showed an affinity to Le Corbusier's ideas, while thematically they corresponded with the ideas of Schwarz. The latter certainly occurred involuntarily and without their knowledge, for they would probably have viewed Schwarz's pompous language with as much suspicion as his goal of anchoring neighborhood communities within small areas of circulation. Also alien to Jorn and Constant would have been the detailed sculptural craftsmanship of Ewald Mataré, a member of Schwarz's circle in Cologne—

an unease, incidentally, they would have been able to share with Joseph Beuys.

For young architects like Paul Schneider-Esleben, Schwarz was the first architect after 1945 to call attention to the achievements of prewar modernism. He was also the only prominent architect who—though mocked for it by Eiermann in the Darmstadt discussion "Mensch und Raum" (Man and Space) of 1951[25]—mourned the disappearance of the old, highly differentiated cities. His aesthetic of ruins, however, was not a makeshift solution, but an aesthetic strategy at a time when Eiermann was grinding up the eloquent physical evidence of destruction to serve as a concrete additive for the St. Matthäus church in Pforzheim in 1951. Though for reasons other than those of the Situationists to come, Schwarz's concern was likewise the lost labyrinths of the city.

1 Rudolf Schwarz, "Bilde Künstler, rede nicht: Eine weitere Betrachtung zum Thema 'Bauen und Schreiben,'" Baukunst und Werkform 1 (1953), pp. 10–17.
2 Thilo Hilpert, Mies van der Rohe im Nachkriegsdeutschland: Das Theaterprojekt Mannheim 1953 (Leipzig, 2001).
3 Michael Foedrowitz, Die Flaktürme in Berlin, Hamburg und Wien 1940–1950 (Wölfersheim-Berstadt, 1996).
4 Ulrich Conrads et al., eds., Die Bauhaus-Debatte 1953: Dokumente einer verdrängten Kontroverse, Bauwelt Fundamente, vol. 100 (Braunschweig and Wiesbaden, 1994).
5 Generalkommissar der Bundesrepublik Deutschland, ed., Weltausstellung Brüssel 1958, n.p., n.d. (p. 52.)
6 "L'OEuvre de Mies van der Rohe," L'Architecture d'aujourd'hui 79 (1958), pp. 1ff.
7 Cf. Françoise Sagan, Bonjour New York: Aufwachen an den schönsten Orten der Welt (Munich, 2008). The book was first published in 1956.

8 Alfons Leitl, Von der Architektur zum Bauen (Berlin, 1936), pp. 30f.

9 Alfons Leitl, "Das Haus eines Arztes: Architekt Rudolf Schwarz, Köln," Bauwelt 52 (1934), pp. 1–8.

10 Hans Josef Zechlin, "Helle Arbeitsräume: Ein Bürohaus in Nordamerika," Bauwelt 5 (1935), insert pp. 5–8, here p. 6.

11 Rudolf Schwarz, "Die Baukunst der Gegenwart: Vortrag zur Immatrikulationsfeier der Staatlichen Kunstakademie Düsseldorf am 14. Februar 1958," in Land Nordrhein-Westfalen, ed., Staat und Kunst: Festschrift zur 10. Verleihung des Grossen Kunstpreises (Krefeld, 1962), pp. 130–170, here pp. 131, 153.

12 Schönheit der Technik: Gedanken und Bilder zu einer Ausstellung des Landesgewerbeamtes Baden-Württemberg; Künstlerische Gestaltung Herbert Hirche (Stuttgart, 1953).

13 Max Bill, "Vom Bauhaus nach Ulm," Du, Europäische Kunstzeitschrift 6 (1976), pp. 12ff., 18.

14 Max Bill: Œuvres 1928–1969, exh. cat. Centre National d'Art Contemporain (Paris, 1969).

15 Max Bill in a letter to Walter Gropius, June 12, 1950.

16 "Bundesschule des Allgemeinen Gewerkschafts-bundes in Berlin-Bernau," Bau-Wettbewerbe 33 (1928).

17 Max Bill in a letter to Inge Scholl, July 6, 1950, cited in Marcela Quijano, ed., HfG Ulm: Programm wird Bau; Die Gebäude Hochschule für Gestaltung Ulm (Stuttgart, 1998), p. 25.

18 Fred Hochstrasser, cited in Martin Krampen and Günther Hörmann, Die Hochschule für Gestaltung Ulm—Anfänge eines Projektes der unnachgiebigen Moderne (Berlin, 2003), p. 70.

19 Max Bill, "Struktur als Kunst? Kunst als Struktur?," in Gyorgy Kepes, ed., Struktur in Kunst und Wissenschaft (Brussels, 1967), p. 150.

20 James Stirling, "Ronchamp: Le Corbusier's Chapel and the Crisis of Rationalism," The Architectural Review 3 (1956), pp. 155–161, here p. 155.

21 Cf. Walter Gropius, Rebuilding Our Communities: A Lecture Held in Chicago, February 23rd 1945 (Chicago, 1945), pp. 35–43.

22 Alfred Schmeller, "Schönheit aus der Maschine, Magnum," Die Zeitschrift für das moderne Leben 16 (1958), pp. 54–55, 59–60, here pp. 59, 55.

147

23 Cf. Thilo Hilpert, Hochhaus der Philosophen, Ferdinand Kramers Philosophisches Seminar, Frankfurt 1961, Gebäude und Möbel, Dokumentation vor dem Abriss, with DVD (Wiesbaden, 2006).

24 Thilo Hilpert, "Die postfordistische Stadt: Suche nach einer Gestaltkultur der offenen Form," in Stiftung Bauhaus Dessau, ed., Zukunft aus Amerika: Fordismus in der Zwischenkriegszeit (Dessau, 1995), pp. 135f. Thilo Hilpert, "Die Last des Konstruktiven," in Karin Wilhelm, ed., Kunst als Revolte? Von der Fähigkeit der Künste, Nein zu sagen (Giessen, 1996), pp. 161–175.

25 See the contribution by Egon Eiermann in Otto Bartning, ed., Mensch und Raum: Darmstädter Gespräch (Darmstadt, 1952), pp. 136–139, here p. 136.

This essay is dedicated to my friend Claude Schnaidt (1931–2007).

150

HONORING THE DEAD FATHER?
THE SITUATIONISTS AS HEIRS
TO THE BAUHAUS
Jörn Etzold

■ 1

In his 1933 essay "Erfahrungsarmut" (Poverty of Experience),[1] Walter Benjamin implicitly defines modernity as a break in experience between the generations. According to Benjamin, it is a condition in which the living are left entirely to themselves. For him, the living were those who had grown up in the trenches of World War I: "A generation that had gone to school in horse-drawn streetcars now stood in the open air, amid a landscape in which nothing was the same except the clouds and, at its center, in a force field of destructive torrents and explosions, the tiny, fragile human body."[2] Here there is nothing more to experience, because there is nothing more to understand and because nothing can be said about what has been experienced. The mortal creature is alone and has been abandoned by God; only the clouds, the old allegory of transience and impermanence, remain the same.[3]

According to Benjamin, modernity defined in this way brings with it a break between the generations—at first, between the young and the old: "[W]ho will even attempt to deal with young people by giving them the benefit of their experience?"[4] Yet even more radical is the break between the living and the dead. For the moderns, the dead have nothing left to say that is of any use; they have nothing more to bequeath. Human experience—the carryover and inheritance of a knowledge of the right way of

life spanning generations—ceases. "[O]ur poverty of experience is not merely poverty on the personal level, but poverty of human experience in general. Hence, a new kind of barbarism."[5]

The moderns are barbarians. As Benjamin writes in his book Ursprung des deutschen Trauerspiels (The Origin of German Tragic Drama), they inhabit an "empty world."[6] In that text, however, Benjamin locates the beginning of modernity elsewhere: the empty world appears as early as in Martin Luther's doctrine of justification, which severs the ritualized connections between the now and the hereafter in its rejection of good works. But even Luther saw himself less as an innovator than as a reformer who was once again uncovering the biblical sources. So where does modernity begin? Is it always merely the actualization of a fundamental disinheritance latent in the fabric of European history—latent in the "cornerstone" on which we, in light of our "Christian inheritance," are to build the "house of Europe"?

The sharpest break with any notion of inheritance already occurs in the New Testament. In the Gospel of Matthew we read: "And another of the disciples said to Him, 'Lord, permit me first to go and bury my father.' But Jesus said to him, 'Follow Me; and allow the dead to bury their own dead.'"[7] The one who follows into the open is not permitted to bury his father; the ritual action that secures the continuity of the inheritance in patriarchal societies may not be performed. By not burying his father, the one living says he has nothing to learn from the dead. Nor will he any longer have a home: "The foxes have holes, and the birds of the air have nests; but the Son of Man has nowhere to lay His head."[8] The line of succession of

many generations is overthrown by the one generation of contemporaries, by the "disciples." The father's body, however, is left out in the open and is there given over to decay. Perhaps every millenarian, every revolutionary, every avant-gardist, perhaps every generation is an actualization of these fatherless disciples. Perhaps in this way we can approach the paradox by which all explicit forms of contemporaneity are—in their gestures of new beginning—strangely similar to each other and always purport to be timeless. Perhaps the Bauhaus is one of the best examples of this very thing.

Benjamin, in any case, affords a special place to the Bauhaus; in "Erfahrungsarmut" he identifies it as an attempt, in the absence of experience and inheritance, to "[begin] anew and with few resources."[9] This observation seems justified. In 1919 Walter Gropius was seeking to found "a new guild of craftsmen"; yet the knowledge needed by this guild in order to create "the new building of the future," the "crystalline symbol of a new and coming faith,"[10] no longer had much in common with traditional craftsmen's skills. The very elements of craftsmanship included in the Bauhaus curriculum were aimed rather at a purely phenomenological encounter with the material, whose "correct" use was by no means established. For Benjamin, the Bauhaus created spaces in which experience was impossible. "This has now been achieved by Scheerbart, with his glass, and by the Bauhaus, with its steel. They have created rooms in which it is hard to leave traces."[11] To leave no traces also means to put down no roots, to possess neither hole nor nest, to neither bequeath nor inherit—hence the industrial materials of the Bauhaus, the austere form of its

objects and buildings, and the idea of the model, intended to replace the individual and thus affirm his poverty. In the end, the Bauhaus actualizes what Benjamin described in his fragmentary text "Kapitalismus als Religion" (Capitalism as Religion) as "vagrant, beggarly monasticism,"[12] and which perhaps has a kernel that is very old.

■ 2
What is the inheritance of the Bauhaus, and how is it possible to inherit from a Bauhaus that, as Benjamin understood it, was itself a way of coming to terms with the absence of experience and inheritance? Presumably this is only the newest rendition of an old European question; for perhaps Europe has always been torn between the inheritance and its repeatedly heralded renunciation. In the fifties, however, this question acquired particular relevance: in the wake of the devastation of World War II, artists, designers, and architects in various places attempted to follow in the footsteps of Bauhaus modernism, but in different ways.

Here I will limit myself to the struggle for succession between two adversarial brothers or brotherhoods: Max Bill and Asger Jorn. On the one hand, there was the Hochschule für Gestaltung (HfG) in Ulm, whose founding was definitively shaped by Bill; on the other, there was the Imaginary and later Imaginist Bauhaus of Jorn, which finally merged with the Situationist International founded in 1957. Later, proceeding above all from the theories of Guy Debord and the plans of Constant, the Situationist International would be intensively concerned with building, with architectural visions. My interest, however, is less in these artists' works than in the differing

ways in which they sought to reclaim the inheritance of the Bauhaus—efforts that reveal the generations' differing political positions and a differing understanding of modernity.[13]

The arena of this struggle for succession was western Europe of the postwar period. In Germany, Inge Scholl (sister of Hans and Sophie Scholl, murdered by the Nazis), her husband Otl Aicher, and the writer Hans Werner Richter were planning the expansion of their Volkshochschule in Ulm. Founded in 1946, this institute for continuing education was intended to convey "democratic values" to the German people and thus enjoyed the support of the American administration. The Bauhaus was the point of reference for the project: since the Bauhaus had been shut down by the Nazis, in the postwar period it was associated (despite its political heterogeneity) with the entombed democratic values of the Weimar Republic, now to be resuscitated with American support. As Scholl, Aicher, and Richter looked for ways to expand the Volkshochschule in Ulm, Swiss architect and former Bauhaus student Max Bill appeared on the scene, offering to help with the creation of a new institution. Although the instruction Scholl and Aicher had envisioned was primarily political, Bill's plan was for an academy of design.

The initial agenda, therefore, was to restore a continuity that had been interrupted by National Socialism. In his approach to design, Bill was clearly influenced by the austere aesthetic of the old Dessau Bauhaus; through the founding of a new Bauhaus in Ulm, modernism was to be restored as an ongoing narrative. It was to be associated with the "traditions" of modernism—that is, with

traditions that had nothing to do with tradition—and the guarantor of this tradition of traditionlessness was to be the father: Walter Gropius. In America, Bill prevailed upon Gropius to take on sponsorship of the new project; Bill also used Gropius to position himself with respect to Scholl and Aicher as the favorite son and therewith the legitimate father of the new child. He managed to procure Gropius as guest speaker for the opening of the school, where the latter announced that in Ulm, "the basic idea of the Bauhaus and the work begun there ... has found a new German home and its organic continuation."[14] The point was to emphasize continuity following an interruption of the work. Bill, the legitimate son, received the father's blessing for his own child, which he established on German soil, so that he could later write to Gropius that the latter was the "grandfather of this school."[15] Bill, however, soon left the institution in the wake of internal conflicts and was abandoned by Gropius as well.

Historical distance dictates that we not disparage the new West German republic's need for lines of tradition to the Weimar Republic and contact with its important figures. But it is also clear that these endeavors were accompanied by a variety of cover-up tactics that essentially amounted to allowing Nazism to appear as an accident. This posture contributed to the fact that the question of the actual nature of National Socialism long remained clouded by unclear concepts and ideas. This is the place neither to pursue this question, nor to ask what it meant that National Socialism was able to emerge from the Weimar democracy. Instead, in the following I will set a different accent and bring into play an obscure, placeless, and fatherless counter-effort to this restitution of

the Bauhaus inheritance. Observation of this development will once again raise the question of the legacy of the Bauhaus and that of modernity.

■ 3

The Danish painter Asger Jorn was one of the most energetic figures in the internationalization of the art scene in the fifties. As a founding member of the group CoBrA active in Copenhagen, Brussels, and Amsterdam, he was always on the lookout for allies. He had heard of Bill's plans and exchanged several letters with him; it quickly became clear, however, that there could be no agreement between the two. "Bauhaus is the name of an artistic inspiration," wrote Jorn to Bill. "Bauhaus is not the name of an artistic inspiration, but the designation for a movement that represents a very well-defined doctrine," wrote Bill to Jorn. "If Bauhaus is not the name of an artistic inspiration, then it is the designation of a doctrine without inspiration, and that means a dead inspiration," wrote Jorn to Bill.[16]

We see two sons in conflict over the inheritance. Bill—the legitimate son—argues in the name of the law, the father. Jorn—the illegitimate son who, unlike Bill, had not attended the Bauhaus—speaks in the name of inspiration, the spirit that blows where it will because it has no roots. The one wants to continue the tradition, give it a place, teach the doctrine, inherit from the father legitimately and with his blessing; the other wants to revive the inspiration for the fellowship of scattered brothers, so that the spirit will enter into them. Jorn quickly broke off contact, declared Bill his enemy—his enemy brother—and founded his own, competing organization, which he

at first wanted to call the Imaginary Bauhaus before coming to the conclusion that it was really Bill's plans that were imaginary. So in the end, he called his organization International Movement for an Imaginist Bauhaus (IMIB). In this way Jorn, too, reclaimed the inheritance of the Bauhaus for himself, but without the blessing of the father. In his nomenclature we hear above all the painter, unwilling to give up canvas and paint or indeed even figurativeness, thinking imaginistically in pictures and not, like Bill, formally and functionally. Nonetheless, soon after giving up its name, the IMIB would also become involved in constructing buildings—strange buildings, materializing the idea of a transient generation without parents or children. During a visit to his colleague Enrico Baj, inventor of the Nuclear Art Movement (Movimento Pittura Nucleare) and cofounder of the IMIB, Jorn came across a bizarre magazine. It originated in Paris and was named P o t l a t c h ; it was only given away, and referred to itself as the I n f o r m a t i o n B u l l e t i n o f t h e F r e n c h S e c t i o n o f t h e L e t t r i s t I n t e r - n a t i o n a l, an offshoot of the postwar avant-garde Lettrist group. Here Jorn appeared to have found allies for his project of illegitimate inheritance. He wrote to the editor André-Frank Conord; the answer, however, came from Michèle Bernstein and her husband, a certain Guy-Ernest Debord. In 1957 in the small Italian town of Cosio d'Arroscia, the Imaginist Bauhaus and the Lettrist International joined together to found a new group with greater impact. Only Debord's skill in negotiation kept the new group from continuing to be called International Movement for an Imaginist Bauhaus; instead, it received the name Situationist International.

Thus inscribed into the prehistory of the Situationist International—today better known for the Paris uprising of 1968 or Debord's media critique S o c i e t y o f t h e S p e c t a c l e —is a conflict over the inheritance of the Bauhaus. The conflict can be schematized in this way: whereas Bill's HfG in Ulm emphasized inheritance, doctrine, and continuity, Jorn and Debord's counter-effort was aimed above all at the intensification and consummation of disinheritance, as well as the affirmation of that absence of experience that Benjamin had identified as the impetus of modernity in the Bauhaus. "The Situationist International was founded above all on a very urgent sense of the emptiness of everyday life and the quest to overcome it,"[17] reads an article in the I n t e r n a t i o n a l S i t u a t i o n i s t journal in retrospect in 1961. This emptiness was exhibited in Debord's first film H o w l s f o r S a d e , which is imageless and shows alternating blank white and black screens accompanying abrupt, melancholy fragments of text. The point, however, was to pass through the emptiness to "constructed situations," conceived by the Situationists as moments in time that carried meaning within themselves as a sudden illumination, without reference to the past. Fathers were unwanted. Here Debord was concerned less about Gropius than about the father figure of the current French scene, Jean-Paul Sartre, whom he incessantly attacked. In the course of his life, other fathers as well were first admired by him and then rejected.[18]

But if the point is to construct situations rather than to create works of art, then an interest in architecture becomes inevitable. The Lettrist International had already shaped the urban practices and concepts that would later

inform the Situationist International. Ivan Chtcheglov's Formulary for a New Urbanism had been circulating in Lettrist bars since 1953, a text in which Chtcheglov calls for the construction of adventurous cities: "The hacienda must be built."[19] This work already includes the most important term in Lettrist urban theory: the nautical term dérive, which means not so much to wander as to drift. Dérives were the primary activity of the Lettrists and the Situationists: they consisted of allowing oneself to drift wide awake through the city, deviating from the customary paths and perceiving what the group described as the "psychogeographical relief" of the city—the interplay of people, sounds, smells, sudden breaks, and ruptures. The object was not an appropriation of urban space—as is often claimed in readings of the Situationists informed by Michel de Certeau's book The Practice of Everyday Life —as, first of all, a disappropriation; the city was to be perceived as a vast ocean by a stranger without a home.

Another term often used by the Lettrists points in the same direction: dépaysement, meaning disorientation, alienation, literally de-landing, disintegration of the soil and finally of the house. In the early days of both Lettrists and Situationists, a number of Arabs and Kabyles participated in the dérives. Their experience of the city was marked by the need to avoid the police, to make themselves invisible and go underground. Situationist International member Abdelhafid Khatib's 1958 attempt to give a "psychogeographical description" of the Halles district of Paris was published in Situationist International in unfinished form, since he was arrested twice during his nightly forays for violating the

curfew for North Africans.[20] The Situationists—even those who could move freely throughout Paris—wanted to feel like strangers in the city. It was a revolt of the sons against the father-city and father-land, and at the same time the actualization of a deeply modern experience for which the Hegel-Marx-Lukács term "alienation" is not really adequate, despite Debord's penchant for it. For this could not be a matter of the "abolition of alienation." What the dérives offered was instead the adventure, the strange sensation of discovering the alien in the midst of the familiar and losing oneself in it.

■ 4

What we find here is a generation of brothers once again issuing a challenge to the dead. In his Mémoires of 1959, collaged onto lithographs by Jorn, Debord quotes Marx's allusion to the gospel of Matthew in a letter to Arnold Ruge: "Let the dead bury their dead and mourn them. On the other hand, it is enviable to be the first to enter the new life alive; that is to be our lot."[21] In actual fact, the tone adopted toward the dead was even harsher: in order for the Lettrists, Imaginist Bauhaus, and Situationists to truly enter the new life alive, in the future the dead would not only bury themselves, but would also have to give up their current resting places. In an article entitled "Project for Rational Improvements to the City of Paris" published in Potlatch 23 in October 1955, Debord suggested: "Cemeteries should be eliminated. All corpses and memories of that sort should be totally destroyed: no ashes and no remains."[22] The bearing of children was forbidden as well; when Debord's friend Gil J. Wolman dared to defy this order, he was excluded

from the Lettrist International. In the short report published in P o t l a t c h under the heading P e n s i o n e d, Wolman was accused of "a ridiculous way of life, cruelly proven by thoughts that grow more moronic and narrowminded every day."[23] For as Hegel had already emphasized, the individual acquiesces to his own death the moment he reproduces himself. The Situationists were forbidden to inherit from a father; how much more to become fathers.

All those who are no longer living or not yet alive must be excluded from a generation without memory and without past, a generation continually seeking a new beginning in a foreign land that will never become home, always drifting from the right path that was never certain in the first place. The Situationists soon adopted the proletariat as a theoretical figure for this disinheritance—not as the working class, but as a class perfectly modern in its rootlessness, lack of property, and absence of qualities. As stated already in 1958 in the first issue of S i t u a t i o n i s t I n t e r n a t i o n a l: "The Situationists place themselves at the service of forgetting. The only force from which they can expect anything is the proletariat, theoretically without a past, which in Marx's words 'is revolutionary or it is nothing.'"[24]

A little later, when the Dutch painter Constant (an old acquaintance of Jorn from his CoBrA days) joined the Situationist International, this non-experience would be built. Constant had long been devoting himself to architectural utopias; in contact with Debord, he had been developing plans for a new city since 1956, which he initially referred to as the "covered city" and then as "New Babylon." The name alluded to the sins that would be

possible in this city as well as the irrevocable confusion and alienation from the "ancestral language" that it would accommodate. But it also referred to the city's structure, reminiscent of the hanging gardens of Semiramis, architectural patroness of Babylon. This New Babylon—the continuation of the Imaginist Bauhaus—was to hang in the air on giant pillars, between an empty, stubbed earth now used only for traffic and an equally empty sky. The city had distanced itself from the earth not only as a place of origin, but as a place of rest for the dead: the plan included no cemeteries.

The city was to generate itself in this way, altering its forms and structures in an endless and probably fairly stressful game, its entire atmosphere subject to continual change by professional Situationists. The potential for shock would wash the sons clean of the past: Constant's description of the "yellow zone" of the city states that "[a]n extended stay in these buildings has the tonic effect of a brainwashing and is frequently undertaken to erase any habits that might be formed."[25] The inhabitants would arrive at an absolute lack of experience, to moments of complete strangeness and presentness. At Documenta XI in Kassel in 2002, where Constant was honored with his own space, plans and maps were displayed next to the models of New Babylon. In some of them, parts of Europe were covered with a network of hanging cities, spreading over Amsterdam, Paris, or the English county of Middlesex—cities of the past, of which little more remained than the names alone, hovering godlike over the map.

By the early sixties, Constant had already left the Situationist International. He had been pressing for con-

crete application of his urbanistic plans, but Debord's interest was directed increasingly to world revolution. Yet it was at this very time that an experimental Situationist city almost came into being on a small Mediterranean island at the invitation of textile entrepreneur and patron Paolo Marinotti. The extremely expensive project finally foundered on the Situationists' demand for the "right to the destruction of the building ensemble."[26]

■ 5

I began with Benjamin's implicit definition of modernity as the break in experience and inheritance and his view of the Bauhaus as a way of coming to terms with this rupture. I have described how in western Europe of the postwar era, following the break introduced into the narrative of modernism by National Socialism, two different projects once again attempted to appropriate the inheritance of the Bauhaus, a legacy that itself consisted in the rejection of the inheritance. On the one hand there was Bill, the legitimate son with the blessing of the father; on the other were Jorn, Debord, and Constant as a pack of illegitimate sons who wanted to neither bury the father nor inherit from him. In the end, however, it was the work of these illegitimate sons that paved the way for the great shock of 1968, when the patched-together continuities of Europe disintegrated and a generation of sons closed ranks against their fathers in order to live life in the here and now.

Today these sons are themselves fathers, albeit unwillingly; Slavoj Žižek calls them "obscene fathers" who will not even give their sons the satisfaction of transgressing their commandments, because transgression is the only

thing they recommend. The Situationist cities, however, seem to have cropped up elsewhere: in shopping paradises and malls, on the islands the Emir of Dubai is building in the ocean off his coasts. He is piling up the earth there, causing the climate and atmosphere to be controlled by professional Situationists, and assembling an international community of nouveaux riches without history or memory, the successors of the Situationist proletariat. Before the major financial crisis, the extravagant settlement of Palm Jebel Ali in Dubai was projected to be the center of a city of 1.7 million as early as 2020. Around its edge, a poem by Muhammad bin Rashid Al Maktum, Sheikh of Dubai, would be written into the sea: "Take wisdom from the wise/It takes a man of vision to write on water/Not everyone who rides a horse is a jockey/Great men rise to greater challenges."[27]

"The names of shipwreckers are only writ in water,"[28] Debord called out after his friend Chtcheglov in 1978 in his film In girum imus nocte et consumimur igni. Chtcheglov, the inventor of Lettrist urban theory who spent his final days in a psychiatric clinic, died in 1998; Constant died in 2005. After his departure from the Situationist International, he still pursued New Babylon for a while; at some point he realized that life in his city would have been appalling. Jorn died in 1973. When Debord heard of his friend's death, he wrote once more: "Let the dead bury their dead and mourn them." He, however, did not allow himself to be buried. After his suicide in 1994, his second wife Alice Becker-Ho scattered his ashes in the Seine—making it clear that there was nothing to inherit from Debord: "It is Debord who will inherit from Debord. We will make sure of that."[29]

Perhaps it remains the greatest provocation of Europe to repeat the sentence a young man named Jesus spoke over two thousand years ago on the Sea of Gennesaret, words that have been repeated by Marx, Debord, and many others: "Let the dead bury their dead"—and begin anew, without the dead, here and now. Yet we should not forget that the fate of the man who said these words was that of the eternal Son. It may be that the Situationists, too, remained eternal sons, not wanting the blessing of the father but not allowing the brother to have it either. American architectural theorist Mark Wigley, at least, recently asserted that "New Babylon is imagined as a playground. The model for it is a children's playground."[30] He reasons that the implicit Stalinism of the model consists in the fact that it forever treats its inhabitants like children, children who are not supposed to grow up so that they will not resemble the father.

Perhaps we need not decide at all between the legitimate heir and the fatherless disciples. Maybe the wars of succession between the doctrine and the spirit can at some point cease, those struggles that only ever occur between brothers and whose goal is the purity of the inheritance— in Constant's case, the traceless forgetting of all fathers made possible by continual brainwashing. Maybe it is possible to inherit impurely not only from one father, but from many fathers, and from brothers as well, and even more so from mothers, daughters, friends, the dead, the living, the undead, animals, things, light, writing. Maybe then the exhausting epoch of "brotherliness" and the conflicts over inheritance—which the Situationists once again wanted to sell as a great innovation and a historical act in May 1968—would be over. Then we would no

longer have to keep starting from nothing, but simply from somewhere—from the Bauhaus, the situation, or beyond it.[31]

1 Walter Benjamin, "Erfahrung und Armut," in id., Walter Benjamin: Gesammelte Schriften, vol. II.1, ed. Rolf Tiedemann and Hermann Schweppenhäuser (Frankfurt am Main, 1989) pp. 213–219. Since the first printing of the Gesammelten Schriften, the text has borne the title "Erfahrung und Armut" (Experience and Poverty); Benjamin's typescript, however, was entitled "Erfahrungs-armut" (Poverty of Experience). Cf. the notes in: Walter Benjamin, "Experience and Poverty," in id., Walter Benjamin: Selected Writings, vol. 2, 1927–1934, ed. Michael W. Jennings et al., trans. Rodney Livingstone (Cambridge, MA, 1999), pp. 731–736.
2 Ibid., p. 732.
3 As early as 1920, these experiences caused Sigmund Freud to postulate a repetition compulsion and a death drive. Cf. Sigmund Freud, "Jenseits des Lustprinzips" (Beyond the Pleasure Principle), in id., Das Ich und das Es (Frankfurt am Main, 1998), pp. 193–249, esp. pp. 197f.
4 Benjamin 1999 (see note 1), p. 731.
5 Ibid., p. 732.
6 Walter Benjamin, "Ursprung des deutschen Trauerspiels," in id., Walter Benjamin: Gesammelte Schriften, vol. I.1, ed. Rolf Tiedemann and Hermann Schweppenhäuser (Frankfurt am Main, 1990), pp. 203–430, here p. 318. English translation: The Origin of German Tragic Drama (London, 1998), p. 139.
7 Matthew 8:21–22, New American Standard Bible (Nashville, 1977).
8 Matthew 8:20.
9 Benjamin 1999 (see note 1), p. 735.
10 Walter Gropius, "Programm des Staatlichen Bauhauses in Weimar," in Bauhaus Archiv and Magdalena Droste, eds., Bauhaus 1919–1933 (Cologne, 1993), p. 19. Also in Hans M. Wingler, ed., Das Bauhaus 1919–1933: Weimar Dessau Berlin und die Nachfolge in Chicago seit 1937 (Cologne, 2002), p. 39.

11 Benjamin 1999 (see note 1), pp. 734.

12 Walter Benjamin, "Kapitalismus als Religion," in id., W a l t e r B e n j a m i n : G e s a m m e l t e S c h r i f t e n , vol. VI, ed. Rolf Tiedemann and Hermann Schweppenhäuser (Frankfurt am Main, 1986), pp. 100–103, here p. 102.

13 For archival evidence I am drawing primarily from Roberto Ohrt, P h a n t o m A v a n t g a r d e : E i n e G e s c h i c h t e d e r S i t u a t i o n i s t i s c h e n I n t e r n a t i o n a l e u n d d e r m o d e r n e n K u n s t (Hamburg, 1990), as well as the dissertation by Claudia Heitmann, D i e B a u h a u s - R e z e p t i o n i n d e r B u n d e s r e p u b l i k D e u t s c h l a n d v o n 1 9 4 9 b i s 1 9 6 8 : E t a p p e n u n d I n s t i t u t i o n e n (Berlin, 2001), http://opus.kobv.de/ udk/volltexte/2003/1 and http://edocs.tu-berlin.de/diss_udk/2001/ heitmann_claudia.htm

14 Walter Gropius, F e s t r e d e z u r E i n w e i h u n g d e r H o c h - s c h u l e f ü r G e s t a l t u n g U l m 1 9 5 5 , cited in Heitmann 2001 (see note 13), p. 109.

15 Max Bill in a letter to Walter Gropius, May 22, 1957, cited in Heitmann 2001 (see note 13), p. 118.

16 Cited in Ohrt 1990 (see note 13), p. 140.

17 I n t e r n a t i o n a l e S i t u a t i o n n i s t e (Paris, 1997), p. 213.

18 Cf. Jean-Marie Apostolidès, L e s t o m b e a u x d e G u y D e b o r d : P r é c é d é d e P o r t r a i t d e G u y - E r n e s t e n j e u n e l i b e r t i n (Paris, 1999).

19 I n t e r n a t i o n a l e S i t u a t i o n n i s t e 1997 (see note 17), p. 15.

20 Cf. ibid., p. 50.

21 Ernest-Guy Debord, M é m o i r e s : S t r u c t u r e s p o r t a n t e s d ' A s g e r J o r n (Paris, 2004), n.p. The quote from the letter to Arnold Ruge, printed on one of the first pages, is found in Karl Marx, "Briefe aus den Deutsch-Französischen Jahrbüchern," in Karl Marx and Friedrich Engels, W e r k e , vol.1 (Berlin, 1976), pp. 337–346, here p. 338.

22 G u y D e b o r d p r é s e n t e P o t l a t c h 1 9 5 4 – 1 9 5 7 , (Paris, 1996), p. 205. English translation: http://www.cddc.vt.edu/sionline/ presitu/potlatch23.html#Anchor-Project-50557

23 Ibid., pp. 266f.

24 I n t e r n a t i o n a l e S i t u a t i o n n i s t e 1997 (see note 17), p. 8. English translation: http://www.cddc.vt.edu/sionline/si/struggle.html.

25 Ibid., p. 133.

26 The contract between Jorn and Marinotti is found in the marginalia in Guy Debord, C o r r e s p o n d a n c e , vol. 2 (Paris, 2001), p. 71.

27 Palm Islands, http://de.wikipedia.org/wiki/palm_islands.
28 Guy Debord, Œuvres cinématographiques complètes (Paris, 1994) p. 250; English translation: http://www.bopsecrets.org/SI/debord.films/ingirum.htm. In English, the title of the film could be rendered: We wander in circles in the night and are consumed by fire.
29 Cited in Apostolidès 1999 (see note 18), p. 156.
30 "Architectural Weaponry: An Interview with Mark Wigley," http://bldgblog.blogspot.com/2007/04/architectural-weaponry-interview-with.html
31 On the question of the impure inheritance, see the late work of Jacques Derrida, above all Specters of Marx: The State of the Debt, the Work of Mourning, and the New International, trans. Peggy Kamuf (New York, 1994).

This slightly modified essay originally appeared in Sonja Neef, ed., An Bord der Bauhaus: Zur Heimatlosigkeit der Moderne (Bielefeld, 2009), pp. 29–43.

I would like to thank Sonja Neef for her critical reading and suggestions.

der arm
die entspringenden punkten der muskeln sind
die punkten
de muskeln sind die verbindungen

THE BAUHAUS AND ULM
Otl Aicher

> "The Bauhaus has taken all sorts of paths in different countries, but upon entering this building, I sense that its most authentic roots will no doubt prosper here."
> Walter Gropius in a speech on the occasion of the opening of the Hochschule für Gestaltung Ulm (The Ulm School of Design) in 1955

when walter gropius offered back then to let us call the hochschule für gestaltung in ulm "bauhaus ulm," we refused.

today i'm almost a little surprised at that myself. in our present-day civilization, where packaging is often more important than content, cross-references, names, and relationships have a different weight. but for those of us who had just returned from the war and were helping to create a new school, the situation was different. so little substance remained—whether material, political, or cultural—that it was almost irrelevant to think in terms of relationships, borrowings, or reciprocities.

of course we, too, recognized the kind of cultural-political aura that a school named "bauhaus ulm" would have, but at the time the idea of "prestige" tended to have a negative connotation. we wanted to do what was right, without speculating as to public image or recognition.

and our intention was not to create a second bauhaus, a repetition. we wanted to distinguish ourselves from it, consciously.

174

to speak of "we" requires some differentiation, since at the time we were not in complete agreement as to fundamental principles, especially as regards the relationship between fine art and design. max bill's ideas were different from those of walter zeischegg, tomás maldonado, hans gugelot, or myself; admittedly, max bill didn't want a repetition either, but in many respects he did want a kind of new bauhaus. while we agreed that in contrast to the bauhaus, painting and sculpture would be consciously omitted from the curriculum in ulm, bill's plans for the new building still included artists' sudios and a workshop for gold- and silversmithing.

walter zeischegg and i had originally been active in the field of art, but had soon left the academies, he in vienna and i in munich. this break occurred for reasons of principle.

we had returned from the war and now, at the academy, were supposed to be working aesthetically for the sake of aesthetics. we couldn't do it anymore; anyone with eyes to see and ears to hear had to recognize that art was a flight from the many responsibilities that accrued to culture, as well, amid the ruins of the nazi regime.

we had to ask whether a culture and an art that ignored the true human problems of a postwar era had not in fact been unmasked; wasn't art in its entirety just an excuse to abandon reality to those who dominated it? wasn't art a bourgeois, sunday-afternoon cover-up aimed at maintaining control in everyday life? weren't those who did the most for art the very ones most interested in hegemony?

at the time, i couldn't answer these questions conclusively, but our interest had shifted completely to the

opposite pole. we were interested in the design of everyday life and the human environment, in industrial products, in the behavior of society. no longer would we agree that creativity should be classified according to objects: should purposeless, purely aesthetic things continue to be viewed as the highest form of human creativity, while things of practice and daily life were relegated to secondary importance—according to the principle of the superiority of the spiritual to the corporeal? today, such dualism is outdated as far as psychology, medicine, and philosophy are concerned, but we still value poetic words more than journalistic one, the aesthetic of museum objects more than that of the street. we still separate matter and spirit and need art to prove it.

in our opinion, what was needed was not to create more works of art, but rather to show that today, culture must take all of life as its object. we even thought we had discerned traditional culture's strategy of creating a distraction from the things of everyday life so that the latter could be commercially exploited. art was writ large by those who profited from the refuse; eternal values were proclaimed by those who didn't want their dirty work to be discovered. we wanted no part of this platonism. culture was to devote itself to reality.

we discovered the bauhaus, constructivism, and de stijl and found what we were looking for in the writings of malevich, tatlin, and moholy-nagy.

the shaping of the everyday, the truly real, design, had become the platform for all human creativity. and if someone was interested in squares, triangles, and circles, in colors and lines, then that was a reasonable aesthetic experiment, but nothing more. on the contrary, its value

had to be proven in its dealings with reality, however broken, filthy, and desolate that reality might be.

max bill was a survivor of the bauhaus, and to some extent he had salvaged in the swiss werkbund what had been forbidden and eradicated in germany and austria. for us, he was the authentic bauhaus that we had at first encountered only in books. but bill had a different frame of mind, too. we were all in agreement that design should develop its results from the object, but for bill, painting and sculpture still ranked above everything else, while we wanted to prevent design from once again being subsumed into applied art and borrowing its solutions from art. charles eames's chairs had appeared on the scene as convincing models of the unity of technology, functionality, and aesthetics. this was design arising from the task itself, design without formal borrowings from art. conversely, the constructivist chairs by rietveld turned out to be nothing more than mondrians for sitting, ineffectual art objects with the pretext of wanting to be useful.

for plato and even still for aristotle, the physical concealed the spiritual. the world would be ideal if matter did not exist; the spirit would be free if there were no body; love would be noble if there were no sexuality. this conception, the root of bourgeois culture, was so common at the time that hardly anyone could think the contrary— though the dada movement came closest with its introduction of the kitchen stool, urinal, bicycle wheel, and broomstick into the museum as a provocation.

the inverse held true as well: those who have nothing to say look for style; those who live from materialism venerate the spirit; those who do business support culture.

hugo ball was the initiator of the dada movement in zurich and gave lectures on kandinsky. but he was also the first to leave dada. negation of the bourgeois wasn't enough for him; accordingly, he condemned the bourgeois element in dada and its flight into spirit. in 1919 he devoted himself to an antithetical "philosophy of productive life": "respect and acceptance of one's neighbor, love of neighbor, can be succeeded by an order of things in which an enormous cultivation of productivity provides the basis for morality." in contrast to an art of pure spirit, he expounded a philosophy of the human design of concrete things, a kind of philosophy of design. he began to doubt the decorative curves of kandinsky.

for adolf loos as well, architecture no longer consisted of style and construction separated like body and soul, and karl kraus no longer divided language into content and form. form was a form of statement.

at that time in ulm we had to get back to the things, the products, the street, to everyday life, to human beings. we had to turn around. the objective was not to extend art into everyday life, to apply it. the objective was an anti-art, a work of civilization, a culture of civilization.

we discovered architecture above all in the building of factories, form in the construction of machines, design in the making of tools.

i met walter zeischegg when he visited the institut für grifforschung in the vicinity of ulm, looking for material to use for the exhibition h a n d u n d g r i f f in vienna.

i myself made posters. my basic principles were only confirmed when, shortly after leaving the academy, one of my posters was exhibited at the museum of modern art next to a picture by paul klee. i created for the street

like the others did for the museum. since i didn't sign any of my works—trying to divorce myself in that way, as well, from the practices of the art world—the poster in new york was labeled: artist unknown. that suited me too. just as others sought for a name and presented themselves in the market of appearances, i liked anonymity. craftsmen, constructors, engineers did not sign their work. the bauhaus had gone through various internal mutations and revolts such as the shift from craft to industrial design, from the painting of hoelzel and itten to that of van doesburg, from a werkbund ideology to the ideology of de stijl. but it had not managed to break away from art. on the contrary, the true princes were the painter-princes: kandinsky, klee, feininger, and schlemmer. and their concern remained the spiritual: kandinsky's theoretical work was entitled c o n c e r n i n g t h e s p i r i t u a l i n a r t. kandinsky and mondrian were adherents of theosophy, a doctrine of pure spirituality that sought to overcome materialism by becoming one with the absolute spirit, with god. for both of them, painting provided access to pure spirit, and the path to non-objectivity was a farewell to the concrete, material world.

in russia, malevich sought pure space, pure plane, pure color with an ambition otherwise reserved only for icons. the goal was an enraptured aesthetic of pure form; of squares, triangles, and circles; of lines and color. klee spoke of the cosmos, of prehistory and primal movement. for kandinsky, objects became fields of energy and complexes of lines. in his painting he pursued pure abstraction as an equal citizen of the abstract kingdom. the goal was spirituality, the super-real, the supra-individual.

but doesn't the world as it is consist only of the individual, the concrete? isn't the spiritual, the general, merely part of the conceptual world of humanity, a way of coming to terms with the world linguistically? this notion had been confirmed by william of ockham, an early precursor of modern-day analytic philosophy.

yet the spirituality of the painters was not all there was to the bauhaus. from the beginning there was a tendency toward the concrete. the first program called for a return to craft, a new guild of craftsmen laboring in the spirit of the workshop. it called for unity of the arts in building and declared art to be the culmination of craft. the applied-arts emphasis of this program is discernable in the final sentence of the first manifesto of 1919: "let us therefore create ... the new building of the future [it] will one day rise towards the heavens from the hands of a million workers as the crystalline symbol of a new and coming faith."

this statement still offers something of value as an expression of the high view of work in the era of craft, when things were made for their own sake. an industry and a service sector fixated on profit are essentially rooted in deception; appearance is more important than the thing itself.

the architect gropius also admitted profane things to the bauhaus such as buildings, tables, chairs, and furniture, though not as such, but as elements of a new faith. the painters found the latter in elemental geometry, in the square, triangle, circle, and the primary colors of red, yellow, blue, black, and white.

and so conflict was inevitable: is design an applied art manifested in the elements of square, triangle, and circle,

or is it a discipline that derives its criteria from the task at hand; from function, production, and technology? does the world consist of the individual and the concrete, or the general and the abstract? this conflict was not resolved at the bauhaus—it couldn't be resolved as long as the concept of art remained taboo, as long as an uncritical platonism of pure form remained in force as a world principle.

certainly there were individual voices of opposition. the younger ones especially, such as josef albers, mart stam, hannes meyer, and marcel breuer, questioned this subordination to an ideal aesthetic. they viewed the results of their work as the product of working methods, material qualities, technology, and organization. as empiricists, they stood opposed to the idealists of pure form. hannes meyer was forced to leave the bauhaus; he risked the statement that art was composition and therefore opposed to purpose, that life was inartistic, and that the aesthetic was the result of economics, function, technology, and social organization.

the bauhaus remained dominated by a geometric style derived from art, and thus exerted more influence on art deco than on modern industrial production. the bauhaus has left more of a mark on the museum than on present-day technology and economy.

geometric principles of design might still be somewhat usable for furniture or typography, but such formal parameters were questionable even for chairs, to say nothing of cars, machines, and appliances. industrial production went a different route, and designers like charles eames were the first to show what it meant to develop products on the basis of their purpose, material,

and methods of manufacture—on the basis of their function.

we all had good reason to have reservations about the bauhaus.

at the same time, neither zeischegg nor i were economists who viewed aesthetics as the byproduct of purely technical production. it seemed reasonable to us to delineate aesthetic categories such as proportion, volume, series, interpenetration, or contrast and to investigate them experimentally—but not as ends in themselves, and certainly not as a superior, overarching, spiritual discipline. rather, they were a kind of grammar, a syntax of design. the design result had to correspond to the problem, and its criteria were function and production. the aesthetic experiment was important for us, and the conceptual control of aesthetic processes was as exciting as it was necessary, but we did not consider newtonian physics to be more correct than nature itself.

hans gugelot brought a technically innovative head to the group, and with maldonado we received a theorist and designer who had likewise defected from painting. gugelot devised the technical-inventive basis of the instruction in product design, while maldonado organized the scientific structure of the curriculum.

bill seemed to go along with us for a while in regard to the classification of art and design. the critical point was whether he could affirm our conception of painting and sculpture as experimental disciplines for defining color and volume, with no other higher significance.

for gugelot the question became acute with respect to the hierarchy of engineer and product designer. was the designer superior to the technician?

gugelot had never been involved in art and could thus decide impartially.

for bill, the designer ranked higher than the engineer, but for gugelot the question itself was flawed. both professions, designer and engineer, approached the same thing from different perspectives—the one from the perspective of technical efficiency, the other from that of function and appearance. gugelot took engineering so seriously that he could not conceive of subordinating it, just as he expected technicians to take design seriously enough to not subordinate it either. he no longer thought of the world in terms of higher or lower, but as an interconnected network of different and coequal activities. furthermore, for him technology yielded too many aesthetic qualities for him to want to look down on them; he himself had become a technician in order to exploit the aesthetic reserves of technology. this was similarly the case with zeischegg, who was now spending more time studying books on mechanics and kinetics than on art. his intellectual curiosity was satisfied more by technical trade fairs than by art exhibitions. at the same time, he was also studying the mathematics of solids and positions in order to explore the laws of volume and topos. for him, what resulted from position and angle of view could not be expressed in hierarchical terms. maldonado and i devoted ourselves to mathematical logic only to find that the answers that we received to the questions of the world were dependent on method, on how the questions were formulated; here, too, a vertical world order collapsed. spirit was a method, but not a substance. we experience the order of the world as the order of thought, as information.

one of the first books i acquired for the library of the hfg was charles morris's s i g n t h e o r y. his classification of information as semantics, syntax, and pragmatics gave us a theoretical foundation for defining design criteria and interpreting art as a syntactical craft. for us, that had the kind of significance that sigmund freud had for many others when he identified the psychic as a form of organization for the physical.

i learned once more how dangerous a purely syntactical art of squares, circles, and triangles could become when it remained unaware of its withdrawal from the semantic dimension of information. my posters had slipped into the formal field of so-called concrete art, and i had to ask myself whether they still served first of all for communication. a photographer, christian staub, who directed the curriculum in that area, called my attention to the fact that my photos were in danger of becoming a formal, "artistic" end in themselves, and that i shouldn't confuse syntactical exercises with information—where was communication?

four years after the school opened, max bill left. without him there would have been no hochschule für gestaltung in ulm. we sought his experiences with the bauhaus; his views on design seemed to point the way for us. but at a basic level he still remained tied to the bauhaus; he remained an artist and reserved a special place for art.

i myself had gleaned little of use from the bauhaus in the areas of typography and graphic design. quite the contrary: in typography, adherence to the basic geometric elements of square, triangle, and circle—for example in the design and assessment of fonts—tended to be disastrous, since no easily legible font uses a circular o or an

184

a formed by an isosceles triangle. a geometric font is a reversion to aesthetic formalism. a legible and therefore functional font seeks to do justice to the reading and writing habits of human beings.

the same was true of photography. the bauhaus had broken new ground in the syntactical aspects of the medium, but a premium was not placed on photography as a mode of communication. the concern was for perspectives, light and shadow, contrasts, structure, and focus. photography as a means of communication was developed by others, by the photojournalists associated with the major illustrated newspapers: felix h. mann, stephan laurant, erich salomon, eugene smith, robert capa, henri cartier-bresson. the photography of man ray or moholy-nagy was primarily formal aestheticism, an aesthetic-formal end in itself, at best a syntactical experience. reality was reproduced as a signal, which admittedly enhanced the significance of this kind of photography for advertising and graphics. the fact that today it is treated as art only confirms this assessment. its formal ambition stood in inverse proportion to its communicative function.

finally, the postmodern design of the present day can also invoke the bauhaus: as in rietveld's time, furniture has once again disintegrated into cubes, cones, and cylinders in the colors of elementary design. the conical pitchers and cylindrical pots of the bauhaus remain immortal as long as elementary geometry is considered art—see aldo rossi.

nor can one avoid the observation that today, we have discovered the extent to which kandinsky can be cannibalized in the interest of commerce. his lines, sticks,

waves, circles, points, circle segments, crescents, and triangles are now consumed as the latest fashion, since mondrian has grown too cold and klee too poetic. kandinsky is the formal source for the current visual fashion; even architectural plans exploit his syntactical repertoire. the times are once again favorable for the higher, the general. art stands in better graces than responses to specifics, results of case studies, solutions for a situation. art affords the eternal.

we have once again arrived at the conflict of the dadaists, who split into two camps: the aesthetes and the moralists. hugo ball withdrew as a moralist and left the aesthetes to themselves. marcel duchamp, who had already had enough of expressionistic painting, likewise quit making provocative objects to shock the bourgeoisie.

the moralists didn't want to evade the accusation that the world consists of refuse, lies, and deception. the principle of the modern market was profit, and neither manufactured objects nor chemical agents nor the products of the food industry resulted from a sense of responsibility toward the product and the thing. the moralists had to abandon the aesthetes.

today not much has changed about this situation; the world is not so different now than it was then. most designers have defected to the camp of the stylists, the aesthetes, and package products in accord with the aesthetic concerns of sales promotion. appearance still counts for everything.

This essay first appeared in Die Moral der Gegenstände, ed. Herbert Lindinger, exh. cat. Hochschule für Gestaltung Ulm (Berlin, 1987), pp. 124–129.

БАУХАУЗ ДЕССАУ
1928—1930

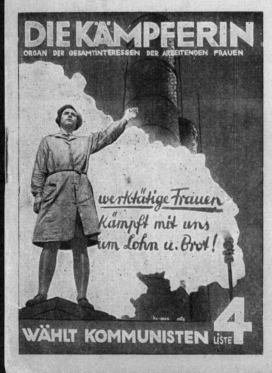

ВОКС
ГМНЗИ
1931

DIESER BAU
WURDE MIT HILFE
VON ÖFFENTLICHEN MITTELN
DER VEREINIGTEN STAATEN
VON AMERIKA
ERRICHTET

THE BAUHAUS AS A
COLD WAR WEAPON
AN AMERICAN-GERMAN JOINT VENTURE
Paul Betts

By now it is hardly any secret that Bauhaus modernism,
once a highly charismatic teaching philosophy and visual
vocabulary, has fallen into serious disfavor over the
years. Ever since the late sixties, denouncing the bad
faith informing the Bauhaus program and the apparent
hubris of its leading figures has developed into a favorite
transatlantic parlor game. For many observers, Tom
Wolfe's widely read 1981 satire, From Bauhaus to
Our House, marked the Bauhaus's final passage
from tragedy to farce, as its once noble dreams were
mocked in a dark round of laughter and forgetting. Sur-
prisingly, however, little scholarly attention has been
devoted to the reasons behind the Bauhaus's remarkable
success and especially its canonization in both West
Germany and the United States after 1945. Given that it
experienced great difficulty throughout the Weimar
Republic, was closed down by the Nazis, and forced into
a difficult exile in the United States, where its partial rein-
carnation in Chicago fizzled out after only a few years,
this clichéd Bauhaus success story is by no means self-
evident. What, then, accounted for its unrivaled cultural
authority after 1945? In this essay, I argue that the post-
war popularization of the Bauhaus in West Germany and
the United States, less a simple function of its own
momentum from the twenties, was shaped to a large
extent by the cultural imperatives of the Cold War.

To this end, I am interested in grounding the West German reinvention of the Bauhaus saga within a broader transatlantic setting in order to explore the ways in which it was used to help underwrite new and necessary cultural narratives after 1945. In this period, the Bauhaus assumed a privileged position within West German culture, in part because it played a crucial role in the larger Cold War project to draw the Weimar Republic and the Federal Republic into the same elective liberal lineage while at the same time conjoining West German and American cultural modernism.

■ SCHWARZ'S BAUHAUS CRITIQUE

In January 1953, the well-known Cologne architect Rudolf Schwarz was invited by the editors of one of West Germany's leading architectural journals, B a u k u n s t u n d W e r k f o r m , to write a contributing essay to the theme "Building and Writing." Since Schwarz had recently served as a key participant in the celebrated 1951 Darmstadt Conference on "People and Space," the editors hoped his piece would help enlarge the current discussion about the problems facing West German architecture and urban design. Schwarz himself welcomed the opportunity to elaborate upon his earlier critique of modernist architecture as a model for post-1945 city planning.[1] More than twenty years prior to that, the architect had ridiculed modernist architecture as "artificial technologism" and "stupid function-loving materialism"; he even proclaimed in 1932 that the "Bauhaus style" had reached its inevitable "dead end."[2] But in 1953 he went much further, veering off from the assigned theme in

order to challenge what he perceived as the unjustified nimbus of cultural authority surrounding Gropius and the Bauhaus. In his sweeping polemic entitled "Bilde Künstler, Rede Nicht" (Artists Should Create, Not Speak), Schwarz openly accused Gropius and the Bauhaus of having irrevocably corrupted German architecture and design, whereby the unfolding tragedy of post-1945 German urban planning only marked the latest installment in its dark and illiberal legacy. He charged that the "pure and benevolent humanity" supposedly characterizing "the great Western discourse" of pre-1914 European architecture had been mercilessly undermined by the "anti-intellectual terrorism of dictatorial groups such as the Bauhaus literati and later the masters of the Third Reich." Here he exercised little restraint in portraying the Bauhaus as an incorrigible band of "wild and agitated terrorists" inspired by the "non-Western thinking" of Gropius himself. For him, the Bauhaus was essentially a perverse red menace that propagated an architectural idiom "that was not German, but rather the jargon of the Communist International." With this, Schwarz had clearly defied postwar convention by arguing that Germany's alleged deviation from the "Western tradition" of humanist culture did not first occur with the Nazi assumption of power in 1933, but rather in 1919 with the creation of the Bauhaus and its "dark, materialist Weltanschauung."[3] Scandalous as this was, he shocked his readers even more so by concluding that well-publicized Nazi closure of the Bauhaus in 1933 was both warranted and necessary. It was hardly surprising that the publication of the essay incited a torrent of indignation. Predictably, Schwarz was immediately branded a Nazi, as Gropius and his defend-

ers denounced his corpus delicti as nothing but the unfortunate replay of former Nazi exhortations. But the implication behind Schwarz's bitter attack that there was a certain continuity from Bauhaus modernism to Nazi architecture and later to post-1945 city planning was forgotten amid the fury resulting from his slander against the Bauhaus, and especially its founder. Much of the intensity of the reaction could be attributed to the fact that Schwarz's diatribe was not only an attack against the Bauhaus, but also against the ongoing reorganization of cultural memory during the Adenauer Restoration. Here it pays to recall that in order to rehabilitate a non-Nazi German past to which a cautious postwar generation could claim allegiance, there was a concerted effort during the late forties and early fifties to recover an exiled, threatened, and/or destroyed "better Germany." Josef Witsch and Max Bense's A l m a n a c h d e r U n - v e r g e s s e n e n (1946), Walter Berendsohn's D i e H u m a n i s t i s c h e F r o n t (1946), and Richard Drew and Alfred Kantorowicz's V e r b o t e n u n d V e r b r a n n t (1947) were only a few titles in a much broader cottage industry of texts devoted to recuperating a select group of cultural figures with which the Federal Republic hoped to establish an elective affinity. However, the project to construct a palatable West German identity was continually bedeviled by the fact that most German cultural spheres, be it architecture, painting, film, music, philosophy, literature, or history writing, had been badly contaminated by Nazi association. Even worse, what little antifascist culture did exist was confounded by its explicit linkage to communism.[4] Much of the attention consequently focused on recounting the glories of exiled

Weimar heroes such as Gropius, Thomas Mann, and even a re-imported Frankfurt School, who were all construed as living testimony of a positive, non-Nazi German culture. In this setting, the Bauhaus provided timely political service in that it was one of the few German traditions that apparently satisfied the Cold War criteria of anti-fascism, anticommunism, and international modernism.

All the same, the Schwarz controversy generated little interest among West German architects. Besides B a u - k u n s t u n d W e r k f o r m , West Germany's other specialized architectural journals published virtually nothing about the event, nor were any follow-up conferences arranged to discuss its possible import. In fact, West German architects and urban planners (despite Schwarz's worries) paid little attention to the Bauhaus and the Bauhäusler during the fifties. Comprising a mixture of traditionalists and middle-of-the-road modernists, most of whom had served under the Nazis, the West German architecture profession still retained a thirties image of a radical leftist Bauhaus, one that blocked off its potential relevance for postwar planning. Yet this absence of interest among postwar architects did not mean that the Bauhaus remained unimportant to West Germans; the point was rather that its reception took place far outside architecture circles, where the Bauhaus and its founder lived on as affirmative icons of an uncorrupted Weimar culture. That the Schwarz controversy enjoyed its most significant coverage not in specialized architecture journals but in more mainstream West German cultural publications only confirms the extent to which Gropius and the Bauhaus were identified by the lay public as precious cultural capital in need of safeguarding.[5]

■ REDISCOVERING THE BAUHAUS

It is well to remember that the postwar rehabilitation of the Bauhaus was already well under way by the time of the Schwarz controversy. Essential here was that the educated West German public did not view the Bauhaus as a renegade band of radical architects. Thanks in large part to the post-1945 retroactive redemption of those condemned by the Nazis at the famous 1937 Degenerate Art exhibition, the popular Cold War image of the Bauhaus shifted from a hotbed of leftist architecture to a bold yet innocent school of fine arts. This was especially evident in the first postwar Bauhaus show, the 1950 Painters at the Bauhaus exhibition in Munich. The once central Bauhaus idea of moving beyond the cult of the autonomous artist and its attendant trappings of excessive subjectivity—perhaps best expressed in Gropius' famous 1923 "Art and Technology: A New Unity" speech—was forgotten amid the postwar rediscovery of the Bauhaus as a key moment in a lost German tradition of liberal humanism. Indeed, the Bauhaus master painters, especially Paul Klee and Wassily Kandinsky, were now celebrated by West Germans as part of this broader Cold War campaign to affix Abstract Expressionism (due to its apparent glorification of artistic freedom and individuality) as the preferred iconography of the West. The dissemination of Bauhaus modernism throughout West German middle-class cultural life (as witnessed in domestic interiors, furniture styling, wallpaper, poster art, and graphic design) further deradicalized the Bauhaus in the eyes of the public, while making its cultural wares available for mass consumption for the first time. Likewise, Bauhaus

teaching pedagogy was hailed by West German educators as an exemplary humanist model for training artists, artisans, and designers.

■ THE CLEANING OF BAUHAUS HISTORY

In this context, Schwarz's polemic against the Bauhaus potentially obstructed this postwar reconstruction of cultural memory. For however much the Bauhaus apologists worked to parry Schwarz's attack with counteraccusations, the charge that the Bauhaus was really communist could not be so easily dismissed. Not only was the school's history peppered throughout with leftist teachers and students, there was no way of denying that Gropius's handpicked successor, Hannes Meyer, who supervised Bauhaus activities from 1927 to 1930, was an avowed communist. During his tenure, Meyer devoted his energies to changing the school's image and uppercrust clientele by instituting a more leftist program based on "the needs of the people instead of luxury needs" ("Volksbedarf statt Luxusbedarf") as well as bringing its workshop in closer contact with trade unions and the workers' movement. Moreover, he radically transformed Bauhaus pedagogy by cleansing it of any lingering artisan ethos and/or Expressionist mysticism in favor of a more "secular" design philosophy grounded in the scientific principles of rationalized industrial production. But given both the Cold War cultural climate and the political value of the Bauhaus legacy, it was clear that this segment of Bauhaus history needed to be rewritten. Meyer thus became the convenient scapegoat of all Bauhaus problems in the Cold War revisionist historiography.

At the above-mentioned 1950 P a i n t e r s a t t h e B a u h a u s exhibition, for instance, Meyer was derided as nothing but a "disciple of doctrinaire materialism" who interpreted "the concept of function too literally and mechanically by suppressing its artistic dimension,"[6] thereby perverting the gospel of Gropius and sabotaging the Bauhaus mission. The eruption of the Schwarz controversy three years later furnished another chance to deflect harmful Bauhaus criticism away from Gropius and the rest of the school and instead onto Meyer's biography. Demonizing Meyer as the real target of Schwarz's charges worked to defuse the potentially damaging attack, closing off any chance of exploring the Bauhaus's rich and contradictory record. After this, all questions about the radical political elements of Bauhaus history— including the peculiar place of Bauhaus modernism within the Third Reich[7]—were effectively suppressed during the fifties and sixties.

With the Schwarz controversy already long forgotten, the 1955 christening of the design school in Ulm—the Hochschule für Gestaltung (HfG)—as the "New Bauhaus" served as a good example of the perceived Cold War connections among antifascism, the Bauhaus heritage, and cultural regeneration. Initially inspired by Inge Scholl, who wanted to create a new school of democratic education in honor of her two siblings, who were killed as members of the White Rose resistance group, the establishment of the HfG represented a decisive moment in American-West German cultural relations after the war. The American High Command of Germany and the West German government jointly underwrote the Ulm project, dramatizing the extent to which rebaptizing the Bauhaus

served as indispensable Cold War diplomacy. In fact, the inauguration ceremony, punctuated by Gropius's keynote address, functioned as a spectacle of a reformed West Germany, as such notables as Henry van de Velde, Albert Einstein, Carl Zuckmayer, Theodor Heuss, and even Ludwig Erhard all lent their public support. Journalists also roundly applauded what one observer called "the Bauhaus idea come home" as a boon for an enlightened West German culture. Given West Germany's campaign to distance itself from its fascist past and to establish closer cultural relations with the United States, the HfG's privileged pedigree of both anti-Nazi resistance and Bauhaus modernism provided timely testimony to this cause. The Ulm design school carried a special mission. Indeed, its unique heritage of antifascism and international modernism was greeted as a vital means by which West Germans could "lead their country back into the main line of European cultural development."[8] The establishment of the HfG as a West German-inspired, American-financed joint venture was thus singled out for its decisive political role in helping forge a new cultural partnership between the United States and West Germany after 1945. It was for this reason that one West German cultural historian ironically described the school's importance as a sort of "coming to terms with past [Vergangenheitsbewältigung] with American assistance."[9]

■ AMERICAN INTERESTS
At the same time, the Bauhaus story also helped Cold War America articulate a new cultural identity. On one level, the celebration of the Bauhaus emigration to the United States was initially part of a larger literature prais-

198

ing the cultural contributions of the Weimar diaspora in America. Peter Blake's Marcel Breuer (1949), Philip Johnson's Mies van der Rohe (1953), and James Marston Fitch's Walter Gropius (1960) were only a few texts among many that chronicled the successful migration of the so-called "Bauhaus idea" to Harvard University's Graduate School of Design, the Illinois Institute of Technology, and North Carolina's Black Mountain College. At stake, however, was more than simply popularizing these transplanted European architects for an American audience. Leaving aside the complexities of this reception story, it suffices to say that American architects and cultural critics during the fifties increasingly viewed Bauhaus modernism as a new and viable alternative to what they felt to be the suffocating romantic provincialism of American architecture, be it the Bay Regional Style or even Frank Lloyd Wright's anti-urban projects. A Bauhaus-inspired International Style was for them a more suitable cultural expression of America's new Cold War political identity.

Throughout the fifties and sixties, American writers rewrote the Bauhaus story in accordance with this new attitude. What is interesting is that they largely relied upon three pre-Cold War texts as touchstones for their revision: Henry Hitchcock and Philip Johnson's catalogue to the 1932 Museum of Modern Art exhibition The International Style, Nikolaus Pevsner's Pioneers of the Modern Movement (1936), and Sigfried Giedion's Space, Time, and Architecture (1941). Even though they were originally written to promote international modernism as the legitimate successor to a classical architectural tradition,

these texts were used to transmute seemingly apolitical architecture history into Cold War cultural capital. Much of this had to do with the fact that insofar as these pre-1945 histories posited Gropius and the Bauhaus as the narrative resolution of architectural history, the Bauhaus's migration to America in turn implied that the United States had now become the very seat of international modernism.

The special 1950 Bauhaus issue of L'Architecture d'Aujourd'hui—which was edited by Gropius's student Paul Rudolph—made this clear by boldly claiming that the Bauhaus exodus to America symbolized the seismic shift of cultural preeminence from Europe to the United States. Other American chroniclers extended this logic during the fifties by downplaying the German phase of the Bauhaus story, emphasizing instead the migration as the decisive event in the narrative. Since these writers construed the success of the Bauhaus program as primarily a function of its emigration to America, praising the Bauhaus was inseparable from lauding the virtues of an America that made this transplant possible in the first place. The school's passage to the United States thus not only promoted the cherished self-image of America as the land of freedom and opportunity, but also as the rightful heir and guardian of International modernism.

No less significant was that these chroniclers saw no contradiction in re-inscribing Bauhaus-style international modernism as fundamentally American. Indeed, they felt that the marriage of European culture and American civil society informed the very substance of an American Cold War cultural identity. The American embassy architecture of the fifties and early sixties

(including Gropius's embassy building in Athens), the marketing of Bauhaus graphic design, and even the New York Museum of Modern Art's concerted interventions to popularize the Bauhaus in American architecture and design circles were all part of this wider Cold War campaign to retool this Bauhaus-inspired International Style to these political ends. So whereas the West Germans worked to salvage the Bauhaus legacy as a needed symbol of a (West) German modernist past, the American celebration of the Bauhaus paid tribute to a new and powerful American modernist present.

■ GROPIUS AS A COLD WAR ACTIVIST

This is by no means to suggest, however, that Gropius was unfairly exploited by American cold warriors. In fact, he very much contributed to this American revision of the Bauhaus story. Following the conclusion of World War II, Gropius again played an active role in repackaging the Bauhaus story for American consumption. Evidence of this could be seen when the United States government enlisted Gropius for Cold War action, sponsoring his return to bombed-out Berlin in 1947 and 1948 for two lectures on the future of German reconstruction. That he arrived as the "official architectural adviser" of General Lucius Clay underscored how the one-time Weimar modernist had now been reflagged as a new spokesperson for American-style modernization. His status as living testimony of both a good German past and a powerful American present granted him special cultural authority as a frequent allied consultant for postwar reconstruction plans, while many of his essays were reprinted in CIA-financed West German publications (for

example, D e r M o n a t) as postwar guidance. In the United States, Gropius continued his publicity campaign to bleach the Bauhaus story of any damaging leftist association and to replace his one-time twenties image as founder of the "Cathedral of Socialism" with his new role as "Apollo in the Democracy."[10] All of the central ideas propagated by Gropius in the 1938 exhibition—that Gropius and the Bauhaus were practically synonymous, that the Bauhaus transcended petty politics, and that the Bauhaus had always been a beacon of freedom and cultural liberalism—were simply incorporated into the Cold War Americanization of the Bauhaus saga.

What is more, this West German conception of the Bauhaus was ultimately reinforced by East Germany as well, albeit from a different political perspective. Here it is worth remembering that by the early fifties, Bauhaus modernism had become a highly politicized symbol in the Cold War cultural rivalry between East and West Germany. In reaction to its ongoing popularization in the West, East German Premier Walter Ulbricht responded by officially condemning first the "Bauhaus style" as debased "bourgeois formalism," and then functionalism in general as sinister ideological propaganda from the United States.[11] Ironically, Schwarz's claim that the Bauhaus was really communist found no resonance in East Germany in the first two decades after the war. Even Hannes Meyer was denounced as a "reactionary constructivist."[12] As a result, Ulbricht's antipathy toward the Bauhaus in favor of a more traditional and even nationalist architectural idiom helped secure the Bauhaus's postwar place as a symbol of Western liberal culture. The occidental conversion of the Bauhaus into ready Cold

War cultural service then went far beyond architectural style wars. Just as the (American-style) narrative of Western liberalism was used during the Cold War as a barometer by which to measure the political health of nations, this International Style was often applied as a yardstick of (Western) cultural progress. From this perspective, Bauhaus modernism not only served as testimony to American and West German maturity, but also as the visual expression of Cold War modernization theory.

■ THE BAUHAUS CELEBRATION OF 1968

The 1968 Stuttgart F i f t y Y e a r s B a u h a u s exhibition functioned as the crowning event in the West German cultural canonization of the Bauhaus and Gropius. Attended by over 75,000 visitors, this show represented the grand spectacle of Bauhaus history by reproducing all of the postwar orthodoxies: the Bauhaus was hailed as Weimar Germany's greatest achievement in cultural liberalism; Gropius once again emerged as the singular hero of the Bauhaus, whereas Mies, Breuer, and the others were recast as simply subordinate figures; and Meyer was accorded merely two sentences in the exhibition catalogue as provisional director during the school's interregnum. This 1968 show thereby acted as the logical culmination of this Cold War reworking of the Bauhaus story as a redemptive icon of twenties culture, one that helped temper the infamous "special path" (Sonderweg) of German history by recalling its Weimar legacy of international modernism. And even if the Bauhaus revision may have indirectly confirmed the Cold War understanding of German history as a tragic tale of cultural

modernity and political immaturity, it did provide evidence—as many West Germans and Americans were quick to indicate—of both a liberal modernist heritage and a bridge to America. The former curator of the Bauhaus Archive, Hans Wingler, could then remark with great justification: "The Bauhaus counts as Germany's most substantial gift of modern culture to America It now belongs to the entire world—but what concerns us especially is this: it is for Americans and Germans the shining symbol of our great spiritual solidarity."[13]

With this, the possibility of opening up a more general historical discussion of the Bauhaus was cordoned off after 1945. Schwarz's effort to challenge the cultural authority of Gropius and the Bauhaus was the first and last public criticism leveled against the Bauhaus in West Germany until the mid-sixties. More than that, the controversy revealed the crucial point that criticizing the Bauhaus had itself become a postwar taboo, a sign of dangerous illiberalism. Certain questions consequently remained untouched in the Cold War revision: Is it not ahistorical and misleading to characterize all Bauhaus opponents as (proto-)Nazis? Why were Weimar liberals and conservatives (long before the advent of the Nazis) often the most vociferous Bauhaus critics? Whatever happened to those Bauhaus members who did not emigrate after 1933? Or, is it not important to recall that Gropius and Mies both submitted architectural proposals to various Nazi exhibitions, complete with swastikas in their drawings? It should be clear that this is not an attempt to slander these figures, but rather to draw attention to the historiographic exclusion of these complicated issues. For what the postwar suppression of these ques-

204

tions ironically reveals is that the long-forgotten Schwarz controversy always rested at the symbolic center of the West German revision, furnishing all of the narrative material necessary for protecting the Bauhaus legend as a precious symbol of benevolent international modernism. In a strange twist of fate, Schwarz unwittingly served as the forgotten mediator of the Cold War canonization of Gropius and the Bauhaus.

■ THE COLLAPSE OF THE BAUHAUS LEGEND

In recent years, however, this postwar project to affix Bauhaus modernism as a totem of International Style liberalism has all but disappeared. The post-1968 re-encoding of Bauhaus modernism as oppressive and inhumane; the revenge of decoration, ornamentation, and historicism as the hallmarks of postmodern architecture; and even the recent criticism of Gropius and Mies van der Rohe as less than angelic figures in their personal politics have cast a noticeable pall over the once sunny Bauhaus imperium.[14] But there was more at stake than simply defrocking the twenties prophets of therapeutic modernism. This post-1968 Bauhaus critique had questioned the central article of faith propelling the Bauhaus revision through the fifties and sixties, namely the equation of Bauhaus modernism with international liberalism. It was thus no small wonder that the postmodern critique, rejecting both the false dreams and practices of institutionalized modernism, identified the Bauhaus as its primary target.

Less well-known, however, is how this Bauhaus critique also registered a decisive shift in United States-West

German cultural relations. Tom Wolfe's 1981 From Bauhaus to Our House represented a telling example in this regard. His rereading of the triumph of Bauhaus modernism in the United States as less a sign of American cultural achievement than an unwanted architectural scourge from Germany indicated the extent to which the former Cold War belief in the Bauhaus as a favorite symbol of this transatlantic cultural partnership had collapsed by the early eighties. The significance of Wolfe's well-publicized polemic resided not in the critique itself (which had been articulated many times since the late sixties), but in the fact that he popularized this Bauhaus critique for a mainstream lay audience. This was certainly no small event, especially if we recall that Gropius and the Bauhaus had long ago been lifted from architectural history proper and recast as popular cultural icons of a shared liberal modernist heritage. So more than just another attack against the long embattled Bauhaus legacy, Wolfe's nationalist booklet mirrored the newly felt separation of American and West German cultural history. The Bauhaus story, which once served as a narrative bridge linking West Germany and the United States, now pointed up their differences.

1 Rudolf Schwarz, "Das Anliegen der Baukunst," in Mensch und
 Raum: Das Darmstädter Gespräch 1951, Bauwelt
 Fundamente 94 (Braunschweig and Wiesbaden, 1991), pp. 73—86.

2 Rudolf Schwarz, "Baustelle Deutschland," in id., W e g w e i s u n g
 der Technik und andere Schriften zum Neuen
 Bauen 1926–1961, Bauwelt Fundamente 51, pp. 139–153.
 Reference is made here first to p. 141 and then to p. 139.

3 Rudolf Schwarz, "Bilde Künstler, rede nicht: Eine weitere Betrachtung
 zum Thema 'Bauen und Schreiben,'" B a u k u n s t u n d W e r k f o r m 1
 (1953), pp. 10–17. Also in Ulrich Conrads, ed., D i e B a u h a u s -
 D e b a t t e 1 9 5 3 : D o k u m e n t e e i n e r v e r d r ä n g t e n K o n t r o -
 v e r s e, Bauwelt Fundamente 100 (Braunschweig and Wiesbaden,
 1994), pp. 34–47, Reference is made here to pp. 39, 40, 35, and 44,
 in that sequence.

4 Cf. Jost Hermand, K u l t u r i m W i e d e r a u f b a u : D i e B u n d e s -
 r e p u b l i k D e u t s c h l a n d 1 9 4 5 – 1 9 6 5 (Munich, 1986),
 pp. 89–108; and Hermann Glaser, K u l t u r g e s c h i c h t e d e r
 B u n d e s r e p u b l i k D e u t s c h l a n d, vol. 1: Z w i s c h e n
 K a p i t u l a t i o n u n d W ä h r u n g s r e f o r m, 1 9 4 5 – 1 9 4 8
 (Munich and Vienna, 1985), pp. 91–110.

5 See, for example, the extensive coverage in D i e N e u e Z e i t u n g,
 March 4 and March 11, 1953.

6 Ludwig Grote, "Vom Bauhaus," in D i e M a l e r a m B a u h a u s,
 ed. id., exh. cat. Haus der Kunst (Munich, 1950), pp. 6–10, here p. 10.

7 This issue was first examined in Winfried Nerdinger, ed., B a u h a u s -
 M o d e r n e i m N a t i o n a l s o z i a l i s m u s : Z w i s c h e n A n -
 b i e d e r u n g u n d V e r f o l g u n g (Munich, 1993).

8 "Editor's Introduction," A t l a n t i c M o n t h l y (March 1957), p. 102.

9 Christian Borngräger, S t i l N o v o : D e s i g n i n d e n F ü n f z i g e r
 J a h r e n (Berlin, 1978), p. 23.

10 This was the title of Gropius's collected essays delivering during his
 1954 world lecture tour as a Rockefeller Fellow. A p o l l o i n t h e
 D e m o c r a c y (New York, 1968).

11 Thomas Hoscislawski, B a u e n z w i s c h e n M a c h t u n d O h n -
 m a c h t : A r c h i t e k t u r u n d S t ä d t e b a u i n d e r D D R
 (Berlin, 1991), pp. 38–43, 101–111, 297–310.

12 Hermann Henselmann, "Der reaktionäre Charakter des Konstrukti-
 vismus," N e u e s D e u t s c h l a n d, December 4, 1951. See
 Winfried Nerdinger, "'Anstössiges Rot,' Hannes Meyer und der linke
 Baufunktionalismus—ein verdrängtes Kapitel Architekturgeschichte,"
 in H a n n e s M e y e r, 1 8 8 9 – 1 9 5 4 : A r c h i t e k t U r b a n i s t
 L e h r e r, ed. Bauhaus-Archiv Berlin, exh. cat. Deutsches Architektur-
 museum, Frankfurt am Main, et al. (Berlin, 1989), pp. 12–29, here
 pp. 27–28.

13 Hans Maria Wingler, "Was hält Amerika von deutscher Kunst?" D i e
Welt, May 14, 1958.
14 Cf. Winfried Nerdinger, Walter Gropius (Berlin, 1985), and
Elaine S. Hochman, Architects of Fortune: Mies van der
Rohe and the Third Reich (New York, 1989).

This article is an abridged and slightly modified version of my article "The
Bauhaus as Cold War Legend: West German Modernism Revisited,"
German Politics and Society 14, no. 2 (Summer 1996),
pp. 75–100.

* HANNES MEYER HAUS *

STATE-SUPPORTING BOREDOM
THE DISTANCE OF THE 1968 STUDENT MOVEMENT
Dieter Hoffmann-Axthelm

In order to avoid misunderstandings, a distinction should be made at the outset: on the one hand, between awareness of the Bauhaus within the student movement in general and the Socialist German Student Union (SDS) in particular, and, on the other, the degree to which the subgroup of politically engaged architecture and design students looked to the Bauhaus as they wrestled with their studies and professional perspectives.

The Bauhaus was of no importance for the student movement as a whole; while it may have come up in the context of general education, it was irrelevant as a point of orientation. The situation was different, however, for those student protesters ("'68ers") whose course of study was related to the Bauhaus, though here, too, one has to distinguish between designers and architects. In the early phases of one's education, the Bauhaus would have been identified with modernism in general. In the course of a design curriculum it was impossible not to run across the Bauhaus, with teachers who were graduates of the school, programs that had originated there, and a lifestyle that had produced a post-Nazi generation of designers who traced their roots to the Bauhaus in hairstyle, clothing, eyewear, and the like.

For architects, on the other hand, there was no immediate need to contend with the Bauhaus. For one thing, the field of architecture offered a wider range of possibilities for identification, since the Bauhaus had constituted only

one of many currents in early modernism. As its chief representative, Walter Gropius made efforts to perpetuate the influence of the Bauhaus in the postwar era (though with no significant correlation to its original methods or way of life), but Ludwig Mies van der Rohe had long been a chapter in his own right with a merely episodic connection to the Bauhaus. Hugo Häring and Hans Scharoun represented a completely different impulse, while Rudolf Schwarz and Otto Bartning embodied a confessionally oriented modernism. But were the architecture students of the time even interested in the past? More important to them was the present: internationally, Team X and above all Aldo van Eyck in the Netherlands; Peter and Alison Smithson, the young James Stirling, and the Archigram group in Great Britain; Alvar Aalto in Finland; and in West Germany such opposing personalities as Egon Eiermann in Karlsruhe, Frey Otto in Stuttgart, Eckhard Schulze-Fielitz in Essen, Hans Scharoun in Berlin, and Oswald Mathias Ungers, whose instruction at the Technische Universität (TU) in Berlin was so decisive for the young architects of the Left.

■ POSTWAR SOCIALIZATION AND MODERNISM

For the '68ers, the Bauhaus was little more than textbook information. The presence of one of the Bauhaus books in the family home would have been the exception rather than the rule, and any early childhood encounter with the clear figures of the W i n t e r h i l f s w e r k —designed by former Bauhaus artists in the forties for door-to-door distribution and mass-produced to help finance the war—would have passed unnoticed.

The Nazi shutdown of the Bauhaus lay a quarter century in the past before anyone began to be concerned, whether in school or informally, with the history buried under the rubble of National Socialism. At the time, it was Expressionism that lay closest to the heart of the current interest in existentialism and Jean-Paul Sartre. Here, two key resources elicited the most excitement: the 1919 anthology M e n s c h h e i t s d ä m m e r u n g by Kurt Pinthus, reprinted by Rowohlt Verlag, and the painters' groups Der Blaue Reiter and Die Brücke. For young people, the appeal of this rediscovery arose chiefly from the conflict with their parents; it gave them a sense of making up for the failures of the previous generation and thus helped overcome their own considerable resistance. That it had all happened so long ago mattered little; one could move almost effortlessly (in the exhibition spaces of the Haus am Waldsee in Berlin, for example) from the discovery of Die Brücke to the art of the fifties, i.e., to the French Informel, and indeed to abstraction in general.

The result was a general identification with modernism. This posture was completely apolitical; it was about finding oneself. The cultural break of the late fifties coincided with the assertion of individual intellectual independence. As for the Bauhaus, the name floated around amid the dawning realization that the twenties had in fact existed. As far as I can remember, it was not a topic of discussion. Only later did we notice that it had been present in particular objects, for example in the glass sphere of the kitchen light or our fathers' desk lamps—flexible, chrome-plated, with perfectly hemispherical shades.

The Bauhaus thus played no part in the political coming-of-age of the early sixties. To use myself as an example: the positive attitude toward the new architecture (such as the Hansaviertel in Berlin) was not up for discussion, but simply played itself out privately when we were not dealing with it in our studies. And so it remained until well into the sixties. Politically, we carried on our critique of capitalism; privately, we bought—even on a tight budget—chairs by Marcel Breuer. Everything was supposed to be clean, spare, and modern. We favored ingrain wallpaper, painted white with roller and Caparol, the tools of youthful decorating. Against the walls stood a few important pieces of furniture, mostly in bright colors.

None of this would have happened without the Bauhaus, since it was precisely the latter's asceticism, its notion of the house as laboratory, that had subjective appeal. But there was no conscious awareness of the source. At that time, readers of T h e P r i n c i p l e o f H o p e could neither understand nor find application for Ernst Bloch's vehement critique of the Bauhaus. The light, transparent, elegant quality that fascinates us today in the best achievements of the fifties was nowhere to be found in family dwellings or most schools; instead, everyday life was defined by what had been lost and needed to be acquired again. Only later, in the sixties, would the living environment (to the extent that one thought about it at all) become streamlined, with furnishings no longer marked by loss or the fear thereof. And of course one of the new answers was not the Bauhaus, but IKEA—beginning with the colorful folding chair.

■ THE BAUHAUS AS STATE SYMBOL

The elevation of the Bauhaus to an icon of modernism occurred parallel to the individual paths and collective forums of gradual politicization, but in a completely different realm. The Bauhaus was, so to speak, a stepping stone that enabled the older generation—the parents' generation, still influential in culture and politics—to regain a cultural foothold. Not coincidentally, the ascent began soon after the end of reconstruction, with the Bauhaus becoming a symbol for the modernization of West Germany. And so from the outset, the 1961 opening of the Bauhaus Archive on the Mathildenhöhe in Darmstadt was a state event; the reappropriation of the Bauhaus was not individual, but official and prefabricated—and thus entirely apolitical. The identification of Bauhaus modernism with democracy was certainly a useful weapon in the Cold War—contrasting with the political micro-management of culture in East Germany—but this identity was tenable only in the context of complete depoliticization and a fixation on the person of Bauhaus director Gropius as a guarantor of continuity.

From then on it was of course impossible not to acknowledge the Bauhaus—but that fact in itself made it politically uninteresting. It had become a part of the existing order, part of the establishment. The work of the Bauhaus Archive, whether in Darmstadt or Berlin, was limited to historical reconstruction and thus could scarcely exert anything other than a purely ideological or cultural-historical effect. In this regard it should be noted that alongside this exceedingly unprofitable institution, there was another instrument of tradition: the Deutscher Werkbund. In those days, it was not yet so moribund as it is today,

but was a lively organization whose members, including Hermann Muthesius, Hans Poelzig, and Heinrich Tessenow, addressed contemporary questions while also aware of other modernist currents.

Finally, there was the Hochschule für Gestaltung (HfG) in Ulm. It was the true Bauhaus of the fifties and sixties, if for no other reason than sheer continuity of personnel. The HfG was the Bauhaus in spades: since Max Bill's departure in 1956, its doctrine had been much more unequivocal; it had left behind the ambiguity, the romantic side of the old Bauhaus. Not coincidentally, it was at that time that the Bauhaus under Hannes Meyer first became a topic of interest. Scientific design and technical precision became the ideal of the second Ulm generation as well. Their HfG believed in methods and technology, and was thus relevant, efficient, and elitist—a challenge to which the Federal Republic was not yet equal. It was no accident that the end of the HfG coincided with the climax of West German Bauhaus-worship as manifested in the traveling exhibition 5 0 J a h r e B a u h a u s of 1968. Both events also marked the beginning of a consistent left-wing critique of the prevailing architectural practice and professional training from within the field itself.

■ THE GENERATION OF '68ERS

The 1968 of the art academies and architecture schools was another chapter altogether, since this was Bauhaus territory proper. The movement itself was unmistakably analogous: away from the specialist and toward the generalist. Approaches were sought that would connect and even merge with the field of social planning. For the archi-

tects, at least, whether in Stuttgart, Aachen, or Berlin, the Bauhaus was irrelevant. Their concern was for contemporary problems: planning theory, the industrialization of building, mass housing construction, and the changing image of the architectural profession. The artist-individualist was to be abolished in favor of a socialized design process in which aesthetics, technology, and science were no longer separate.

This intention corresponded closely to reality. This was the heyday of mass housing projects; the French large-panel system was adopted and imitated under license. Housing construction companies and private building firms established major offices with hundreds of employees. Network diagrams organized building activities on the new large-scale construction sites. The practical demands of the left-wing students and junior faculty differed from this scenario primarily in their call for the elimination of the artist-architect, a figure they still encountered in their university professors.

Critique of the new housing projects, on the other hand, came from other areas of the student movement, from sociologists, educators, and social workers. Certainly Alexander Mitscherlich's 1965 essay "Die Unwirtlichkeit unserer Städte" (The Inhospitality of our Cities) was influential in this regard. But the protest was elicited above all by first-hand experience of the new housing projects themselves, bogged down in a thousand makeshifts and stopgaps. Also occurring simultaneously with the construction of new buildings was the demolition of the urban districts of the nineteenth century, a condition for the resettlement of residents in the new housing projects. In this way, the politics of urban

redevelopment became an additional focus of left-wing activity.

The heterogeneity of the protest was vividly demonstrated in the summer of 1968 with A k t i o n 5 0 7, a student exhibition at the TU in Berlin mounted in the shell structure of Scharoun's architecture department building on Ernst Reuter Platz. Despite Gropius's presence, bestowing his blessing on the young people from the gallery, some of the works in the exhibition marked the beginning of a decisive critique of modernism in the field of urban planning. Here, at least, personal memory and subsequent development seem closely connected to each other.

Where was the Bauhaus in all of this? Its only importance lay in its reduction to the person of Gropius. Accordingly, the only text I can remember that made any reference to the Bauhaus was an essay by Wolf Meyer-Christian, at the time assistant to the professor for architectural history. It represented the most annihilating critique of Gropius heretofore (consistently referring to him only as "Walter G."). The author observed the very thing that, a generation later, would also be said of Hermann Henselmann: that there was not a single work whose essential design could be unequivocally attributed to Gropius and not to a member of his staff.

■ POLITICS AND BASIC CURRICULUM

If the Bauhaus found a home anywhere at all in the decades following its demise, it was in the basic curriculum for students of architecture, structural engineering, art education, visual art, and product and graphic design. Here, however, it was the Weimar Bauhaus that was most

influential with its predominantly anti-rationalistic, gestalt-psychological orientation. The curriculum had been developed by Gertrud Gröner, Johannes Itten, Josef Albers, Theo van Doesburg, Wassily Kandinsky, and Paul Klee, and its long-term effects on art and art education as well as on graphic, communication, and product design are as familiar as they are difficult to summarize. The training in Ulm, on the other hand, had moved in the opposite direction ever since Max Bill's departure. Under the direction of Tomás Maldonado and Otl Aicher, a narrow orientation to linguistics, cybernetics, and the psychology of perception was matched aesthetically by an ascetic, technocratic approach to design with such overwhelming public successes as Dieter Ram's appliances for Braun or the Lufthansa signet, which resembles a crane.

The surge of politicization in the late sixties naturally included students of art and design, but also many young designers who were already active in their profession. Not a few of them dropped out in search of something better, such as a course of study in art education. Their protest was now directed against a practice that, if at all, could only have come from the late Dessau Bauhaus. At the time, I was teaching a whole group of such dissidents at the Pädagogische Hochschule in Berlin. They were searching for the link between politics and design, for the cause of the political malaise specific to their field. They already knew that the distinction between use value and exchange value in the first chapter of Karl Marx's D a s K a p i t a l was of no help to them, and were thus all the more excited about what could be learned from Herbert Marcuse's reading of Sigmund Freud. Whence the dis-

junction between design surface and functional object? What really lay hidden behind the reversion to basic forms, to cube and sphere, point and line, to the primary colors of red, yellow, and blue? In short, they were moving toward a critique of the Bauhaus.

■ UNIVERSITY POLITICS WITH HANNES MEYER

Claude Schnaidt's book Hannes Meyer: Bauten, Projekte und Schriften was published in 1965, but by the time it was assimilated into the left-wing architectural discussion, the student movement was a thing of the past. University politics now consisted of a struggle less between students and professors than among various leftist cadres. The combination of Bauhaus and communism had only limited appeal, not least of all because in West Berlin, it was propagated first and foremost by the communist Socialist Unity Party; let us not forget that at that time, the Hochschule der Künste (HdK) in Berlin—above all the architecture department—was firmly in the hands of people whose political home was in East Germany and who were studiously avoided as revisionists by others on the Left, whether Maoists or spontaneists. The working group around Jonas Geist, who taught at the HdK, was more interested in Meyer as a communist, rationalist, and systematizer than in his aesthetics.

Despite admiration for Meyer's architecture of the Allgemeiner Deutscher Gewerkschaftsbund school on the edge of Bernau, historically it was too late for his concepts to exert any influence. By the mid-seventies, the approaches to architecture and planning adopted by

the '68ers had long since developed in widely divergent directions. University training and practical application had gone their separate ways, and the architectural and professional discussions from the early seventies were already history. Regardless of what happened at the TU in Berlin, the focal point of activity had shifted to urban districts such as Kreuzberg and Wedding and into the hands of practitioners. The appearance of a banner reading "Hannes Meyer Haus"[1] over the main entrance to the architecture department on Ernst Reuter Platz one day in 1977 was an isolated moment that had nothing to do with the concurrent student strike protesting the new examination regulations.

In any case, by 1975 the convergence of modernism, socialism, and the Bauhaus had ceased to be viable. Julius Posener, who had never believed in the Bauhaus, pointed out that it was not the dictators who had strangled modernism, but rather the trend toward the monumentalizing—toward the fascistic, if you will—that had dominated all of Europe since the early thirties; meanwhile, design specialist Christian Borngräber assiduously defended the aesthetics of Stalinallee. The general discussion had thus long since moved on. As far as the current favorites of the architectural scene were concerned, Aldo Rossi was the new star, and what he promised pointed in the opposite direction—if not politically, then certainly aesthetically. Finally, Robert Venturi's book Learning from Las Vegas buried the entire question of the connection between form and socialism in the desert sand of architectural irony. Since then, the Bauhaus has truly been historical.

1 Along with Italian architect and fellow communist Aldo Rossi, Hannes
 Meyer was an important point of reference for the architectural
 segment of the student movement. Texts by and about Meyer were
 published in the magazine A r c h + in 1974 and the A r c h i t e k t u r
 S t u d e n t e n Z e i t u n g in Vienna in 1979. During a national
 university strike in the winter semester of 1976/77 protesting
 "Berufsverbote" (the banning of those with suspect political opinions
 from public service), a strike assembly at the TU in Berlin resolved to
 rename the university's architecture building "Hannes Meyer Haus."
 The idea originated in a study group that had come out of a seminar
 taught by Jonas Geist and Joachim Krausse. Along with the two
 instructors, the group consisted of a number of students, including
 Hilde Léon and Martin Kieren. Since Meyer was little known, the
 study group presented an informational program on February 10,
 1977, and produced a brochure entitled H a n n e s M e y e r : D i e
 T r a d i t i o n u n d W i r . In the three issues published, the brochure
 profiled socially engaged architects such as Hannes Meyer,
 Alexander Schwab, Bruno Taut, and Martin Wagner, as well as reform
 models of architectural education at the Bauhaus, the HfG in Ulm,
 and the TU Berlin. Later, at the ETH (Swiss Federal Institute of
 Technology) in Zurich, Kieren studied the portion of the Meyer estate
 present at that location and wrote his doctoral dissertation on the
 subject. In 1989, he co-curated an exhibition in honor of Meyer's
 one-hundredth birthday, shown in Berlin, Frankfurt am Main, and
 Zurich.

ARCHITEKTUR

BAUHAUS

10

STATE DOCTRINE
OR CRITICISM OF THE REGIME
ON THE RECEPTION OF THE BAUHAUS
IN EAST GERMANY, 1963–1990

Wolfgang Thöner

In 1976, the Bauhaus was officially recognized by the German Democratic Republic (GDR). Not only were internal debates halted from that time forward, but individual exhibitions were also organized, several books were published, and Bauhaus buildings were given landmark status. More importantly, however, there was now an institution—the Wissenschaftlich-Kulturelles Zentrum (Scientific-Cultural Center) (WKZ) in the Bauhaus building, which was initially run by the University for Architecture and Civil Engineering Weimar (HAB) and funded by the city of Dessau until 1986—that kept the Bauhaus in the public eye by means of events as well as by assembling a collection. This development received fresh impetus after 1986: the Bauhaus Dessau was reestablished as a center for design.

The debate regarding this institution took on a new quality in 1963 upon the publication of the short book D a s schöpferische Erbe des Bauhauses 1919– 1933 (The Creative Legacy of the Bauhaus 1919– 1933) by the Soviet author Leonid N. Pazitnov.[1] Bauhaus and progress: this combination of terms became almost obligatory in East Germany. In 1967, the Staatliche Galerie Dessau in Georgium Castle put on the exhibition M o d e r n e F o r m g e s t a l t u n g : D a s f o r t s c h r i t t - l i c h e E r b e d e s B a u h a u s e s (Modern Design: The Progressive Legacy of the Bauhaus). The permanent

226

exhibition that was opened at the Bauhaus in 1976 was entitled D a s p r o g r e s s i v e E r b e d e s B a u - h a u s e s u n d d i e E n t w i c k l u n g v o n S t ä d t e - b a u , A r c h i t e k t u r u n d F o r m g e s t a l t u n g i n d e r D D R (The Progressive Legacy of the Bauhaus and the Development of Urban Planning, Architecture, and Design in the GDR). And the first Bauhaus colloquium in late October 1976 in Weimar bore the title "Die progressiven Ideen des Dessauer Bauhauses und ihre Bedeutung für die sozialistische Entwicklung von Städtebau und Architektur sowie für die industrielle Formgestaltung in der DDR" (The Progressive Ideas of the Dessau Bauhaus and Its Importance for the Socialist Development of Urban Planning and Architecture as well as Industrial Design in the GDR).

In East Germany, speaking of the Bauhaus and its legacy was always a political issue tied to questions regarding art and culture as well as what was known as the "socialist way of life." For Walter Ulbricht, the General Secretary of the Socialist Unity Party (SED), the Bauhaus was still akin to an "enemy of the people" in 1951.[2] The East German leadership prescribed a cultural concept of "national traditions" in which there was no room for the Bauhaus. The opening after 1956—contingent upon economic necessities and forced by discourses in the academic and design disciplines—took place without an overriding concept. The basic conflict remained: on the one hand, there was a practice that not only aimed at the design of mass needs but also at increasing individualization and cultural policies, while it, on the other hand, consistently had an eye on the reason of state in addition to the political workings of art and design.

The present text devotes itself first to the question about how official dealings with the legacy of the Bauhaus attempted to harmoniously integrate it into the East German canon of values, and secondly, how a potential of conflicts came about that provoked a controversy.

■ PERSONNEL CONTINUITY/ DISCOURSE WITHOUT A FORUM

The Bauhaus was not only present in East Germany through its publications, its products for everyday life, and its dilapidating buildings. Of greater significance, however, were the Bauhaus veterans working as architects, designers, and university teachers in Weimar, Berlin, Dresden, and Halle, all of whom were familiar with the modernism debates that had taken place in left-wing circles in the twenties. While many of them had conformed to the new accepted order, they were all interested in a rehabilitation of the Bauhaus. A conflict was inevitable on numerous levels, because the "progressive legacy" of the Bauhaus, after its across-the-board condemnation in the early fifties, was now to provide legitimacy to the political system. But an atmosphere of constructive debate had never developed on a political level for experiments in terms of art and design. On the contrary, provocations were undesired and regarded as disruptive and even sabotage. Outside the boundaries of pure academic discourse, those who questioned the doctrine faced state repression.

The new debate on the Bauhaus began at a time marked by the "new economic system of planning and controlling the economy." After the Berlin Wall was erected in 1961, East Germany's economic power was to be

increased by means of increased competition. The "national traditions" were disbanded not least because the SED had abandoned the goal of German reunification. A spirit of optimism existed for a while in the field of art and design, but was soon disappointed by the censorship and prohibition measures that followed the Eleventh Plenum of the Central Committee of the SED in 1965 and by the events in reaction to the developments in Czechoslovakia in 1968. In the meanwhile, however, questions regarding a standard of living largely defined by consumption took on a new significance. Product design in particular—which was consistently characterized as "industrial design" in East Germany—was now removed from the ideological art discourse. At that time, the view was expanded to include a "management of the environment" in which the responsibility of designers from all disciplines was dealt with, also with respect to the Bauhaus.[3]

■ PLANS FOR THE RESTORATION OF THE BAUHAUS/THE FAILURE OF WALTER GROPIUS'S PLANNED VISIT

As one of the first after the "formalism" debate, Karl-Heinz Hüter examined the Bauhaus issue in 1956 and gave a positive evaluation of the school.[4] Herbert Letsch, on the other hand, accused the institution around 1960 of a technologized aesthetic that stood in contrast to a humanist art.[5] Starting in 1962, the city of Dessau sought to restore the Bauhaus. The Dessau architect Karlheinz Schlesier summarized the resolutions in a "Concept Paper on the Reconstruction of the Bauhaus in Dessau" in 1964.[6] It was the hope for an improvement in East

Germany's reputation in specialist circles and abroad that led to such dealings with the previously unloved legacy. That same year, Walter Gropius's American biographer, Reginald R. Isaacs, traveled to East Germany to interview former members of the Bauhaus and historians and as well as to prepare the way for a visit by Gropius. This request led to a meeting that took place in late October 1964 at the Haus des Lehrers on Alexanderplatz in Berlin. The president of the Federation of German Architects, Hans Hopp, the East German general conservator, Ludwig Deiters, the architectural historians Karl-Heinz Hüter and Kurt Junghanns, and the Bauhaus veteran and retired university teacher Peter Keler were among those who participated, together with several representatives of the Ministry of Culture. Gropius's wish to visit Dessau and Weimar was "accepted with approval and willingness to consider an invitation."[7] What was still lacking, however, was an official assessment of the Bauhaus. "Because inviting Prof. Gropius presupposes our unequivocal position on the Bauhaus," Schlesier noted, "a clarifying statement is to be compiled as soon as possible making use of existing material and in cooperation with the Ministry of Culture, the German Architectural Academy, and the HAB."[8]

And something else was also resolved at the meeting at the Haus des Lehrers: "The large-scale architectonic reconstruction of the Bauhaus in Dessau by the Ministry of Culture, the Council of the District of Halle, and the Dessau City Council will commence in 1965."[9] An opinion of the German Architectural Academy written by Junghanns in November 1964 emphasized that the Bauhaus and its building were not only significant as a

socialist legacy, but also had international standing as a "historic monument of the institution and as an artistic monument from the early period of contemporary architecture." To disregard this legacy would mean to be in danger of "arousing incomprehension and astonishment in the capitalist and socialist camps and particularly provoke the criticism of the architectural colleagues in the GDR."[10] Junghanns also argued that the Bauhaus provided support to the German Communist Party and that it was "opposed by the reactionary wing of the German bourgeoisie and dissolved in 1933." As regards the estimation of the Bauhaus as an initiator of current developments, Junghanns pointed out that its "new objective stylistic elements" can be considered important stimuli "in the phase of the transition to industrial building methods and the struggle for the recognition of the modular construction system as the foundation of a socialist architecture." The "cultivation of Abstract Art and the one-sidedness of the architects influenced by it" are, on the other hand, to be rejected as a "negative consequence of capitalism."[11]

■ INTERPRETATIONS OF THE BAUHAUS/ LOTHAR LANG AND DIETHER SCHMIDT

In the end, Gropius did not visit the sites of his earlier activities in Weimar and Dessau. And the Bauhaus was not restored until ten years later. But at least Bauhaus buildings were entered on landmark lists and research on the Bauhaus was revived.

Lothar Lang's Bauhaus book was published in 1965. In it, he singled out the Dessau period as a decisive phase, because its transition from "abstract constructivism to

concrete functionalism"[12] also laid the foundation for socialist architecture and industrial design. Only in an educational context was Lang to offer a positive opinion of the Abstract Art of the Bauhaus.[13] Diether Schmidt's Bauhaus book was published in 1966. He primarily emphasized the notion of a new "Gesamtkunstwerk" from which concepts to create an environment that allowed all members of society to live equally in dignity were developed. Hannes Meyer, on the other hand, accused Schmidt of "latent art animosity."[14] Both authors agreed that the Bauhaus Dessau under the directorship of Walter Gropius was of particular contemporary interest. The outcome of this interpretation made its way into the official curriculum of the extended secondary school. A primer of architectural styles for the tenth grade dating from the sixties shows an illustration of the Bauhaus on the cover alongside other significant buildings from the history of European architecture. A photograph of the Dessau building heads the chapter dealing with "Architecture in the Capitalist Era." In the same section of the primer, Crown Hall in Chicago, which was designed by Ludwig Mies van der Rohe, the third director of the Bauhaus, advanced "in its outer architectonic discipline, the unity of space and body ... to become one of the most impressive buildings of recent decades."[15]

■ THE BAUHAUS ANNIVERSARY IN 1976/ AN ATMOSPHERE OF PARALYSIS
In the meantime, the use of the Bauhaus as an educational facility for designers was now also conceivable at an official level. There were, however, points of contention involving attitudes relating to the structure of such

an institution as well as notions regarding Abstract Art which could not be integrated into the concept of Socialist Realism as it existed at the time. The reasons for the Bauhaus itself not yet having been restored were, however, purely economical. When Manfred Sack, the architectural critic of the Hamburg weekly news magazine D i e Z e i t visited Dessau in 1972, he no longer encountered an ideological rejection of the Bauhaus; "shortages were the primary obstacle for a restoration," Sack wrote. "There was a scarcity of money, of construction material, and of construction workers."[16]

The financing and the logistics required for a restoration were clarified several years later at a government level; a "permanent Bauhaus study group in the GDR" was constituted.[17] The Bauhaus was restored on the occasion of its fiftieth anniversary in early December 1976; the WKZ commenced working. Yet the event was overshadowed by a culturally and politically explosive disciplinary measure: in mid-November 1976, the East German government responded to a concert given in Cologne by the singer-songwriter Wolf Biermann by denaturalizing him. Protests in the GDR were followed by prohibitions and retributions. An atmosphere of paralysis ensued. While this atmosphere did not ostensibly affect the Bauhaus anniversary, the painting S o n g v o m l e t z t e n B a u h a u s f e s t (Song of the Last Bauhaus Celebration) by the Bauhaus veteran Carl Marx does contain hidden allusions to Biermann's denaturalization.[18]

Along with Richard Paulick, Grete Reichardt, Franz Ehrlich, Hubert Hoffmann, and Max Bill, among others, Carl Marx was one of the Bauhaus veterans to come to Dessau for the fiftieth anniversary celebrations. The

above-mentioned permanent exhibition was opened in the former studio tract. Members of the Free German Youth presented the Bauhaus veterans with a medallion minted to commemorate the anniversary. From then on, the Bauhaus was now a part of official East German culture. There was a clear shift in the aspects of the Bauhaus that were now considered "progressive": While Walter Gropius and Ludwig Mies van der Rohe were regarded before 1976 as the "most progressive" Bauhaus directors, after that it was Hannes Meyer. And after 1986, Meyer's concept was in fact regarded as the single most important legacy of the Bauhaus, as the East German housing program could also be attributed to it.

■ BAUHAUS COLLOQUIUMS/ NEW THINKING ABOUT ART

The Bauhaus colloquiums established themselves as a significant international forum. Along with Constructivism, other tendencies of Abstract Art at the Bauhaus were now also considered an important part of its legacy. At the Second Bauhaus Colloquium in 1979, Harald Olbrich said that the time had come to "simply call the works of art from the 'Bauhaus' and its surroundings 'beautiful' within the total context of our legacy policy. Not only because of its usefulness for art, architecture, and design education, but also for its own sake in the face of its specific aesthetic and humanist potential." But what Olbrich propounded did not amount to a rejection of Socialist Realism; he sought an expansion of artistic means and placed a new accent on "realistic models of reception."[19] Karin Hirdina examined "Bauhaus functionalism," to which the author attributed the role of an aesthetic prin-

ciple in the field of architecture and design similar to the one played by realism in the field of art.[20] As a consequence of his critical examination of the Bauhaus, the philosopher and cultural theorist Lothar Kühne developed his reflections into an integrated model of a socially and ecologically sustainable society as well as its corresponding spatial and objective fashioning. Kühne sought a design concept "that combines the values of urban life with those of nature for the populace."[21] He criticized the social as well as architectural reality of the GDR. He saw exemplary models in the architecture of Gropius's Bauhaus in Dessau and in Meyer's Bundesschule in Bernau.

The final congress of the East German Artist's Federation took leave of the term Socialist Realism in 1988. The more open "functional understanding of realism" that had already been employed in the late seventies served to continue to set East Germany apart from art in the West and its links to capitalism.[22] The term realism became almost congruent with the term art, just as the term functionalism became synonymous for good architecture and design for some of the theorists mentioned above.

■ PERFORMANCE ON THE BAUHAUS STAGE/LUTZ DAMMBECK'S EXHIBITION

The term realism was used for all art forms deemed useful to society and which employed means of design that were comprehensible to as large a section of the populace as possible. This terminology could hardly encompass actions and performances such as those based on Joseph Beuys's concept of social sculpture. But this art as well, in addition to the theater influenced by it, had

become particularly important for the Bauhaus in the early eighties. Until 1983, concentration had been placed on expanding the collection, the cataloguing of bequests, as well as events taking place on the stage. There was no overriding concept, and there were also no official guidelines in this regard. It was first Lutz Schöbe, who came to the Bauhaus in 1983, who had the plan of again making the institution a place of experimentation for critical multimedia art.

The first Action artist to appear on the Bauhaus stage was the Joseph Beuys follower Erhard Monden, whose performance took place in conjunction with the Second Bauhaus Meeting in mid-September 1984. In later years, Via Lewandowsky and Else Gabriel from the "auto-perforation" scene in Dresden also performed in Dessau. A new collaboration was begun with the Leipzig artist Lutz Dammbeck, after which future projects were modeled. In early January 1985, Dammbeck staged his multimedia piece H e r a k l e s, on which he collaborated with other artists, such as the performer Fine Kwiatkowski, at the Bauhaus.[23] The performance on January 19, 1985, was entitled L a S a r r a z. Films showing National Socialist parades and photographs of sculptures by Arno Breker were projected onto paintings produced on the spot as well as onto the dancer's body. Dance and sound collages drastically dealt with the mechanisms of disciplinary measures in authoritarian states. The parallels to the patterns of action as regards East Germany's social and political reality were more than evident.

The highlight was an exhibition shown from late November 1985 to early February 1986 in the former Bauhaus cabinetmaker's workshop under the title L u t z

Dammbeck—Bilder, Collagen, Aktionsdoku-mentation (Lutz Dammbeck—Pictures, Collages, Action Documentation). On the occasion of the opening on November 30, 1985, Dammbeck performed the mul-timedia action R E A L F i l m in the overcrowded audito-rium. The planned exhibition z . z t . (At the Moment) was supposed to show critical photographs by Andreas Hentschel, Thomas Florschuetz, Andreas Leupold, and Matthias Leupold from late March to late May 1986. The invitations—prints of a photograph by Florschuetz—has already been printed. The Dresden group Fabrik was to play at the opening, and the author Sascha Anderson was scheduled to speak. But then the Ministry for State Security intervened and prohibited the exhibition. Participants were disciplined; some left the GDR.

■ BAUHAUS ANNIVERSARY 1986/THE REESTABLISHMENT OF THE BAUHAUS

The reestablishment of the Bauhaus Dessau took place at the height of this kind of "course correction." The exist-ing advanced training and experimental facilities were merged with the WKZ to form the Bauhaus Dessau at a ceremonial act on the occasion of the sixtieth anniver-sary of the opening of the Bauhaus on December 4, 1986. A board of trustees comprising representatives of the Building and Culture Ministry and the Office for Industrial Design watched over the institution's course. A special role was played by Bernd Grönwald, professor at the HAB and vice-president of the East German Architectural Academy. The urban sociologist Rolf Kuhn was made director of the new Bauhaus. As Grönwald wrote in a local newspaper at the time, the goals of the

Bauhaus were "maintaining the legacy, practice-oriented research, and advanced training."[24]

After an interview with Kuhn, the same local newspaper reported in late 1987 how the new Bauhaus had "taken on the challenge" of "linking on to the tradition of socially oriented architecture. We are still obliged to the programmatic goals of the 'old' Bauhaus members that will first become possible in socialist society. Here, in the GDR, the housing question will be solved by 1990. But even now, we must already begin developing ideas regarding housing and urban development in the nineties."[25] In this sense, the First Walter Gropius Seminar that took place with international participation in 1987 pointed the way to a reversal of the dominating urban planning policies with interdisciplinary designs for downtown Dessau. The realization of these plans, however, foundered on typically East German realities. The planned richly varied conclusion of the north side of the Dessau marketplace was to be built by means of industrial housing construction. It involved putting an end to building on the outskirts of town and the end of the decay of the inner cities. Interior architectural suggestions were simultaneously produced at the Ferdinand Kramer Seminar. The controversy largely concerned the technical and economic requirements that would have made the production of construction elements with a larger span possible. The selected design was never built; the plan fell through in 1988.

Several weeks earlier, the E x p e r i m e n t B a u h a u s exhibition organized by the West Berlin Bauhaus Archive opened in Dessau. The show was probably the most spectacular outshot of the cultural agreement concluded

by East and West Germany in 1986. The Bauhaus had become an integrating factor in the convergence of the two German states. But the GDR did not simply shelve its old strategy. While the governing mayor of West Berlin, Eberhard Diepgen, saw in his address on the occasion of the exhibition opening in early August 1988 the "current relevance of the Bauhaus concept" in the measure of "self-administered freedom of teaching and education,"[26] Karl Schmiechen, the East German undersecretary for urban development, housing, and local construction, used the "scientific foundations of social housing" worked out at the Bauhaus"[27] as a rationale for East Germany's housing policies. This was thwarted by the failure of the First Walter Gropius Seminar, but it remained uncommented on in both the East and West.

Jo Fabian's play E x a m p l e N o . P . , which depicts confinement, stagnation, and futility in dreamlike scenes, was performed on the Bauhaus stage in late summer 1989.[28] The piece was cancelled after two performances for political reasons, and only the opening of the borders prevented the planned disciplinary measures against the Bauhaus director. During that same November week, when the Berlin Wall fell, an international seminar was taking place at the Bauhaus Dessau in which the idea of the Industrial Garden Realm was born. For about ten years, this concept served as the guiding principle of the Stiftung Bauhaus Dessau, which was founded in 1994.

Until the end of the GDR, its leaders were never interested in developing a critically activating institute that took social contradictions into consideration with reference to the Bauhaus legacy. Seen from the perspective of the political practicalities of art and culture, it was

rather the case that one solely reacted to developments in the practice and theory of art and design. The political authorities utilized the Bauhaus more like a "marketing" instrument through which East Germany would also be able to attain a "world-class standing" in the field of architecture and design. The comprehension of the Bauhaus as a place of experimentation and the wish to develop it as a venue where criticism of common practices and the designing of alternatives could have taken place was, on the other hand, only possible for a brief while, and then only in very specific circumstances and only accompanied by the civil courage of its agents.

1 Leonid N. Pazitnov, Das schöpferische Erbe des Bauhauses (Berlin, 1963).
2 Walter Ulbricht, "Rede vor der Volkskammer am 31.10.1951," cited in Andreas Schätzke, Zwischen Bauhaus und Stalinallee: Architekturdiskussion im östlichen Deutschland 1945−1955, Bauwelt Fundamente 95, ed. Ulrich Conrads and Peter Neitzke (Braunschweig and Wiesbaden, 1991), p. 145.
3 See Siegfried Heinz Begenau, Funktion−Form−Qualität: Zur Problematik einer Theorie der Gestaltung (Berlin, 1967), p. 69.
4 The summing up of his research was first published many years later. See Karl-Heinz Hüter, Das Bauhaus in Weimar: Studie zur gesellschaftspolitischen Geschichte einer deutschen Kunstschule (Berlin, 1976).
5 Herbert Letsch, "Zur Frage des Klassencharakters der ästhetischen Konzeption des Bauhauskonstruktivismus," Wissenschaftliche Zeitschrift der Hochschule für Architektur und Bauwesen Weimar 2 (1959/1960), pp. 143−149.
6 Stadt Dessau, Stadtbauamt, Stadtarchitekt Karlheinz Schlesier, "Konzeption für die Rekonstruktion des Bauhauses in Dessau," June 20, 1964, Stadtarchiv Dessau, SB/68.
7 Cited in Karlheinz Schlesier, "Aktenvermerk zur Beratung am 29.10.1964," October 31, 1964, private archive.
8 Ibid.

9 Ibid.
10 Kurt Junghanns, "Gutachten der Deutschen Bauakademie, adressiert an den Bund Deutscher Architekten, zur Auf- nahme des Bauhaus-Gebäudes in die Liste der zentral betreuten Baudenkmäler," November 23, 1964, transcript, Stadtarchiv Dessau, SB 68.
11 Ibid.
12 Lothar Lang, Das Bauhaus 1919–1933: Idee und Wirklichkeit (Berlin, 1965), p. 62.
13 Ibid., p. 96
14 Diether Schmidt, Bauhaus, Weimar 1919 bis 1925, Dessau 1925 bis 1932, Berlin 1932 bis 1933 (Dresden, 1966), p. 47.
15 Architektur, Bauwerke und Baustile von der Antike bis zur Gegenwart: Lehrbuch für die Kunstbetrachtung in der zehnten Klasse der erweiterten Oberschule (Berlin, 1965), p. 188
16 Manfred Sack, "Am Anfang war das Bauhaus," Zeit Magazin (September 8, 1972), pp. 2ff.
17 See Martin Bober, Von der Idee zum Mythos: Die Rezeption des Bauhaus in beiden Teilen Deutschlands in Zeiten des Neuanfangs (1945 und 1989), Ph.D. diss. (University of Kassel, 2006), p. 154, available online at http://kobra.bibliothek.uni-kassel.de/handle/ urn:nbn:de:hebis:34-200603157583
18 See Wolfgang Thöner, "'Anstöße und Erkenntnisse, die meinem ganzen Leben Substanz und Richtung gaben,' Der Dessauer Maler Carl Marx und das Bauhaus," in Dessauer Kalender 2007: Heimatliches Jahrbuch für Dessau und Umgebung (Dessau, 2006), pp. 30–41.
19 Harald Olbrich, "Maler am Bauhaus—Probleme der Forschung und Rezeption," Wissenschaftliche Zeitschrift der Hochschule für Architektur und Bauwesen Weimar (May 4, 1979), p. 367.
20 Karin Hirdina, "Zur Ästhetik des Bauhausfunktionalismus," Wissenschaftliche Zeitschrift der Hochschule für Architektur und Bauwesen Weimar (June 5, 1976), pp. 520–522. See also Karin Hirdina, Pathos der Sachlichkeit: Tendenzen matrialistischer Ästhetik in den zwanziger Jahren (Berlin, 1981).
21 Lothar Kühne, "Haus und Landschaft: Zu einem Umriss der kommunistischen Kultur des gesellschaftlichen Raums," in id., Haus und Landschaft: Aufsätze (Dresden, 1985), p. 39.

22 See Ulrike Goeschen, Vom sozialistischen Realismus zur Kunst im Sozialismus: Die Rezeption der Moderne in Kunst und Kunstwissenschaft der DDR (Berlin, 2001).

23 The project is described in Torsten Blume and Burghard Duhm, eds., Bauhaus Bühne Dessau: Szenenwechsel (Berlin, 2008), pp. 70–75.

24 Bernd Grönwald, "Neues Leben im Bauhaus," Freiheit, Tageszeitung der SED für den Bezirk Halle, November 29/30, 1986, p. 9.

25 Marlene Köhler, "Die Herausforderung angenommen," Freiheit, Tageszeitung der SED für den Bezirk Halle, Sunday supplement Blick, October 9, 1987, p. 10.

26 Eberhard Diepgen, "Rede zur Eröffnung der Ausstellung Experiment Bauhaus am 6.8.1988 in Dessau," cited in Bober 2006 (see note 17), p. 151.

27 Karl Schmiechen, "Rede zur Eröffnung der Ausstellung Experiment Bauhaus am 6.8.1988 in Dessau," cited in ibid, p. 152.

28 The project is described in Blume and Duhm 2008 (see note 23), pp. 84f.

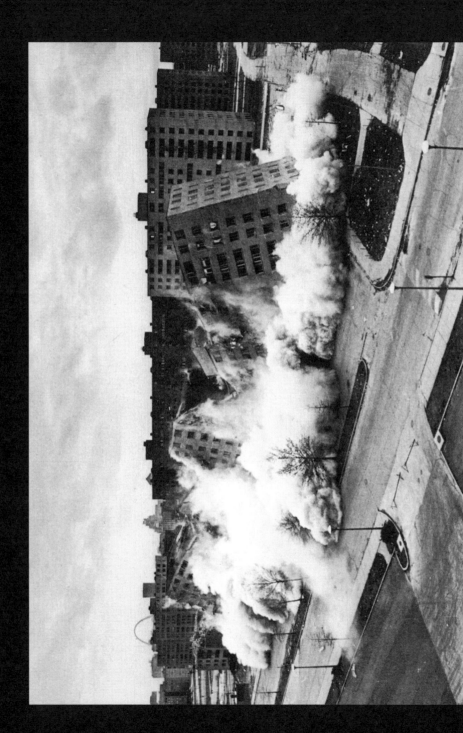

244

LEMON TARTS
ON A BARCELONA CHAIR
TOM WOLFE'S FROM BAUHAUS TO OUR HOUSE

Ullrich Schwarz

In the fall of 2007, on the occasion of the twenty-fifth anniversary of his book From Bauhaus to Our House, Tom Wolfe appeared at Yale University in his white suit to discuss his old theses. His furious attack on the architecture of Bauhaus modernism in America had been published in 1981. He was not an architectural historian, but rather one of the most prominent representatives of New Journalism, and his book was conceived not as a contribution to architectural history but as a cultural-historical polemic. Accordingly, his tone was ironic, sarcastic, always with a punch line; well informed in the details, he leaned toward tendentiousness. The main arguments of the book are easily summarized: in the United States, a European invasion of the Bauhaus style spearheaded by Walter Gropius had dictated an approach to architectural taste that ignored the wishes of both the clients and "the people." A clique of architects—Wolfe called them a "compound"—maintained this dictatorship of taste. The imported style of the Bauhaus was the sign of an inferiority complex and had nothing to do with American culture.

On that occasion in 2007, Wolfe, a Yale graduate, was joined by Peter Eisenman, a professor at Yale. Naturally, this combination—the eccentric journalist and popular novelist on the one hand, and the equally eccentric grand old man of American architectural discourse on the

other—drove the ratings to the top of the chart. The hall was filled to overflowing; it was a media event, though admittedly somewhat lacking in content. Wolfe repeated his assertions from former days; Eisenman confined himself to arrogant jibes.[1] The conversation between Wolfe and Eisenman immediately following the publication of the book had been similarly unsatisfying.[2] Wolfe was given opportunity to formulate his opinions on modern architecture in his typical hyperbole; Eisenman—who of course for Wolfe was a member of the dominant architectural clique—remained surprisingly reserved during the conversation; he was indifferent, at most amused.

■ INCAPABLE OF SATISFYING THE ARCHITECTS

This attitude seems not atypical of the initial reaction to Wolfe's book in the American architectural world. Already a well-known media personality in 1981, Wolfe did receive a major review by Paul Goldberger, architecture critic of the N e w Y o r k T i m e s , as well as write-ups in various magazines. Yet the reigning U. S. architectural scene—what Wolfe called the "compound"—scarcely acknowledged the book at all. Of course, one could see that as proof of Wolfe's thesis of a "compound" that would brook no opposition, but the lack of response from the architectural profession probably had more to do with the content and timing of his critique of modern architecture. Even apart from his conspiracy theory, one has to conclude that the journalist Wolfe was simply incapable of satisfying the profession. This undoubtedly came as no surprise to Wolfe himself, since his strategy consisted of casting everything that diverged from his

conception of "American architecture"— situated some-where between Frank Lloyd Wright and John Portman—into the Hades of modernism, whether the Bauhaus tradition in the narrower sense, postmodernism, or deconstruction. And so for Wolfe, Walter Gropius, Robert Venturi, and Peter Eisenman ultimately all stood for the same thing: a clique system that despised the masses and which, in the throes of a cultural "colonial complex," prostrated itself before anything European. In a reverse polemic one might be tempted to say that Wolfe's campaign against un-American activities made him the McCarthy of architecture; hence, his most vehement critics denounced him as "reactionary."[3]

What more can you say after a political karate chop like that? That kind of rhetorical annihilation requires few words. Winfried Nerdinger, for example, in one of the few direct reactions to the book in Germany, described it as "a vilification as fashionable as it is stupid." [4] Aside from complete contempt, this type constitutes the severest form of response to Wolfe. And then there is the type of the reprimand, where the author is indicted for a myriad of historical errors. Wolfe probably only laughed at this kind of ultra-pedantic humorlessness, since his critics mistook the genre of his text: Wolfe was writing not a scholarly treatise on the history of the Bauhaus and its reception in the United States, but a polemic intended for the laity—not by chance first published in H a r p e r ' s M a g a z i n e . It was probably the funniest account that had ever been given of its subject. But as is well known, few professions handle wit, irony, and sarcasm as poorly as architects. That is not coincidental; it has to do with

their understanding of themselves. Here Wolfe makes his point even in the humorless response to his provocation. And then we have the third type of reaction. This category includes those reviews of Wolfe's book that distance themselves from its constant hyperbole, one-sidedness, and glaring omissions, and may even reproach the author for the one or the other historical error, but finally arrive at the conclusion: somehow the fellow has a point and has not completely missed the mark. Goldberger's review in the New York Times was a prominent example of this approach.[5] First he summarized one of Wolfe's central theses: that the "compound" had its heart set on bringing more and more boring, culturally impoverished steel-and-glass boxes into the world and in so doing had lost touch with "common sense." Characteristically, then, Goldberger follows with the rather prim commentary that Wolfe's argument "is not altogether distant from the truth." Modern architecture, according to Goldberger, never was as popular as its creators contended; the rows of abstract skyscrapers have destroyed the vitality of American cities. In the end, however, Goldberger doubts that Wolfe is really interested in architecture and implies that he is actually more concerned about the hot salon topics of the rich and beautiful in uptown Manhattan.

So much for the tenor of the reaction to Wolfe's book in the American media. Interestingly, the reviews in architectural journals were especially apathetic and lacking in content, noting merely that while Wolfe may have touched on a few important, critical aspects related to modern architecture and urbanism, on the whole his arguments

were weak. In particular, the thesis of the cultural infiltration of America through the wholesale, unresisting acceptance of European influence seemed to elicit a generally negative response.

■ POPULAR WITH ORDINARY PEOPLE

The reserved, if not non-existent, reaction to Wolfe's critique of the Bauhaus among architectural professionals contrasts strikingly with the book's extraordinary circulation both in the United States and worldwide. The American original was reprinted in numerous editions; it was translated into numerous languages and disseminated internationally. Although this broad reception is hard to document, one has to proceed from the as-sumption that Wolfe's book hit a nerve. Apparently, a widespread uneasiness about modernism had arisen by the sixties at the latest and had by no means diminished in 1980. This unease had little to do with the specific architectural subtleties of the Bauhaus and its aftereffects, but was more diffuse and was fueled by the vision—now in a genuinely bad sense—of the constructed reality of the International Style.

In the eyes of large segments of the population, the reality of modern architecture had ultimately failed to produce the "New Jerusalem" envisioned by many proponents of Neues Bauen (New Architecture) in the twenties. Of course Wolfe was not the first to give voice to this unease, but the success of his book indicates how popular critiques of the Bauhaus and of modern architecture had meanwhile become. The contrast between the public circulation of the book on the one hand and the almost compulsively suppressed professional reaction on the

other bears witness to a communication breakdown between architects and public, one that persists even to this day. Empirical investigations have shown that architects and ordinary people differ widely in their opinions about good architecture; it is still hard for architects to describe the views of laypeople in terms other than "uninformed," "narrow-minded," "philistine," and the like. The diverging responses to Wolfe's book were an indicator of this dilemma and of the fact that even in 1980, the public had little awareness that a radical self-critique of modernist architecture had long since been in progress.

■ THE MYTH OF THE BAUHAUS INVASION

Wolfe's historical inaccuracies are not difficult to demonstrate. The notion that a handful of white Bauhaus gods—perhaps supported by Mr. Rockefeller and his Museum of Modern Art (MoMA) in New York—would be in a position to turn both the education of architects and the architectural production of the United States completely upside down is more than naïve. On the one hand, such a notion grossly overestimates the influence of a few persons; on the other, it grossly underestimates the pervasive willingness of Americans—by no means the result of a cultural inferiority complex—to adopt the architecture of modernism. Wolfe portrays the historical process as the almost violent overwhelming of a helpless partner. In addition, the impact of the exhibition The International Style at MoMA in 1932 so exaggerated by Wolfe is assessed quite differently by an art historian like Hilton Kramer: Kramer speaks of it influencing at most "a few dozen people."[6]

In this case, Wolfe is presenting not so much an error as an intentional distortion for ideological reasons. In reality, the cultural and political reciprocity between Europe and the United States was much more complex than Wolfe portrays it. Thus, in his review of the book, Michael Sorkin points indirectly to a decisive historical aspect that Wolfe ignores: "Modern architecture triumphed because it fit both the expressive and the functional requirements of those who built it. It may have been invented in Europe, but we sure were ready. Those buildings were the cheapest you could build and as replicable as the Model T Modern architecture didn't conquer America; it was the other way around."[7]

■ RATIONALIZATION À LA FORD

Although Sorkin was not thinking of this, the mention of Henry Ford's legendary Model T points to a historical recognition that casts doubt on Wolfe's simplistic concept of influence. As is well known, the principle of strict rationalization derived from Ford's factory system had gained a foothold in Europe not only in the industrial processes of labor, but in all areas of society before the Weimar Bauhaus even existed. Apart from Fordism and Taylorism, there is no making sense of ideas of the industrialization of building and, in general, the concepts of series, type, and standardization that were also developed in the Dessau Bauhaus. In the Europe of the first decades of the twentieth century, Ford was a hero across the spectrum from Right to Left. German industrial capitalists, social democrats, communists—even Le Corbusier in Paris and Vladimir Ilyich Lenin in Moscow—admired

American Fordism as the organizational foundation of social progress. In Europe, and above all in Germany, by 1900 at the latest, America stood for "modernity."[8] But this association also brought with it a cultural ambivalence. One person's promise of the future was another person's vision of horror. Thus it is not surprising to find the opinion in Germany at the end of the Weimar Republic that "not socialism, but Americanism will be the end of all things."[9] The United States as utopia or enemy—the appropriation of America by both Left and Right was not engraved in stone, but shifted almost arbitrarily from one side to the other, and back again. Thus in the early days of East Germany, the Bauhaus was rejected as "American," while in West Germany during the Cold War it radiated back from the United States as a unifying cultural symbol of "the West."[10]

■ A BOOK WITHOUT LASTING IMPACT

Wolfe's conspiracy theory thus has little to do with the historical reality of the twentieth century. Yet it hardly seems sensible to correct the author's errors and distortions in detail; his notion of a cultural infiltration of the United States is already fanciful enough. Other objections could be raised as well: in his talk of "the Bauhaus," Wolfe ignores the differences between its directors Walter Gropius, Hannes Meyer, and Ludwig Mies van der Rohe. Wolfe's lack of concern for differentiation becomes clear at the latest when he includes Le Corbusier in the Bauhaus tradition. Actually, he should have realized that he was using the term "Bauhaus" as a synonym for "modern architecture," but he never gets that far. His

concern is for style and design. He has no concept either of modern architecture or of modernism in general. Most likely, such themes just do not interest the New York society reporter; in any case, he understands nothing of these issues.

In this regard, Hilton Kramer notes pityingly that Wolfe is completely "helpless" when it comes to the real architectural discussion in the phase "after modernism."[11] The brief media hype following the publication of his book probably had more to do with the author's person than with his arguments. Beyond this, Wolfe's book had no lasting impact on the architectural discussion either in America or abroad, a fact that is due not to the allegedly repressive mechanisms of the architectural establishment, but rather to the lack of substance in his book. A survey of anthologies devoted to the recent and current architectural discussion that have come out since the eighties—for example the publications by Heinrich Klotz in 1984, Hanno Walter Kruft in 1985, Kate Nesbitt in 1996, Gerd de Bruyn and Stephan Trüby in 2003, and Akos Moravánszky in 2003—yields virtually no mention of Wolfe's name.

Nor is that a coincidence, of course, since even in 1981 Wolfe was hopelessly behind the times in terms of the current debate within the architectural field. Widely read books like Jane Jacobs' The Death and Life of Great American Cities published in America in 1961 and Alexander Mitscherlich's Die Unwirtlichkeit unserer Städte (The Inhospitality of Our Cities) published in West Germany in 1965 had already called the public's attention to the disaster of modern urbanism, an aspect Wolfe barely touches on.

■ THE SELF-CRITIQUE
OF MODERN ARCHITECTURE

With Wolfe there is of course no question of a serious treatment of modern architecture. Although a radical self-critique of modern architecture had begun decades before Wolfe appeared on the scene, he fails to even take note of it. Of all people, Henry-Russell Hitchcock—who had curated the famous New York exhibition on the International Style in 1932 together with Philip Johnson—had announced the dawn of the "late phase" of modern architecture as early as 1951, and in 1966 noted the death of the International Style.[12] In the seventies in particular, the drastic diagnoses proliferated: in 1976, Brent C. Brolin spoke of the "failure" of modern architecture, and in 1977, Peter Blake referred to it as a "fiasco"; that same year, Charles A. Jencks even announced its "death."[13] Nor did the obituaries cease; occasionally they were only announcements, but no more conciliatory for all that: "If it isn't dead already," said Colin Rowe, "then it will be soon."[14]

Wolfe was never so thorough, nor did he really want to know that much. He did not understand that in the mid-seventies, architects like Robert Venturi and Aldo Rossi—along with theorists like Manfredo Tafuri, Christian Norberg-Schulz, and Peter Eisenman—had introduced a revolution that he himself misread as a new, postmodern style. The Swinging Sixties had seen a last burst of the architectural avant-garde, for example in the mega-structures of Yona Friedman, Archigram, and Constant. But the Swinging Sixties had also seen increasing public criticism of the banalization of modern architecture into faceless and history-less economically determined func-

tionalism. By the mid-seventies at the latest, architecture had lost its narrative. The project of modernism had to be redefined.

Not surprisingly, a 1998 anthology edited by K. Michael Hays on the international architectural discussion since 1968 included no text by Wolfe. He was mentioned briefly only once in these eight hundred pages, if only to be graced once again with the adjective "reactionary."[15] This reference occurred in a lecture by Fredric Jameson, given in 1982 at Eisenman's New York Institute for Architecture and Urban Studies—a stronghold outside the university not only for the American, but also for the international architectural intelligentsia from the late sixties to the mid-eighties. During this period, the Institute's journal O p p o s i t i o n s was without doubt the most important international forum for architectural-theoretical discussions. If it existed anywhere at all, then this was the home of the "compound" that set the terms and standards of the debate around 1980.

In contrast, Wolfe's "compound" of old Bauhaus heroes had long since been consigned to the Hall of Fame. His anachronistic view prevented him from seeing that the development of the architectural discussion had long since moved beyond the pros and cons of the Bauhaus style. Beyond questions of taste in design, the attempt was being made to regain a substantial cultural role for architecture. That was, and is, easier said than done. Of course, one version of this attempt consisted of the effort, in an explicitly political dimension, to re-actualize the radical utopian content that had always been at least attested for modern architecture—though in so doing credence was not always given to the fact that such

architecturally mediated visions of a "New Jerusalem" were and are one of the primary problems of a self-mythologizing modernism.[16]

■ PERSPECTIVES ON MODERN ARCHITECTURE IN 1982

In any case, in New York in 1982 the American Marxist Fredric Jameson spoke about the Italian Marxist Manfredo Tafuri, seeking perspectives for overcoming the hopeless negativism of Tafuri's diagnosis of a politically interpreted departure from modern architecture. This kind of discussion—in the same city and at about the same time—embodied an intellectual ambience that was the polar opposite of the world in which Wolfe was at home. Parenthetically, it should be mentioned that in 1982, the question of a proletarian revolution was hardly at the forefront of the political agenda either in Europe or in the United States—and it was always something distinctive to be an American Marxist, especially in 1982. Lacking any social basis, American Marxism was always a purely academic phenomenon; it could therefore uninhibitedly indulge in even the most radical verbal flourishes.

Even Jameson cannot be exonerated from such academicism, though in the end, in order to escape from the self-blockade of Tafuri's position he took refuge no longer in a Marxist, but in a postmodern notion of social contradictions and heterogeneities. Jameson's lecture was one of the many attempts to conceive of a modernism beyond the avant-garde and beyond style. The remainder of the twentieth century was defined by attempts of this kind. To this project, however, Wolfe's book did not make the slightest contribution.

Back to Jameson and Tafuri: the memory of the New York lecture demonstrates the unbelievable simultaneity of the incongruity in the landscape of the American discussion around 1980. While Tafuri, as presented by Jameson, used Mies van der Rohe to lament the final silencing of modern architecture—actually, its end in the Hegelian sense—for Wolfe it is much more entertaining to ridicule the quasi-religious veneration of the Barcelona chair as a lifestyle icon. This is the world of the "Lemon Tarts," those very rich, very thin, very blonde New York society women whom he describes in his novel The Bonfire of the Vanities.[17] And that is his world.

1 Yale Daily News, September 11, 2007.
2 Peter Eisenman and Tom Wolfe, "Ein Interview: Unser Haus und Bauhaus," Arch + 63/64 (1982), pp. 94ff.
3 Garry Wills, "Pose and Prejudice," in Doug Shomette, ed., The Critical Response to Tom Wolfe (Westport, CT, and London, 1992), p. 141.
4 Winfried Nerdinger, "Das Bauhaus zwischen Mythisierung und Kritik," in Ulrich Conrads et al., eds., Die Bauhaus-Debatte 1953: Dokumente einer verdrängten Kontroverse, Bauwelt Fundamente 100 (Braunschweig and Wiesbaden, 1994), p. 8.
5 Paul Goldberger, "From Bauhaus to Our House," The New York Times, October 11, 1981.
6 Hilton Kramer, "Tom Wolfe vs. Modern Architecture," in Shomette 1992 (see note 3), p. 139.
7 Michael Sorkin, "Wolfe at the Door," in id., Exquisite Corpse: Writing on Buildings (London and New York, 1991), p. 45.
8 Christian Schwaabe, Antiamerikanismus: Wandlungen eines Feindbildes (Munich, 2003), p. 10.
9 Günther Dehn, cited in ibid., p. 73.
10 Paul Betts, "Die Bauhaus-Legende: Amerikanisch-Deutsches Joint-Venture des Kalten Krieges," in Alf Lüdtke et al., eds., Amerikanisierung: Traum und Albtraum im Deutschland des 20. Jahrhunderts (Stuttgart, 1996), pp. 270ff.
11 Kramer 1992 (see note 6), p. 139.

12 Henry-Russell Hitchcock and Philip Johnson, Der Internationale Stil, 1932, Bauwelt Fundamente 70 (Braunschweig and Wiesbaden, 1985), p. 199, p. 15.

13 Brent C. Brolin, The Failure of Modern Architecture (London, 1976); Peter Blake, Form Follows Fiasco: Why Modern Architecture Hasn't Worked (Boston, 1977); Charles Jencks, The Language of Post-Modern Architecture (London, 1977).

14 Colin Rowe, The Architecture of Good Intentions: Towards a Possible Retrospect (London, 1994), p. 133. Rowe indicates that the idea for his book originated in the sixties.

15 Fredric Jameson, "Architecture and the Critique of Ideology," in Michael Hays, ed., Architecture Theory since 1968 (Cambridge, MA, and London, 1998), p. 456.

16 For the concept of the "New Jerusalem" as it relates to the Bauhaus, see Werner Hofmann, Grundlagen der modernen Kunst: Eine Einführung in ihre symbolischen Formen (Stuttgart, 1966), p. 379. For a critique of the modern movement as architectural theology, see Rowe 1994 (see note 14), passim. For its empirical application to the urbanism of the twentieth century, see Angelus Eisinger, Die Stadt der Architekten: Anatomie einer Selbstdemontage, Bauwelt Fundamente 131 (Basel, 2006).

17 "... the so-called Lemon Tarts ... were women in their twenties or early thirties, mostly blondes (the Lemon in the Tarts), who were the second, third, and fourth wives or live-in girlfriends of men over forty or fifty or sixty (or seventy), the sort of women men refer to, quite without thinking, as girls." Tom Wolfe, The Bonfire of the Vanities (New York, 1988), p. 344.

For support and valuable suggestions I am grateful to Steffen de Rudder of the Bauhaus Universität Weimar and to the Bauhaus Dessau.

GALA Papierservietten. Bläugrün oder rosa. 38×38 cm. Mit 4 Kerzen. 25 Stück 4.-

GALA Servietten und Kerzen

4.-

PLAKETT Frühstücksservice 16teilig

29.-

Sotheby's

EST 1744

Deutscher Werkbund to Bauhaus:
An Important Collection of German Design

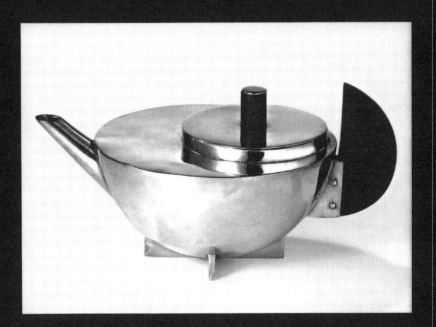

NEW YORK DECEMBER 14, 2007

"THIS CHAIR IS A WORK OF ART"
THE ZIGZAG COURSE OF BAUHAUS FURNITURE ON THE PATH TO FAME
Gerda Breuer

In 1982, Marcel Breuer's Wassily Chair was granted copyright protection in West Germany as accorded to the work of artists by law. As a result, the furniture manufacturer Knoll International was able to expand its licensing rights considerably; since compared with design patent protection, which lasts twenty-five years and which product design may typically claim, now the protection lasts for seventy years post mortem auctoris. Knoll International therefore proudly advertised with the slogan: "This chair is a work of art."[1] Viewed more closely, this court decision was utterly scandalous, since Breuer neither designed the Wassily Chair as a one-of-a-kind object or original work of art, nor was it supposed have the look and feel of being precious. On the contrary: it was conceived as an industrially mass-produced product. Much the same was to befall Le Corbusier. His tubular steel furniture was the subject of a similar nonsensical legal ruling eleven years later. The line of argumentation in both judgments was similar. In 1928, Le Corbusier collaborated with Pierre Jeanneret and Charlotte Perriand to design the chaise longue LC4, which went into production in 1930 and, like the Wassily Chair, is today a classic par excellence. Despite all manner of protests from the professional world, in 1993 the chaise longue was granted copyright protection by the Higher Regional Court in Frankfurt am Main. "It is irrelevant that Le Corbusier himself did not design his chair for art," read

the ruling. "Since the artwork concept is, in this context, a legal concept, which is to be understood not in accordance with the opinions of the creator of the work, but in accordance with the opinions of current German copyright protection laws." The intentions linked to a lot of furniture, in particular from the twenties, go unheeded by such rulings. According to judges, the object is already exalted by virtue of the recognition it receives from the art world. In substantiating the artwork character of another Le Corbusier furniture item, the LC2 Chair, the ruling mentioned stated that, by itself, the fact of its "being selected for a number of famous museums and catalogues"[2] was proof enough.

◼ THE INTENTIONS OF LE CORBUSIER AND MARCEL BREUER

As much as the re-editions by Le Corbusier today accommodate the penchant for an elegant, individual style of living—the furniture also flirted primarily more strongly with the technical aesthetic of Art Deco than the German Bauhaus classics—they originally stood firmly in the context of the concept of modern big-city life. Le Corbusier had observed that urban space, including interior space, presided over the psyche of the modern human being and, accordingly, contributed to his sense of happiness or unease. This gave the architect hope that, by organizing the city in a modern, hence rationalist way, he could impact the lives of his contemporaries— the "new human being," the "man of the mechanical age."[3] The urban space of the "plan voisin," for instance, was designed to stimulate not just body and soul but all the senses, even while relaxing on the "chaise longue à

réglage"—initially named the LC4 by its later manufacturer, Cassina. Thus Le Corbusier referred to the chaise longue as the "relaxation machine," as he called all of his tubular steel furniture "equipment." That the chaise longue, no different than the tubular steel furniture from the Pavillon de l'Esprit Nouveau, is today a luxury furniture item stands in diametrical opposition to the intention of its creator.

The case was similar for Breuer. The Bauhaus student and later director of the Bauhaus furniture workshop was actually a bit of a pragmatist. In his essay "Form Funktion" from 1924, the then just twenty-two-year-old Breuer distanced himself from Expressionism, De Stijl, and elementarianism—in particular from the heft of their theories—in demanding that things be "worked out without resorting to philosophizing about every action."[4] Yet at the same time, in his design Breuer was alert to every shift in direction given by Bauhaus director Walter Gropius to his colleagues in 1923: art and technology should form a new, single entity. In accordance with the Principles of Bauhaus Production published in 1926, in which Gropius called for studying the essence of an object—"for it must serve its purpose perfectly, that is, it must fulfill its function usefully and be durable, economical, and 'beautiful'"[5]—the chair was now supposed to be factory produced, economical, comfortable, and hygienic.

During this period, 'industrial' meant in many cases that an object was still capable of being manufactured. Although furniture was produced in series, it still required a high degree of hands-on work. It was not designed to be produced entirely by machine, as was the case with

upholstered or wood furniture, but noticeably simplified for serial manufacturing. Translating a design into machine-friendly form also still appeared to present a number of intellectual challenges at the time. László Moholy-Nagy, himself a protagonist of a new Bauhaus orientation, still complained at the end of the twenties that the "fear of machines" was a "children's illness."[6] The products corresponded much more to the bent wood chairs by the firms Thonet, Mundus, or Cohn, which Gropius, Breuer, Moholy-Nagy, and Bayer presented alongside their tubular steel furniture at the 1930 Parisian Werkbund Exhibition dedicated to high-rise living. Incidentally, the bent wood chairs were also highly popular with Le Corbusier; they matched well his vision of function-oriented furnishing items.

Breuer matched the tendency of the Dessau workshops to want them to be "laboratories in which prototypes of products suitable for mass production and typical of our time are carefully developed and constantly improved."[7] Accordingly, he positioned his tubular steel furniture in the spirit of the new aesthetic and economical industrial approaches. Like Le Corbusier, he shared the opinion that "metal furniture is intended to be nothing but a necessary apparatus for contemporary life."[8]

■ FROM SIMPLE FURNITURE TO DESIGN OBJECT

The legal ruling on the Wassily Chair mentioned at the outset was not handed down until after Breuer's death. It can be assumed, however, that he—having become a successful architect in the United States—would not have objected to the 1982 decision, since demand for

the chair had been waning for some time. Experimenting with new materials in the sixties, especially plastics, was common. And, in 1962, Breuer was pleased when the Italian furniture fabricator Dino Gavina applied for the license to manufacture the tubular steel furniture.[9]

Two years after Gavina's founding, the firm launched the new edition of the original B3 club chair. On Breuer's advice, the company gave it the catchier name Wassily so it would remind people of his colleague Wassily Kandinsky. After all, the painter had been a fan of the chair when its destiny at the Bauhaus was still unknown and before it was celebrated as a "masterpiece" at the 1926 Breuer exhibition at the Dresden Kunsthalle. Another Breuer design, the cantilever tubular steel chair B64, for which Gavina applied for the rights at the same time, was named Cesca by the firm after Breuer's adopted daughter Francesca.

Taking a different approach than Breuer had at the time the tubular steel chair was created, Gavina now aimed to improve upon the mass production of furniture through the addition of special features. This was the secret element to the success of the "linea italiana." In emphasizing design it was as if Italian industrial products had been awakened from a long slumber with a kiss. And, in only a short period of time, Italy succeeded in becoming a market leader with its own national signature, a position it has held since the late fifties. The unrivaled way in which Italian design combines beauty and technical rationality was its recipe for success. In the words of an advertising slogan by the audiovisual devices manufacturer Brionvega: "La tecnica nella sua forma più bella"—

technology should exhibit the most beautiful form possible. One spoke, therefore, of Italian Bel Design.

If German design, especially from the Hochschule für Gestaltung in Ulm, placed value on technical perfection in its most reserved form—the notion of the "silent server" was also relevant here—and if Scandinavian design focused on its long tradition of handwork-inspired functionalism, then Italian design now emerged through a plethora of individual products that functioned like personalities and were also developed by different, frequently independent designers. Accordingly, individual products were given fitting names like Bobby, Algol, Black, or Valentine; the designations played with associations to film actors, songs, and—like the Wassily—to famous personalities of the past. Designers no longer hid themselves behind anonymous designs, but appeared with their products and transformed themselves, not infrequently, into the stars of the design scene. Thwarting the modernist dictum "unity in multiplicity," it was now possible to say "multiplicity in unity." Italy invented modern non-corporate design. The names were designed to make vital characters out of inanimate objects. Utilitarian items were no longer reduced to simple functional rationality but were instead given an identity. And, at the same time, they were also recognized as Italian design.

■ FROM DESIGN OBJECT TO CULTURAL PRODUCT

When Gavina opened its showroom in 1963 on Via Condotti in Rome, instead of presenting furniture, a collection of ready-mades by Marcel Duchamp were on

display. During this time, Dino Gavina also proposed putting on an exhibition of Duchamp's works at his company headquarters in Rome. It was one of the artist's first appearances in Italy. In 1969, the entrepreneur founded the Centro Duchamp in San Lazzaro di Savena. Evidently, all of his admiration was devoted to the inventor of the ready-made.

Beginning in 1913, Duchamp selected everyday objects, stripped them of their function, and designated them works of art. He wanted to explore whether it was possible for a recognized artist to create an object that was not art. According to his own evidence, he failed. Whereas the bicycle wheel from 1913 was still a combination of wheel, front fork, and wooden stool, the industrially fabricated bottle rack from 1914 and urinal from 1917 were used unaltered, simply placed on a pedestal, furnished with a controversial title, and signed by Duchamp or his sister. The urinal featured an additional special detail. Wanting to present it at the first Salon of Independents in New York in 1917, Duchamp named the piece F o u n t a i n and signed it "R. Mutt." The name was a reference to the New York-based fabricators Mutt that had mass-produced the urinal. Though the jury denied Duchamp acceptance to the salon based on the provocative nature of his action, the urinal was exhibited in Cologne in 1920. There, at the Winter Brewery, which counted as the main address of the Rhenish avant-garde, it was accepted as an artwork.

If Duchamp had initially sought to plumb art's indifference to objects, then he put them on display in the context of art from 1935—41 with the suitcase museum "La Boîte-en-Valise." Using photos and small models, he

arranged his group of ready-mades and documented them. In 1964, in the context of emerging Pop Art, Duchamp perfected the confusion surrounding the ready-mades in commissioning the Milan-based gallerist Arturo Schwartz to produce and exhibit replicas of fourteen of them as serial objects.

It belongs to the irony of history that the ready-mades now resembled multiples, i.e., artworks of a serial nature first created in the early sixties that used duplication to downplay the art aspect of the object. Such a "loss of aura," to invoke Walter Benjamin, was intended by artists and was part of their desire to democratize art. The avant-garde's disposition toward dissolving the boundaries of art during the sixties was of use to Gavina in raising the profile of furniture produced by his company: using famous names, he tailored furniture to the trend in art, without denying its factory origins. Art's progressive attitude during the sixties and the industrial production of furniture suddenly appeared to be not so far removed from one another; they nearly resembled each other. Gavina interpreted Gropius's words, "Art and technology—a new unity," in his own way.

Duchamp's manner of stripping daily objects of their use value and elevating them within new surroundings to the status of a work of had an experimental, anarchistic, and provocative streak that was therefore particularly popular among Dadaists and Surrealists. Even today, the magical transformation of an item from functional use object to art object is a perennial hit in the art scene, but was highly controversial with Pop Art in the sixties. Significantly, this tendency in art was also first called Neodada. Andy Warhol's B r i l l o B o x e s and C a m p b e l l ' s

Soup Cans exemplify this link. The technique of serigraphy by itself yielded multiples. The Belgian Marcel Broodthaers satirized his signature as proof of the originality of art in an endless film loop of serial signatures. Any number of other examples may be cited here. If these were experiments in art that were part of a long tradition of exploring the boundaries of art, then it was Gavina's intention to completely ignore the boundaries between art and design. In the process, an amalgam was produced, which in the sixties in the context of his critique of historicism Theodor W. Adorno termed "Verkunstung," citing the example of the "culture industry."[10] The fine and applied arts moved closer together. The purposelessness of fine art was transferred onto the applied arts, although this purposelessness did not match the functional nature of applied arts in any way. Practical objects now gained attributes accorded to art, such as individuality and the status of the original, in this case, however, as a calculated move. "New on the part of the culture industry," wrote Adorno, "is the direct and undisguised primacy of a precisely and thoroughly calculated efficacy in its most typical products,"[11] an efficacy bound solely to the principle of utilization.

■ "ART AND TECHNOLOGY—A NEW UNITY"

It could not have been lost on companies like Gavina that while Duchamp's art act may have been a purposeless gimmick, this did not prevent the urinal, of all things, from being celebrated as an original, and that, over time, its monetary value increased considerably. The transformation of an everyday product into a work of art was there-

fore commensurate with a kind of magic. What could be done to lend tubular steel furniture the image of a high-quality product? What could be done to turn an object conceived as mass furniture into something exceptional, even into an icon? The solution consisted in shaping the perception of the consumer. With the examples of Duchamp and Pop Art, Gavina had learned that without the willingness of the art-interested public to recognize art in its given form, it is bereft of meaning. Just as for Catholic Christians a wafer only becomes the host and body of Christ under the acceptance of the sacraments of the Eucharist, for laypersons art is nothing more than a simply designed object. The Black Square by Kasimir Malevich is to laypersons nothing more than just that; to art connoisseurs, the painting is an icon.

The art system and the art market are governed by fundamental principles and operational mechanisms that resemble religious dogmas. A work of art gains meaning and importance not just through the artist himself, but also, even primarily, through the importance the art market ascribes to it, without which the artistic gestures remain ineffective. Other than the artist who has created the work, the recognition of critics, gallerists, curators, collectors, and art historians first gives the artwork its value. That experts are more or less unified through this process gives rise to an art system, a social construction, which, after a certain period of time, also remains immune to criticism. Within this circular process, criticism and arguments amount to negative advertising.

A design world emerged that was akin to the art market, which according to Pierre Bourdieu "claims a monopoly on the consecration of works of the past and on the pro-

duction and consecration of conforming consumers."[12] In the world of consecrated design classics it boils down to an effect that is opposed to the type of profit associated with fashion. If fashion generates profit through wear and tear and the manufacturing of endlessly new products, then the design classics are bestsellers with long-term perspective. On the one hand, the "timeless classics" suit the high production costs of the furniture industry, which has to factor in a longer sales cycle, and, on the other hand, the consumer, who in paying a higher purchase price is buying the guarantee of furniture with long-term attractiveness.

Something was created in Italy that has since been associated with high-quality interior design: the design object. It was important to Italians to market design as a cultural product in order to distinguish design from being perceived as the manufacturing of mass-produced products typical of industrial production. They succeeded in mastering the balancing act: namely to admit to industrial and technological rationality on the one hand, and, on the other, to produce an overabundance of meaning—the creation of an aura around an industrially mass-produced product. To this very day, with so-called design classics, consumers are seduced by the magic of purchasing not a product of industry and mass-produced furniture, but an original, a status object. Such furniture— not only because of its high price, and despite competition from a flourishing market of more affordable copies—is located in the foyers of banks and museums, in executive offices, and in every style of architectural space that values prestige.

■ "THE BEST WAY TO PREDICT THE FUTURE IS TO CREATE IT"

Meanwhile, fundamental principles and operational mechanisms are an inherent part of postmodern, mainstream rules of management. According to the formula "The best way to predict the future is to create it," success is no longer left to chance. Clever public relations replaces the time-honored trust in the belief that quality retains itself over time. With the recognition of Bauhaus furniture and other furnishings by well-known designers, in particular from the twenties, a pool of so-called modern classics emerged that were distributed widely both in licensed re-editions and as plagiarized copies. On the Internet, historical data disappears behind the abundance of primarily Italian discounters offering copies and appropriated versions of the furniture classics. Surrounding these pieces is an almost mythical power of attraction that cannot be broken, regardless of the improvements or changes made to the design.

Even the copies and plagiarized versions have their own—albeit nowadays hard to understand—history. It started by the thirties and experienced a climax during the sixties when the transfer of new licenses went into effect. Manufacturers offered customers forms whose origins were clearly recognizable but which differed enough that no one could have accused them of being copies. As a precaution, manufacturers voluntarily included design elements that often corresponded to the fashion of the particular eras: rosewood panels in the imitations of the Barcelona Chair by Ludwig Mies van der Rohe alluded to the characteristic materials of the

International Style. The geometric-futuristic lines in replicas of the Diamond Chair by Harry Bertoia emphasized a modernist-rationalist image in contrast to the soft, organic forms of the original. Thonet's so-called coffeehouse chairs were no longer sold in bent wood but in colorful plastic, since this reduced material costs and made them easier to produce. For similar reasons, the waxed-thread coverings of Breuer's Wassily Chair were replaced by plastic cord. And design classic compilations, such as Le Corbusier's LC2 and the Blow Chair, brought the twenties and sixties together.

At the beginning of postmodernism, Alessandro Mendini drew attention to the shift in perception and the new use context of well-known furniture. Accordingly, in the sixties, he proposed that chairs be redesigned and advocated for a cessation of innovation in favor of reflection. For many design icons—from Alfonso Bialetti's espresso maker to Gio Ponti's Superleggera Chair—he proposed seasonal modifications, a cherished game still played by designers today. In the endless chain of meanings associated with tubular steel furniture, almost the opposite meaning can arise within one and the same object. If, in the examples mentioned above, the meaning ascribed to the furniture runs from the industrially mass-produced product to the design object with an affinity to art, then meaning can, in a zigzag course, fall back again into a discussion that was fostered prior to the advent of tubular steel furniture. Now effort is made to use handcraft as a sign of the furniture's distinctiveness.

The original steel furniture models began with a liberating utopia. With the chairs and armchairs, the hope once was that with industrialization it might have been possi-

ble to make up for the inequities in society. Solving the "social question" was an essential component to the modernizing of life from the applied arts to the life reform movement, from the German Werkbund to the Bauhaus. But at the time of its making, Bauhaus furniture was appreciated predominantly by the educated, culturally savvy elites, and the wealthy business class. Nevertheless, the aura of the modernity of the machine age, including its promises to society, pervades this furniture through the present day.

Against the background of the furniture's multiple perceptions, it comes as no surprise that on the Internet, the firms producing plagiarized versions now emphasize their handmade manufacturing process in order to justify the high sales price of the pieces. The individual, often complicated steps in the manufacturing process can be followed on the computer monitor: the bending of the steel tubes, the assembly and fastening together of the tubes, the cutting and sewing of the fabric coverings. For Le Corbusier's furniture, welding is also a part of the process; for Mies van der Rohe's Barcelona Chair this also involves the crosswise assembly of the flat steel underframe as well as the sewing of the just eight-by-eight-centimeter squares of leather padding.

Despite the amount of handcraft, the plagiarized furniture is a mass-produced product. It is sold in greater quantities at a comparatively lower price; the range in prices for re-editions by legitimate firms is vast. In a paradoxical way, the modern classics first realize a part of the original utopia under these new conditions, namely affordable furniture—if not for everyone, then still for many. As Hans Magnus Enzensberger remarks, modern-

ism's farewell to utopia has an ironic punch line: "In a highly intricate way, it consists in a loss that also brought with it its own redemption. The poor intuition of common sense, that things happen in a way other than what one expects, is therefore challenged in a way that no philosophy of history can explain."[13]

1 Knoll International advertising slogan in D e r S p i e g e l 5 1 (1984), p. 182.
2 Cited in Sabine Zentek, E i n H a n d b u c h f ü r R e c h t i n K u n s t u n d D e s i g n (Stuttgart, 1998), p. 35.
3 Le Corbusier, S t ä d t e b a u (Stuttgart, 1979), p. 158.
4 Marcel Breuer, "Form Funktion," J u n g e M e n s c h e n 8 (1924), p. 191. Cited in Angelika Emmerich, "Marcel Breuer: Tischlerlehrling und Geselle des Weimarer Bauhauses 1920–1925," W i s s e n - s c h a f t l i c h e Z e i t s c h r i f t d e r H o c h s c h u l e f ü r A r c h i t e k t u r u n d B a u w e s e n W e i m a r 2, series A (1989), pp. 79-84, here p. 81.
5 Walter Gropius, cited in Paul-Alan Johnson, T h e T h e o r y o f A r c h i t e c t u r e (London, 1994) p. 85.
6 László Moholy-Nagy, V o n M a t e r i a l z u A r c h i t e k t u r , Bauhausbücher no. 14 (Munich, 1929), p. 13.
7 Walter Gropius, "Principles of Bauhaus Production," in Ulrich Conrads, ed., P r o g r a m s a n d M a n i f e s t o s o n 2 0 t h - C e n t u r y A r c h i t e c t u r e (Cambridge, MA, 1975), p. 96.
8 Marcel Breuer, cited in Christopher Wilk, "Furnishing the Future: Bent Wood and Metal Furniture 1925–1946," in Derek E. Ostergard, ed., B e n t W o o d a n d M e t a l F u r n i t u r e 1 8 5 0 – 1 9 4 6 (Seattle, 1987), p. 139.
9 See Donatella Cacciola, "Etablierte Moderne: Möbel von Breuer in der Produktion von Gavina und Knoll," in M a r c e l B r e u e r : D e s i g n u n d A r c h i t e k t u r , ed. Alexander von Vegesack and Mathias Remmele, exh. cat. Vitra Design Museum (Weil am Rhein, 2003), pp. 148–166.
10 Theodor W. Adorno, "Functionalism Today," in Neil Leach, ed., R e t h i n k i n g A r c h i t e c t u r e : A R e a d e r i n C u l t u r a l T h e o r y (London, 1997), pp. 5–18, here p. 6.
11 Theodor W. Adorno, "Culture Industry Reconsidered," N e w G e r m a n C r i t i q u e 6 (Autumn 1975), pp. 12–19, here p. 13.

12 Pierre Bourdieu, T h e R u l e s o f A r t (Stanford, 1996), p. 147.

13 Hans Magnus Enzensberger, "Gangarten," in Z i c k z a c k :
A u f s ä t z e (Frankfurt am Main, 1997), pp. 64–78, here p. 70.

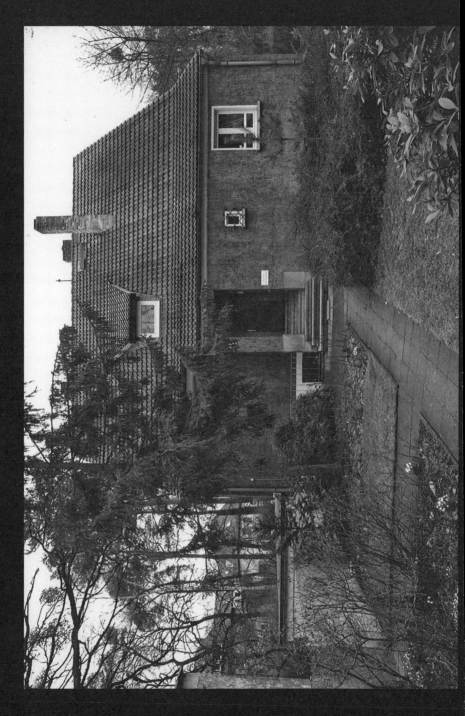

JUST A FAÇADE?
THE CONFLICT
OVER THE RECONSTRUCTION
OF THE MASTERS' HOUSES
Walter Prigge

"In the future, art lovers not only from Germany but from the entire world will pilgrimage to the friendly city of Dessau to see the impressive document of the will to art in our day that presents itself in the new complex of buildings for the Bauhaus, ... where Gropius built homes for himself and a sextet of colleagues—for Moholy-Nagy and Feininger, Muche and Schlemmer, Kandinsky and Klee. They are separate from the workshop complex, nestled among old pines on a green lawn. I still remember the prototype house from the Weimar exhibition of 1923—how terribly uncomfortable, orthodox-puritanical, empty, and cold it looked. Now, in both the design of space and the interior furnishings, these dwellings have taken on a sense of coziness, well-being, and comfort. Every detail is oriented to practicality with refined care; no force whatsoever is applied to the individual occupant. Even though the halves of the duplexes for these six masters are identical to each other, there is a different look everywhere. Each one contributes his own individuality; Kandinsky has even installed fine heirloom Russian furniture from bygone decades, and see, it looks wonderful. The bold, highly effective use of color gives all the interiors a special accent. Walls in the same room often receive different or rhythmically changing shades; the dwellings even have gold or silver walls that can have an

extraordinarily distinctive effect. Nor is there a lack of black surfaces."[1]

Since their restoration in the nineties, it is now once again possible to enjoy a tour through the Masters' Houses like the one described in 1926 by Max Osborn, the architecture, art, and theatre critic of the Berlin newspaper Vossische Zeitung. Five homes in two and a half duplex houses are now on view: in addition to Feininger House, which lost its other half during the war (the home for László Moholy-Nagy, a mirror image of the existing half turned ninety degrees), the Kandinsky and Klee houses have also been restored to the condition of 1926. In addition, numerous alterations from the Nazi period and the era of the German Democratic Republic (GDR) were removed, and extensive areas such as windows reconstructed.

Today, the Masters' Houses are as good as new and yet still contain enough original substance to offer visitors an experience of the Bauhaus world—and who would not like to imagine him- or herself at the easel of Wassily Kandinsky or Paul Klee? The restoration focused on the appearance of things in 1926 und presents them as if this period had continued to the present. In so doing, it offers an experiential encounter with the aesthetic principles of historic architecture from the repertoire of Cubistic modernism, which Jürgen Habermas once described as that felicitous moment when strict functionalism coincided with aesthetically self-confident Constructivism.

The restoration of the third duplex house, however, where Georg Muche and Oskar Schlemmer lived, reflects a

different goal. Like the other houses, its exterior is restored to the image of 1926; on the interior, however, emphasis is placed on historical memory rather than aesthetics. Here the traces of remodeling from the Nazi and GDR periods have not been removed, but are preserved. Since the goal is to reveal history through architecture, these homes, too, become objects of demonstration. In terms of content, they tell stories from the twentieth century; formally, they show approaches to historic preservation different from those of today. But while there is conflict among historic preservationists over these two strategies—the aesthetic on the one hand, the memorial-political on the other—the Masters' Houses also implicate yet another, third variation.

■ FROM GROPIUS HOUSE
TO EMMER HOUSE

"Many objections," wrote the newspaper D e s s a u e r Z e i t u n g in October 1926, have been raised against the new architecture as it shows itself in the Bauhaus and the Masters' Houses. Many of these complaints may be justified, and so in order to arrive at an independent judgment, the Hausfrauenverein decided to test the new buildings for itself, especially the interior household furnishings. Today we are taking a stroll out to Burgkühnauer Allee. At every turn, it becomes clear that the woman who manages the home also helped invent it, helped build it. Guided by Frau Direktor Gropius, we were permitted to wander through all the rooms. The dining room and common work room are divided only by a smooth curtain in order to be able to create a large space. The desk does not dominate the room, but stands to one side,

allowing husband and wife plenty of space for shared work. Unhindered, light floods in onto wide mirror panes. In the work room as well as in the dining room and bedrooms, we admire built-in cabinets with smooth doors that open with a quick push rather than tedious latches and even have automatic lights in dark corners. The kitchen is a chapter of its own. The dear lady of the house was kind enough to show us many practical household appliances that she has tested with her own hands and found functional, and therefore commendable—a heartwarming prospect for any housewife who does not passionately enjoy cleaning and scrubbing.[2]

Today, it is no longer possible to experience what the Dessau Hausfrauenverein (Housewives' Association) saw in 1926, since the freestanding Gropius House was destroyed in the war and cleared away. In 1956, an opportunity to rebuild Gropius House arose when an engineer named Emmer decided to construct a home above the custodian's dwelling preserved in the cellar, a house that would bear some formal resemblance to Gropius House. At the time, however, the building code prohibited him from doing so, and instead called for a pitched-roof house in the tradition of the modernism of the Stuttgart school, which in the meantime has come to dominate the periphery of German cities in millions of examples. Here on the east side, therefore, Emmer House, with its plan borrowed from Gropius House, involuntarily demonstrated the devaluing of the Bauhaus in the GDR of the fifties.

This other, conservative modernism also dominates the current setting of the Masters' Houses. To the west are three triplexes from the forties and six single-family

homes of the same type as Emmer House. Across the way there are also conventional, middle-class single-family dwellings from the subsequent decades. Builders in Dessau never emulated the quality of Gropius's Master's Houses, which thus appear today as white anomalies in their environment. From all sides, they are hemmed in by the traditional development houses of the suburban "Deutschlandscape" (Francesca Ferguson). Even the classicizing architectural elements of the Wörlitz Garden Kingdom, emphasized by visual axes at the beginning and end of the country highway, do nothing to alter this situation.

Today, the Masters' Houses function as museums for cultural use; since 1996, they have even been designated part of the UNESCO World Cultural Heritage. Their restoration was completed in 2002, and with the purchase of Emmer House the municipal government declared its intent to reconstruct the shell of Gropius House. At least facing the east—the direction from which tourists approach from the Bauhaus—the Masters' Houses were to be set apart from their everyday environment. The city wanted to once again restore the appearance of a complete row of houses.

"Reconstructions" of historic buildings, as they are generally called, are new structures with historicizing façades; the interiors are usually marked by contemporary forms and functions. To copy the façade of the sixth house-half, Moholy-Nagy House, in accord with the surviving house-halves would not pose a technical problem, since the focus of such copies is the overall appearance rather than comprehensive detail. Even the refreshment kiosk designed by Ludwig Mies van der Rohe, torn down

in the sixties, could be reconstructed in the rectangular gap in the garden wall, which is also to be rebuilt at the edge of the Gropius House site. What is problematic is the façade of Gropius House itself. It could be rebuilt on the basis of plans and photographs from 1926, but in order to do so, Emmer House would have to be torn down—thus obscuring the real history of Gropius House and the transformations it has undergone.

This, then, is the point of conflict. Should the World Cultural Heritage of the Bauhaus be presented at the Masters' Houses as a kind of theme park of historic preservation, a demonstration of approaches to the restoration of modern buildings ranging from mere preservation of original elements, the conservation of historical transformations, to the reconstruction of complete façades? The Stiftung Bauhaus Dessau has been discussing the alternatives since 2003. Two colloquiums, a film, and a book of interviews with experts, along with the 2006 Bauhaus Award for designs for Gropius House set the stage for an international competition in 2008 sponsored jointly by the City of Dessau and the State of Saxony-Anhalt—a competition that made a special point of not calling for reconstruction.

■ BEAUTY VERSUS HISTORY

"The whole theory of historic preservation is ... something ICOMOS is very concerned about," explained Michael Petzet, president of the German National Committee of the International Council on Monuments and Sites (ICOMOS) in November 2008.

"We have the famous Venice Charter, our founding document, so to speak. People always say that it forbids

reconstruction. But that isn't in the charter at all What is authentic is quite simply what is genuine and true—but that can also be a true design. I was just involved in a conflict with some people in Dessau: there, too, it is a question of the World Cultural Heritage with respect to the Bauhaus. Now, if they are going to have a competition that explores how present-day architects respond to the Bauhaus, then I have to say: that's not the point! The Bauhaus influenced the entire world. A half of a house there in Dessau is destroyed: it should be rebuilt exactly as it was. A building by Gropius should also be constructed again insofar as it is really needed as the "head" of the complex—if it is really needed, then the Gropius building must be reconstructed. The same goes for a pavilion by Mies van der Rohe: one can't just think up something new. In other words, sometimes reconstruction really is a possibility, though it is clear that there are dangers associated with that as well."[3]

ICOMOS intervened in the two-phase competition for the "urbanistic repair" of the complex of Masters' Houses; apparently, Petzet viewed the competition as a threat to the World Cultural Heritage status of the Dessau Bauhaus. The daily practice of historic preservationists with regard to small things must also be possible on a larger scale: according to Petzet, the missing portions of the Masters' Houses should be replicated and reconstructed, whether an entire building or a garden wall with a refreshment kiosk.

At the same time, it is hardly as though these modernist buildings were destroyed by a bolt of lightning or a household fire, as journalist Walter Dirks noted in 1947 with regard to the ruins of the Goethe House in Frankfurt.

The experts from the international committee for the Documentation and Conservation of Buildings, Sites and Neighborhoods of the Modern Movement (Docomomo), a relatively new association of architects, art historians, and historic preservationists who focus on the buildings of classical modernism, make a similar case. Docomomo contests the necessity of taking action on the Masters' Houses; instead, in the "Brno Declaration" of June 2008 they advocated the conservation of the current combination of original and added parts and careful appropriateness in its use: "We regard a reconstruction of the buildings as they were in 1926 as no less misguided than projects for the construction of new buildings, the purpose of which is to eliminate the existing fabric that is so extraordinarily illustrative of modernist architecture … . Current deficiencies of an urban planning and architectural nature can only be remedied by contemporary artistic and architectural designs which respect to the special characteristics of the location and incorporate the findings of architectural and building research."[4]

While ICOMOS insists on the image value of the complete row of houses, Docomomo is concerned with the historically transformed fragments. Both are present-day interpretations, and therefore present-day designs. The "reconstruction" of Gropius House is an interpretation of what is now only a fictitious original condition; the "conservation" of Emmer House is an interpretive selection of transformative historical events. The one looks for beauty, the other for history. In the future, which should have pride of place—didactic architectural forms that produce historicizing images of the city, or didactic historical events that shape the politics of memory? On the

basis of their experience with a combination of differing approaches to restoration in their own building, for the Masters' Houses the Stiftung Bauhaus Dessau sought a way out of the mere alternative of reconstruction or conservation.

■ OBJECT VERSUS IDEA

"Herr Raabe, what is provincial about the Stiftung Bauhaus Dessau?" the newspaper M i t t e l d e u t s c h e Z e i t u n g asked the author of the B l a u b u c h 2 0 0 6, the most recent assessment of nationally significant cultural institutions in the eastern German states. "What is provincial about it," answered Paul Raabe, "is that it has not been successful in anchoring the Dessau Bauhaus as a 'cultural beacon' in the consciousness of all of Germany. The Bauhaus was Germany's most famous school of modernism; there is no comparable German cultural institution of such lasting and worldwide significance. Very little of that is visible on location; you find the magnificent building, but nothing more." Later in the conversation, the interviewer asked, "You write that in Dessau, the past seems to be perceived as a liability. What brings you to that conclusion?" Raabe responded: "Not least of all, the discussion about Gropius House We don't understand how there can be such an uproar about the reconstruction of a building whose foundation and basement are still preserved—a reconstruction that anywhere else would pose no problem at all. The point is to once again be able to experience the ensemble of Masters' Houses. It makes perfect sense to reconstruct Gropius House—but for the Stiftung Bauhaus Dessau, apparently not."[5]

288

Cultural objects of outstanding value are the heritage of the "Kulturnation" (cultural nation) which comes alongside the "Staatsnation" (state-nation) and supersedes the normative conceptions of a homogenous "Leitkultur" (core culture). In the periodic evaluation of the eastern German "cultural beacons," the point is not the content or protection of the institutions themselves, but their value in relation to other institutions. In contrast to normative "Leitkultur" policy, the "Kulturnation" collects valuable objects without normative criteria. Here culture is understood as non-economic property, as the treasure of the nation: "Conceived as property, the cultural legacy nonetheless becomes an argument for cultural norms that are justified through origin—quite different than tradition, which can be understood as the inhomogeneous totality of culture transferred to us from preceding generations in the form of libraries, archives, collections, and through cultural practices such as readings and translations."[6]

The inclusion of a building or complex in UNESCO's list of World Cultural Heritage sites increases the danger of such a normative treasure-making, for the worldwide compilation of national cultural sites detaches them from their specific relationships of content and form. As with any exhibition, this abstraction from regional context integrates them into relational connections that represent their economic value independent of content and form. The unit of measure for this decontextualization is "outstanding universal value," the criterion by which UNESCO determines the political value of national candidates for world heritage—that is, for international tourism and cultural consumerism.

The controversies over how the legacy of modernism should be presented at the Bauhaus as a place of memory play themselves out against the background of this political overdetermination of the "Kulturnation." If modern culture is conceived as the historical property of the nation and is musealized in the objects of the Bauhaus, then modernism is preserved as a past epoch—like a specimen. But if modern culture is transmitted through the ideas of the Bauhaus, which are critically actualized in current approaches to design, then modernism is integrated into the present—in both its display and its continuation. The historical Bauhaus is included in the UNESCO list as both an object and an idea of modern design in the twentieth century, and the Stiftung Bauhaus Dessau is legally charged with cultivating both the past and the future of the objects and ideas of the Bauhaus. Accordingly, as a third way beyond reconstruction and conservation, the Stiftung Bauhaus Dessau engaged the conflict over the politics of memory surrounding the Masters' Houses under the title "Actualization of Modernism"—though here, too, the individualization and medialization of the collective memory of modernism in civil society must be taken into account.

■ IMAGE VERSUS SPACE

"Around 250 people have an opinion and have made it known. Eighty-four percent of survey participants were in favor of reconstructing the Gropius Director's House and the Moholy-Nagy Master's House, 11% want to leave things as they are, and 5% want a high-quality new building. 'That represents a clear trend,' says Harald Wetzel. He is chair of the Förderverein Meisterhäuser, on

whose Web site votes have now been accepted for some time."[7] Four years earlier, a postcard survey by the Stiftung Bauhaus Dessau yielded the following results: reconstruction 39%, conservation 14%, new composition 23%; there was also provocation 10%, addition 6%, subtraction 2%, and one's own design 6%. The more differentiated the survey, the more diverse the answers. Following the conflict over B l a u b u c h 2 0 0 6, media and politics made sure that in the Dessau Internet, the discussion of the competition of 2008 was reduced to the level of "Gropius House: for or against." When opinion surveys, campaigns, and media politics dominate local debates and decisions, the number of participants interested in history expands through the individualization and transnationalization of memory. The meaning of national history and collective memory in an age of global cultures, then, is no longer defined merely by historians, national institutions, and experts in historiography, but is negotiated in broader arenas of media and civil society.

The Förderverein Meisterhäuser (Friends of the Masters' Houses) is one such local agent in civil society. It stands for independence and the new middle class in Dessau, and for it, the Bauhaus is still the "sacred district" (Paul Betts) of the "Kulturnation," inhabited by individual monuments. The iconic strategy of this kind of monumentalization—still in the planning stages for the Masters' Houses—is already visible in the new design of the area around the Bauhaus. The urbanistic isolation of the building through such features as the elevation of the terrain and the distinctive design of the street and its accessories is guided by the "Kodak view of the sightseeing industry" (Gerhard Matzig), which establishes a hierar-

chy of individual objects by isolating them. In this way, the Bauhaus, too, separated from the culture of the city, can become the elite object of a particular lifestyle: "When local agents, above all those from the service sector, associate liberality, interest in culture, and cosmopolitanism with the Bauhaus and create corresponding living environments for themselves, then the 'Bauhaus style as lifestyle' is also proof that one has arrived in the new Germany, to whose center one feels that one belongs … . As a World Heritage site, the Bauhaus makes available symbolic resources that correspond to the lifestyle of this academic elite."[8]

The new "space pioneers," on the other hand, are different. These avant-garde activists are likewise recruited from the educated middle class, but in the shrinking cities of eastern Germany they are looking for very different forms of culture. In the spirit of the slogan "use it, don't own it," they facilitate the municipal appropriation of abandoned industrial buildings. With their orientation to space rather than image, their interest focuses on a design of urban space that is contemporary in the best sense, and thus also on the future of that space. Because of their experience in salvaging historic buildings for new uses, they advocate the actualization rather than the reproduction of past images of the city.

"In this prominent location at the beginning of the twenty-first century, the architecture of the Bauhaus must be further developed instead of reconstructing an outdated architectural language," says Thomas Busch, member of the Fraktion Bürgerliste/Die Grünen in the Dessau-Rosslau city council. In Dessau, the new building for the

Federal Environmental Office by architects Sauerbruch Hutton has "only recently proved that outstanding contemporary architecture can support a structural change." What is important, Busch says, is to once again "ignite" the "revolutionary mood" of the Bauhaus of the twenties.[9]

■ MONUMENT

But that will not happen with the Masters' Houses. None of the competition designs achieved the quality of Gropius's architecture. Instead of "urbanistic repair," the competition might just as well have reached the international architecture scene under the title "Gropius Master House Remodeling." The projects were dominated by cubic structures and neo-modern variations on the Gropius House façades, which for the layperson constitutes no significant departure from the historical appearance of the building. Hence the city council of Dessau-Rosslau decided in favor of reconstruction, thereby going the route of monumentalizing isolation and a tourist-oriented image strategy. The function of the new Masters' Houses is still being negotiated.

Emmer House will be torn down. The demolition will be documented and explained in an exhibition inside the shell of the new building, which will most certainly once again be called Gropius House. "Why do we do this?" asks the historian Philipp Blom, considering such procedures. "Because we have a perverse relationship to the past We are the first culture in the history of the world to venerate the old simply because it is old, and our museums are bastions for the conservation of our undead pasts."[10]

As monuments for the World Cultural Heritage, the Masters' Houses can be written off with a minimum of regret or loss, along with a few other monuments in Dessau by Gropius that do not belong to the World Cultural Heritage but could still have been saved if there had been willingness to spend some of the money devoted to reconstruction on them. But there is nothing more to think about the matter, "because monuments make us think about history, but reconstructions make us think we can take charge of history."[11] What aesthetic impression the new Gropius imitations will leave behind remains to be seen.

1 Max Osborn, "Das Neue Bauhaus," Vossische Zeitung, December 4, 1926. Cited in Leben am Bauhaus: Die Meisterhäuser in Dessau, exh. cat. Bayerische Vereinsbank (Munich, 1993).
2 M. Schmidt-Goffrau, "Ein Gang durch die Meisterhäuser," Der Besuch der Hausfrauen, Dessauer Zeitung, October 16, 1926. Cited in Leben am Bauhaus 1993 (see note 1).
3 "Dr. Michael Petzet, Präsident Internationaler Rat für Denkmalpflege, im Gespräch mit Dr. Dieter Lehner," Bayerischer Rundfunk, alpha-Forum, broadcast on November 19, 2008, http://www.br-online.de
4 Docomomo Deutschland e.V., Brno Declaration on the Debate about the Masters' Houses Ensemble in Dessau, June 7, 2008, http://www.docomomo.de
5 "'Das ist nicht genug,' MZ-Gespräch mit 'Blaubuch'-Autor Paul Raabe über die Kritik an der Bauhaus Stiftung Dessau," Mitteldeutsche Zeitung, February 26, 2007. Cf. Paul Raabe, Blaubuch 2006: Kulturelle Leuchttürme in Brandenburg, Mecklenburg-Vorpommern, Sachsen, Sachsen-Anhalt, Thüringen (Berlin, 2006), pp. 138–143.
6 Sigrid Weigel, "Die Flucht ins Erbe, Alle wollen die 'Kulturnation'—warum?" Süddeutsche Zeitung, February 1, 2008.
7 Ilka Hillger, "Abstimmung im Internet zeigt einen eindeutigen Trend: Förderverein Meisterhäuser bilanziert zur Halbzeit aktuelle Ausstellung," Mitteldeutsche Zeitung Dessau, August 14, 2008.

8 Regina Bittner, "Leuchtturm Bauhaus," in Walter Prigge, ed., I k o n e der Moderne: Das Bauhausgebäude in Dessau (Berlin, 2006), p. 47. Cf. Bittner's dissertation on the Bauhaus city of Dessau (Berlin, 2009).

9 Thomas Busch, "Internationaler Wettbewerb Meisterhäuser," Amtsblatt Dessau, June 2007.

10 Philipp Blom, "Schafft die Museen ab!" Die Zeit, January 3, 2008.

11 Ronald Berg, "Wer bestimmt, was gestern war?" Die Tageszeitung, April 3, 2007.

Authors

OTL AICHER
Born in 1922, died in 1991. Studied sculpture at the Akademie der Bildenden Künste in Munich. In 1948, opened a graphic design studio in Ulm. In 1953, initiated the Hochschule für Gestaltung (HfG) in Ulm together with Inge Aicher-Scholl and Max Bill. From 1962 to 1964, served as rector of the HfG Ulm. In 1967, received the commission for the visual design of the 1972 Olympic Games in Munich. Designed numerous brand identities for German companies. In 1984, founded the Rotis Institut für analoge Studien. In 1988, developed the Rotis family of typefaces.

PAUL BETTS
Born in 1963. Studied history at Haverford College in Haverford, Pennsylvania, and the University of Chicago. From 1996 to 1999, assistant professor at the University of North Carolina in Charlotte. Since 2000, teaches history at the University of Sussex in Brighton, specializing in the history of society, culture, and mentality in twentieth-century Germany. Currently preparing a publication on the history of private life in the GDR.

GERDA BREUER
Born in 1948. Studied art and architectural history, philosophy, and sociology in Aachen, Ann Arbor, Michigan, and Amsterdam. From 1985 to 1995, directorial activity at various West German museums. Since 1995, professor of art and design history at the Bergische Universität Wuppertal. Since 2005, chair of the academic advisory council of the Stiftung Bauhaus Dessau. Numerous publications on the history of art, photography, and design in the nineteenth and twentieth centuries.

MAGDALENA DROSTE
Born in 1948. Studied art history and German literature in Aachen und Marburg. In 1977, completed doctorate under Heinrich Klotz and Martin Warnke with a dissertation on German murals in the nineteenth century. From 1980 to 1991 research assistant, from 1991 to 1997 acting director of the Bauhaus-Archiv Museum für Gestaltung Berlin. In 1990, publication of the standard work B a u h a u s 1 9 1 9 – 1 9 3 3 . Since 1997, professor of art history at the Brandenburgische Technische Universität Cottbus.

JÖRN ETZOLD

Born in 1975. Studied applied theater in Giessen. From 1999 to 2003, directed and performed in theater projects, above all with the Drei Wolken group. From 2001 to 2004, member of the Graduiertenkolleg "Zeiterfahrung und ästhetische Wahrnehmung" at the Johann-Wolfgang-Goethe-Universiät Frankfurt am Main. In 2006, completed doctorate with a dissertation on Guy-Ernest Debord. Since 2007, research assistant at the Institut für Angewandte Theaterwissenschaft at the Justus-Liebig-Universität Giessen.

SIMONE HAIN

Born in 1956. Studied art history in Brno and Berlin. In 1987, completed doctorate with a dissertation on the Czech avant-garde. Since 1990, numerous publications on the history of architecture and urbanism in the GDR and various projects related to the shrinking cities of eastern Germany. Since 2000, teaching activity at the Hochschule für bildende Künste Hamburg and the Bauhaus-Universität Weimar. Since 2006, professor at the Institut für Stadt- und Baugeschichte of the Technische Universität Graz.

KAI-UWE HEMKEN

Born in 1962. Studied art history, philosophy, and literature in Marburg and Munich. In 1993, completed doctorate with a dissertation on El Lissitzky. Developed exhibition concepts for the Sprengel Museum Hannover and the Kunstsammlung Nordrhein-Westfalen Düsseldorf. From 1992 to 2005, academic assistant at the Kunstgeschichtliches Institut of the Ruhr-Universität Bochum, then curator of the art collections of the Ruhr-Universität Bochum. Since 2005, professor of art history at the Kunsthochschule Kassel.

THILO HILPERT

Born in 1947. Studied sociology, art history, and German literature in Mannheim and Göttingen, and architecture in Berlin, Paris, and Kaiserslautern. In 1976, completed doctorate under Hans Paul Bahrdt. Since 1985, professor of architecture and architectural history at the Fachhochschule Wiesbaden. Research on the work of Le Corbusier, publications on the urbanism of the twentieth and twenty-first centuries. Author of major urban planning evaluations for Frankfurt am Main and Hannover. Since 1999, member of the academic advisory council of the Stiftung Bauhaus Dessau.

DIETER HOFFMANN-AXTHELM

Born in 1940. Studied theology, philosophy, and history. In 1968, completed Ph.D. in theology in Münster. Since 1975, member of editorial board for the journal Ästhetik und Kommunikation. Since 1978, involvement in urban planning, initially in the context of the redevelopment of the Kreuzberg district of Berlin. Author of numerous urban planning evaluations, most significantly in connection with Planwerk Innenstadt Berlin from 1996 to 1999. From 2002 to 2003, fellow at the Internationales Forschungszentrum Kulturwissenschaften in Vienna.

JOACHIM KRAUSSE

Born in 1943. Studied philosophy, literature, art history, and journalism in Tübingen, Vienna, Hamburg, and Berlin. From 1981 to 1998, teaching activity at the Hochschule der Künste Berlin. In 1994, completed doctorate at the Universität Bremen with a dissertation on the relation between scientific world views and architecture since the eighteenth century. Since 1999, professor of design theory at the Hochschule Anhalt Dessau-Rosslau. In 1999 and 2001, published the standard work Your Private Sky: R. Buckminster Fuller with Claude Lichtenstein.

MICHAEL MÜLLER

Born in 1946. Studied art history, archaeology, social psychology, and philosophy. In 1970, published the standard work Die Villa als Herrschaftsarchitektur with Reinhard Bentmann. Since 1977, professor at the Institut für Kunstwissenschaft und Kunstpädagogik of the Universität Bremen. Founding member of Architop, Bremer Institut für Architektur, Kunst und städtische Kultur. Publications on Neues Bauen in Frankfurt am Main and on questions of design, the critique of postmodernism, and the relation between architecture, avant-garde, and politics.

PHILIPP OSWALT

Born in 1964. Studied architecture in Berlin. From 1988 to 1994, editor of the journal Arch+. In 1996 and 1997, worked with the Office for Metropolitan Architecture/Rem Koolhaas, Rotterdam. From 2000 to 2002, visiting professor at the Brandenburgische Technische Hochschule Cottbus. From 2002 to 2005, co-initiator and co-curator of the program for temporary cultural use of the Palast der Republik in Berlin. From 2002 to 2008, director of the Shrinking Cities project for the Kulturstiftung des Bundes. Since 2006, professor of architectural theory and design at the Universität Kassel. Since 2009, director of the Stiftung Bauhaus Dessau.

WALTER PRIGGE

Born in 1946. Studied sociology in Frankfurt am Main. In 1984, completed doctorate with a dissertation on time, space, and architecture. Subsequent activity as independent urban researcher in Frankfurt am Main. Since 1996, active at the Stiftung Bauhaus Dessau with research, programs, exhibitions, and publications on city, space, and architecture in the twentieth and twenty-first centuries, including studies on the development of the periphery, the work of Ernst Neufert, and the relation between modernity and barbarism.

ULLRICH SCHWARZ

Born in 1950. Studied German literature and sociology. In 1981, completed doctorate with a dissertation on concepts of aesthetic experience in Jan Mukařovský, Walter Benjamin, and Theodor W. Adorno. Since 1984, director of the Hamburg Chamber of Architects. From 1992 to 1998, visiting professor of architectural theory at the Hochschule für bildende Künste Hamburg. In 2002, curated the exhibition Neue Deutsche Architektur: Eine Reflexive Moderne. Since 2004, professor of architectural theory at the Technische Universität Graz.

WOLFGANG THÖNER

Born in 1957. Studied art education and German literature in Berlin. Since 1985, research assistant at the Bauhaus Dessau, focusing primarily on the history and reception of the Bauhaus as well as the culture of modernism. In 1997, co-curator with Ingrid Radewaldt of an exhibition on textile designer Gunta Stölzl. In 2006, co-curator with Peter Müller of an exhibition on architect Richard Paulick between Bauhaus tradition and the modernism of the GDR.

JUSTUS H. ULBRICHT

Born in 1954. Studied German literature, history, and education in Tübingen. In 1979, state examination for secondary school teacher certification. From 1980 to 1995, independent scholarly activity. From 1995 to 2009, research assistant at the Stiftung Weimarer Klassik. In 2006, completed doctorate in Jena with a dissertation on the construction of cultural identity in classic German modernism. Numerous essays on the history of the educated bourgeoisie in Germany with its conservative and nationalistic propensities .

Images

173 ■ John Lottes, student project on the visualization of progressions of movement and functions in graphics, designed under the lecturer Anthony Fröshaug at the HfG Ulm, 1958–1959; © Ulmer Museum/ HfG-Archiv

188 ■ Unknown designer, catalogue of the exhibition Bauhaus Dessau 1928–1930, Moscow 1931, using a poster motif by Max Gebhard and Albert Mentzel, ko-prop; Bauhaus-Archiv Berlin

189 ■ Memorial plaque at the HfG Ulm, lost; photo: Karl-Heinz Rueß/ SWP Archiv, © Stadtarchiv Ulm

210 ■ Annemarie Renger, the president of the German Parliament, at the Bauhaus-Archiv Berlin, 1975; photo: Karl-Heinz Schubert/Landesarchiv Berlin

211 ■ Architecture department of the Technische Universität Berlin during the student strike 1977; photo: Archiv Martin Kieren

224 ■ Cover of the book Architektur, Bauwerke und Baustile von der Antike bis zur Gegenwart: Lehrbuch für die Kunstbetrachtung in der zehnten Klasse der erweiterten Oberschule, Berlin 1965; legal heirs of Verlag Volk & Wissen, Cornelsen Verlag

225 ■ Lutz Dammbeck, invitation to the media collage Film, Musik, Tanz, Malerei auf der Bühne des Bauhauses Dessau, 1985; Stiftung Bauhaus Dessau and Lutz Dammbeck, © VG Bild-Kunst Bonn 2009

244 ■ The demolition of a housing complex at Pruitt-Igoe in St. Louis, 1972; illustration from Idee, Prozess, Ergebnis by Felix Zwoch

245 ■ Foreign-language editions of Tom Wolfe's book From Bauhaus to Our House, 1982–2008; photo: Christoph Petras

260 ■ IKEA catalogue, 1989; Inter IKEA Systems B. V.

261 ■ Sotheby's catalogue, 2007 (The estimated price of Marianne Brandt's 1927 teapot was between 300,000 and 500,000 dollars; it sold for 361,000 dollars); collection of the Kamm Teapot Foundation/ Sotheby's

278 ■ Haus Emmer, Dessau, 1956; photo: Winfried Brenne Architekten

279 ■ nijo architekten Zürich, study from the reconstruction planning of Gropius House, Dessau, 2009

The Work of the Stiftung Bauhaus Dessau

The Stiftung Bauhaus Dessau, located in the historic Bauhaus building in Dessau, was founded in 1994 by the Federal Government of Germany, the State of Sachsen-Anhalt, and the City of Dessau-Rosslau. One of the cultural beacons of the eastern German states, the institution was commissioned to "preserve the legacy of the historical Bauhaus" and "address the design problems of the contemporary living environment."

The work of the Stiftung Bauhaus Dessau rests on three pillars. Dessau holds the second-largest collection related to the history of the Bauhaus with over twenty thousand objects, above all from the Dessau phase from 1925 to 1932. Against the background of the Bauhaus legacy, the workshop focuses on projects related to present-day concerns; here, research and design are integrated. The academy serves educational purposes: since 1999, the Internationales Bauhaus-Kolleg has offered a one-year, English-language interdisciplinary program, regularly attended by architects, urban planners, artists, and scholars of culture, the humanities, and the social sciences from around the world.

With a variety of events on the legendary Bauhaus stage as well as its newly conceived permanent exhibition and changing temporary exhibitions, the Stiftung Bauhaus Dessau is devoted to both the historical legacy and contemporary artistic questions. As many as 100,000 visitors annually from around the world come to Dessau to see the well-known building and take advantage of the extensive program, ranging from a day trip to a year's stay at the Bauhaus-Kolleg.

Stiftung Bauhaus Dessau
Gropiusallee 38
06846 Dessau
Germany
Tel. + 49 (0340) 6508250
Fax + 49 (0340) 6508226
service@bauhaus-dessau.de
www.bauhaus-dessau.de

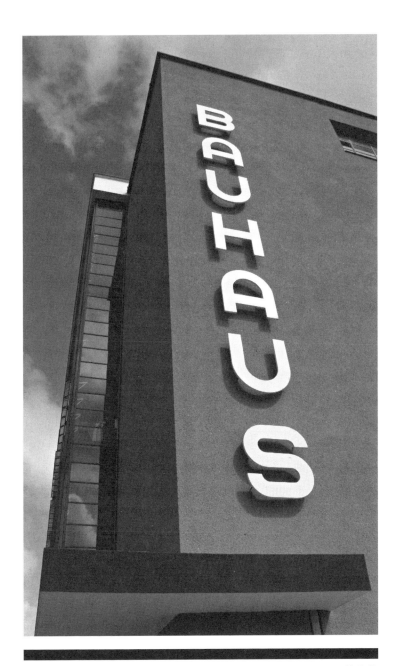

COLOPHON

This catalogue is published in conjunction with exhibitions commemorating the ninetieth anniversary of the founding of the Bauhaus:
modell bauhaus, Martin-Gropius-Bau, Berlin
July 22–October 4, 2009
and
Bauhaus 1919–1933: Workshops for Modernity, The Museum of Modern Art, New York
November 8, 2009–January 18, 2010

Editor: Philipp Oswalt (Stiftung Bauhaus Dessau)
Managing editors: Philipp Oswalt, Walter Prigge
Project manager and image research: Nicole Minten-Jung
Editorial coordination: Tas Skorupa, Hatje Cantz
Copyediting: Rebecca van Dyck
Translations: Melissa Thorson Hause, Erik Smith, John S. Southard, Michael Wolfson
Graphic design: Müller & Wesse, Berlin
Production: Stefanie Langner, Hatje Cantz
Typeface: Venus (Bauersche Giesserei)
Paper: Munken Print Cream, 115 g/m^2
Printing and binding: Kösel GmbH & Co. KG, Altusried

Published by
Hatje Cantz Verlag
Zeppelinstrasse 32, 73760 Ostfildern, Germany
Tel. +49 711 4405-200, Fax +49 711 4405-220
www.hatjecantz.com

Hatje Cantz books are available internationally at selected bookstores. For more information about our distribution partners, please visit our homepage at www.hatjecantz.com.

ISBN 978-3-7757-2488-3 (English edition)
ISBN 978-3-7757-2454-8 (German edition)

Printed in Germany